D1071906

J. M. W. TURNER

The publisher gratefully acknowledges the contribution provided by the Art Book Fund of the Associates of the University of California Press, which is supported by a major gift from the Ahmanson Foundation.

J. M. W. Turner

Romantic Painter of the Industrial Revolution

W I L L I A M S. R O D N E R

UNIVERSITY OF CALIFORNIA PRESS

Berkeley Los Angeles London

University of California Press
Berkeley and Los Angeles, California

University of California Press, Ltd.
London, England

© 1997 by
The Regents of the University of California

Library of Congress Cataloging-in-Publication Data

Rodner, William S., 1948–
 J. M. W. Turner : romantic painter of the industrial revolution / William S. Rodner.
 p. cm.
 Includes bibliographical references and index.
 ISBN 0-520-20479-4 (cloth : alk. paper)
 1. Turner, J. M. W. (Joseph Mallord William), 1775–1851—Themes, motives. 2. Industrial revolution in art. 3. Great Britain—In art. I. Turner, J. M. W. (Joseph Mallord William), 1775–1851. II. Title.
 ND497.T8A4 1997
 759.2—dc21 97-11127
 CIP

Printed in the United States of America
9 8 7 6 5 4 3 2 1

The paper used in this publication meets the minimum requirements of American National Standard for Information Sciences—Permanence of Paper for Printed Library Materials, ANSI Z39.48-1984.

For Lorraine

Contents

Illustrations

Throughout, titles are given with Turner's own capitalization and punctuation. (Quotation marks have been added for names of ships within titles.) Watercolors and drawings from the Turner Bequest at the Tate Gallery, London, are cited by the TB numbers used in Finberg, *Inventory*.

Acknowledgments

Many individuals and institutions offered invaluable assistance in the completion of this study. In London I owe a debt of gratitude to the staff of the British Museum Department of Prints and Drawings, with a special thanks to Ann Forsdyke, for assisting me in working with the Turner Bequest, then under their care but now at the Clore Gallery of the Tate. I am indebted to administrators at the Tate Gallery for permission to examine their many Turner oil paintings, particularly those not ordinarily on display. I also wish to acknowledge the curators and librarians at the National Gallery, the Victoria and Albert Museum and Library, the art collection at University College, the Science Museum, the National Maritime Museum, the Guildhall Library (with special thanks to Ralph Hyde), the British Library (especially the staff of the map room), the London Library, and the Institute for Historical Research. Elsewhere in Britain, I wish to thank the staff at the Fitzwilliam Museum (Cambridge), the Ashmolean Museum (Oxford), the Lady Lever Collection (Port Sunlight), the Sheffield Museum and Library, the Dudley Museum and Library (especially Roger Dodsworth), the Ironbridge Gorge Museum Trust (David de Haan, curator of art, and John Powell, librarian), and the Leeds Public Library.

In the United States I received important assistance from the knowledgeable staff at the Yale Center for British Art, chiefly Patrick Noon and Marilyn Hunt. Also of enormous help were the personnel at the Mariners' Museum (Newport News, Va.), the Jean Outland Chrysler Library and the Chrysler Museum (Norfolk, Va.), the Pierpont Morgan Library, the Firestone Library (Princeton University), and Pattee Library (Pennsylvania State University). Jacquelyn A. Dessino, of Tidewater Community College (Virginia Beach, Va.), provided cheerful assistance with numerous and often obscure interlibrary loan requests.

Much of the research for this book was supported by grants from The Pennsylvania State University, in particular awards from the Myra E. Pershing Fund, the Altoona Campus Faculty Development Fund, and the Liberal Arts Fund for Research. Kjell Meling enthusiastically helped acquire photographs and secure funding for travel. Stanley Weintraub promoted my work with two generous grants from the Institute for the Arts and Humanistic Studies. In 1986 I received the first Kent Forster Award from Penn State's Department of History, which enabled me to complete essential research in Britain and to begin writing. I am extremely grateful to Gerald G. Eggert, then chair of the department, for his backing. Chancellor Arnold R. Oliver of the Virginia Community College System released me from some teaching responsibilities and Larry Whitworth, president of Tidewater Community College, provided me with sabbatical leave to complete work on this project. I also wish to acknowledge the consistent support of Maxine Singleton and the late Michael F. La Bouve, both at Tidewater Community College, as well as Harold S. Wilson and my colleagues in the Department of History at Old Dominion University.

Preliminary results of my research on Turner and industrialism appeared in journals concerned with British studies and art. I thank Michael Moore of *Albion* and Eric Shanes of *Turner Studies* for publishing these essays and for helping me strengthen my arguments. Shelby Whittingham generously arranged for me to present a talk at the Courtauld Institute. Andrew Wilton helped me locate and evaluate significant Turner works while also offering gracious hospitality and warm companionship during two fruitful stays in London. Professor Maurice Beresford of the University of Leeds furnished invaluable information about the nineteenth-century city of Leeds and its environs, as did Peter C. D. Bears, Director of Museums, Leeds. The late Walton James Lord, a passionate Turnerian, offered much in the way of inspiration at an early stage of this project. Finally, at the University of California Press, Deborah Kirshman and Kimberly Darwin Manning helped bring this project to fruition, and Rose Vekony, through her sensitive and thorough editing of my manuscript, sharpened my focus and my writing.

Introduction

In 1851, at the Great Exhibition, Britain celebrated its technological achievement. Millions of visitors flocked to Joseph Paxton's futuristic Crystal Palace to marvel at exhibits that underscored not only the nation's industrial preeminence but also the Victorian faith in progress and the machine. Less noticed that same year was the death of the artist J. M. W. Turner, one of the most perceptive observers of this vibrant age. Turner, praised for his paintings of landscapes, storms at sea, and Alpine avalanches, also drew inspiration from the new forces that were rapidly transforming Britain and the world.

Turner was born in 1775, the year when Richard Arkwright was perfecting his first spinning mill at Cromford and James Watt was seeking to extend patent rights for an improved steam engine. His life spanned one of the most innovative and influential phases of technological development. The expansion of cities devoted to manufacturing brought a dramatic rise in population. Production swelled as new techniques were applied to a variety of complicated tasks. The perfection of the steamboat and the introduction of the railroad revolutionized transportation. So pervasive were the effects of industry that no aspect of life, whether political, literary, or artistic, escaped its influence. Turner's watercolors of multistory mills, fiery furnaces, and polluted skies reflect the startling novelty of industrialism, while his oils, such as *The Fighting "Temeraire"* and *Rain, Steam, and Speed,* capture its relentless dynamism.

A highly versatile and prolific artist, Turner executed more than five hundred oils and thousands of watercolors, drawings, and sketches over his long career, in addition to numerous engravings, many worked personally. Turner developed quickly as an artist, producing his earliest drawing in the 1780s. He exhibited his first watercolor in 1790; it was followed by an oil six years later. Elected As-

sociate of the Royal Academy in 1799, he was granted full membership in 1802. Turner's training at the Royal Academy Schools and his penchant for serious reading (his library included learned treatises on painting, as well as literary and historical classics) contributed to what John Constable later termed his "wonderful range of mind."[1]

Turner mastered most of the artistic styles of his time, from classicism to the picturesque, from romanticism to the sublime. He won early and consistent patronage and popularity, achieving lifelong financial security, although in later years some of his freely executed, individualistic canvases met with controversy. One notable Victorian, however, rose to his defense with memorable vigor. In 1843 the young John Ruskin published the first volume of *Modern Painters,* a book devoted largely to celebrating Turner's greatness.

Landscape occupied a central place in Turner's art, and he strove to augment the range of the genre as a vehicle for serious and probing insight.[2] His attention to nature's humbling complexity and his concern for humanity's connection to the environment found expression in these works. Turner discovered in the Industrial Revolution opportunities to reaffirm, in distinctly modern terms, landscape (and marine) painting's ageless concepts of ambition, progress, and limitation. By heightening his colors and loosening his technique, he conveyed technology's distinctive power as well as its rash challenge to nature.

In his steam paintings Turner came to welcome industrialism, arguing for the serious consideration of machines as worthy subjects for art. He rendered utilitarian technology visually interesting and at the same time advanced some of its claims to inevitability, promise, progress, and affluence. Absent from these paintings, however, are overt references to the economic privation and social disruption that accompanied this revolution. Although he showed distaste for the more facile pretensions of Regency and Victorian science, Turner never questioned the Industrial Revolution's rightful place in early nineteenth-century life.

Each chapter of this book considers a particular facet of Turner's concern with industrialism. Chapter 1 places his reaction to the Industrial Revolution against the controversies surrounding this phenomenon of change, both within the artistic community and in the world at large. Because Turner's romanticism figured in his approach to mechanization, I look closely at this elusive aesthetic term as it applies to his steam paintings.

Chapter 2 examines Turner's favorite machine subject, the steamboat, and his paintings treating the steamer's novelty, its place in traditionally admired settings, and its arresting dynamism. This chapter also includes a discussion of

steam transport and early nineteenth-century travel as represented in Turner's engravings for the *Rivers of France* books, as well as in his paintings of steam shipping on the Rhine and on Swiss lakes—works that confirmed the steamer's popularity, utility, and aesthetic value. At the same time this chapter charts the development of Turner's artistic approach to steamboat images, from the detailed, straightforward drawing of the central vessel in *Dover Castle from the Sea*, to the focused and vigorous tugs of *Between Quilleboeuf and Villequier*, and finally to the generalized hulking ocean steamer, cast in all-encompassing, utilitarian blackness, in *Peace—Burial at Sea*. In Chapter 3 we see how Turner pitted steamers against a superior natural environment. Two of his greatest paintings, *Staffa, Fingal's Cave* and *Snow Storm—Steam-Boat off a Harbour's Mouth*, convey a message of unmitigated human vulnerability, unusual for this optimistic age.

Urban manufacturing captured the attention of Turner and his contemporaries more than any aspect of industrialism, save, perhaps, the railroad. Smoke-laden communities became landscapes that linked familiar custom with wrenching innovation. Chapter 4 probes Turner's renderings of the provincial manufacturing centers of Leeds, Newcastle, and Shields in three watercolors and the painting *Keelmen heaving in Coals by Night* as visual documents of change and studies of the aerial effects of industry's transforming fires. In *Keelmen* Turner converted a grim industrial scene into a painting reminiscent of the grand manner. The watercolor *Dudley, Worcestershire*, engraved for his ambitious landscape survey *Picturesque Views in England and Wales*, serves as the nucleus of this chapter. Delineating a small iron-making town in the center of England's Black Country, *Dudley* is noteworthy for its focused depiction of industry and transport, its dramatic tonal contrasts and probing intensity, its clear indication of how manufacturing altered the traditional environment, and its fame as an industrial icon for Victorian and Edwardian critics.

London, the premier city of the Industrial Revolution, was the setting that most often inspired Turner. Chapter 5 examines Turner's many pictures of the river Thames and its crowded London embankments, the matrix of a vast human community of mills, workshops, and steamboats. Central to Turner's conception of modern London is a painting not exhibited during the artist's lifetime and infrequently discussed to this day, *The Thames above Waterloo Bridge*. An imaginative evocation of the new, early nineteenth-century environment of all-consuming haze, it attests to Turner's understanding of the nature of urban industrialism and his ability to communicate, through observation and imagination, the essential characteristics of industrial activity. The result bespeaks an artificial landscape of both apparent and submerged complexity, energy, and crowded humanity.

Rain, Steam, and Speed—The Great Western Railway, one of the earliest railroad paintings by a major artist, was Turner's last significant depiction of a steam subject. Through its free handling and emotive effects, it dramatically exposed one of the principal aspects of industrial advancement after 1830. Chapter 6 examines how this portrayal of the railroad's speed and energy communicates the union of technology and landscape, evokes promise tinged with anxiety, and manages imagination and atmosphere.

The focus on the early Industrial Revolution limits us to a relatively small part of Turner's oeuvre. Yet many of these steam paintings rank as major creative achievements by virtue of their aesthetic value and their contribution to Turner's artistic development. At the same time, they reflect the intellectual and cultural discourse of incipient European industrialism. These graphic images of change are underscored by a romantic fascination with the complex energies of machines. In them Turner explored the ramifications of such power for humanity's yearnings and its relationship with nature.

The Industrial Revolution
and the Romantic Imagination

1 &

Turner and the Art of Modern Life

In a long series of watercolors begun immediately after the Napoleonic Wars, in numerous graphic works, and in a group of significant oil paintings executed between 1832 and 1844, Turner examined a wide range of steam subjects with such commitment and insight as to deserve recognition as the premier artist of the early Industrial Revolution.[1] Given his pronounced interest in the principal events and changes of his tumultuous time—the wars with republican and imperial France, royal progresses, the destruction of Parliament by fire—it is hardly surprising that he incorporated images of the Industrial Revolution in his work.

Moreover, he had firsthand experience of his subject: A regular passenger of steamboats and trains, he made recurrent tours of Britain that took him to the new manufacturing districts, where he breathed the foul air of crowded cities and observed barges laden with goods making their languid way along a labyrinth of recently excavated canals. He enjoyed the friendship of leaders of the scientific community, such as Charles Babbage and Mary Somerville, whose inquiries complemented and enhanced the period's technological advances. His patrons included some of the more conspicuous entrepreneurs of the day—men such as the ironmaster Edwin Bullock, the coachmaker Benjamin Windus, the clothier John Sheepshanks, and the textile manufacturer Henry McConnel. And he adopted technological advances in printmaking, notably steel engraving, in his publishing projects, especially in books aimed at an increasingly large and influential bourgeois audience.

Still, Turner's embrace of industrial subject matter was measured, becoming meaningful only in the two decades prior to the Great Exhibition. In this respect it mirrored the Industrial Revolution's own gradual yet deliberate course. Despite numerous technological advances, Britain in the 1830s still relied on

animals or the wind for transport, with the horse as the preferred source of power. Although certain industries, such as cotton manufacture, made an early and dramatic impact, giant enterprises had yet to consolidate and dominate production.[2] By 1837 "only a small proportion of British workers had ever seen the inside of a 'dark satanic mill.'"[3] By 1851, however, the population had soared, and the majority of Britons no longer lived on the land. The percentage of the population dwelling in towns of over 100,000 was higher than anywhere else in Europe. Manufactured goods formed almost the entire bulk of the country's exports. Despite the continued dominance of a host of modest enterprises, most areas of the economy had come to depend on the factories.[4]

Turner surely considered contemporary views of industry when he decided to introduce modern machine technology into his art. For many of the artist's generation, the Industrial Revolution fueled the belief that recent accomplishment heralded a future of unlimited human development. Thomas Babington Macaulay, in his famous 1837 essay on Francis Bacon, equated advancement with the era's confident scientific spirit. Babbage shared these sentiments: "There exists, perhaps, no single circumstance which distinguishes our country more remarkably from all others, than the vast extent and perfection to which we have carried the contrivance of tools and machines for forming those conveniences of which so large a quantity is consumed by almost every class of the community."[5]

Those living through this period of transformation were fascinated by the startling examples of technological progress—the advancing locomotive, the smoking steamer, the fiery forge. The physical presence of industry excited particular attention. Consider Andrew Ure's tribute to one recent industrial structure of the 1830s: "A magnificent factory . . . is beautifully situated in the environs of Stockport. . . . In beauty of architectural design, it will yield to no analogous edifice, and may indeed, bear a comparison in respect of grandeur, elegance, and simplicity, with many aristocratic mansions." For Ure, the attraction of such a building rested as much in its up-to-date, economical design as in its function as a new, energetic human venture providing work and profit for many. A chemist, writer, and lecturer on a host of scientific matters, Ure was an uncritical champion of the Industrial Revolution. His best-known book, *The Philosophy of Manufactures* (1835), proclaimed the virtues of progress for all through the "blessings which physico-mechanical science has bestowed on society."[6]

Almost ten years later, industry could still elicit admiration, as in Benjamin Disraeli's novel *Coningsby*. Although the future prime minister harbored many reservations about the social consequences of industrialism, here he communi-

cated the appeal of machine energy. The hero's voyage of discovery in Lancashire includes a telling picture of an immense mill rising out of a green valley:

a vast deep red brick pile, which though formal and monotonous in its general character, is not without a certain beauty of proportion and an artist-like finish in its occasional masonry. The front, which is of great extent, and covered with many tiers of small windows, is flanked by two projecting wings in the same style, which form a large court. . . . In the centre [stands] the principal entrance, a lofty portal of bold and beautiful design, surmounted by a statue of Commerce.

Inside, the young Coningsby "beheld in this great factory the last and the most refined inventions of mechanical genius." He had earlier found much to appreciate in the metropolis of Manchester, where some enterprises contained "chambers vaster than are told of in Arabian fable."[7] Whereas Ure's apology epitomized the confidence in industrial progress, Disraeli's novel voiced the more complex viewpoint of England's Conservatives, who by the 1840s were uneasily broadening their customary agrarian base to include the ever more significant manufacturing districts.[8]

Steam, the key practical application of scientific inquiry in the first half of the nineteenth century, was at the center of these progressive achievements. When Turner attached "steam" to the titles of his paintings (*Snow Storm—Steam-Boat off a Harbour's Mouth* and *Rain, Steam and Speed—The Great Western Railway*), he underscored its significance. Ure called steam that "benignant power" to which were drawn "myriads of willing menials" in endlessly productive factories.[9] The *Quarterly Review* reported that "science has, at last ended the quarrel which since the beginning had existed between fire and water, and by the union . . . of these two furious elements, she has created that gigantic power of steam."[10] In 1848, Somerville wrote that the "history of former ages exhibits nothing to be compared with the mental activity of the present. Steam, which annihilates time and space, fills mankind with schemes for advantage or defence."[11]

During these years no nation embraced steam's potential so totally as Britain. In 1833 the *Mechanics' Magazine* listed this nation's steam accomplishments:

Most of the London presses are worked by steam; logs and marble are sawed, and chickens are hatched by steam; potatoes are boiled, money is coined, whiskey distilled, water is pumped, bullets are driven, gun-barrels bored, watch cases turned, foul clothes washed, tortoise shell combs mended, anchors hammered, ships' cables twisted, linen is bleached, sugar refined, jellies and soups are made, and houses warmed, by steam; in short, there is scarcely an object of human ne-

cessity, comfort or luxury, in the productions of which some use is not made of this universal and most accommodating of all agents.[12]

The pervasiveness of steam made such an impression on the visiting Ralph Waldo Emerson that he proclaimed it "almost an Englishman. I do not know but they will send him to Parliament, next, to make laws." By 1850 Britain had become the largest user of steam power in the world.[13]

Steam-generated industrial development, however, also had its detractors. Some felt it endangered the nation's traditional social order. The patrons of virtuous custom and rural paternalism, disdainful of the fashion for unbridled self-interest, found much to question in the new economic realities; trepidation grew as seismic shifts in population and wealth shattered social frameworks.[14]

Critics such as Friedrich Engels, Charles Dickens, Thomas Carlyle, and others deplored the human cost of the factory system, the crowding of towns and cities, and the callousness of laissez-faire economics. Carlyle's writings in particular offer insights into the complexity of the industrial phenomenon. While admiring technology's accomplishments and finding "aesthetic pleasure in the industrial landscape,"[15] he nevertheless felt uneasy about the implications of what he termed in 1829 the "Age of Machinery." The unrestrained materialism of the time and the disregard for suffering—an attitude he would further condemn in the 1843 Past and Present—troubled him, as did the absence of spiritual qualities so essential to humanity. "The truth is, men have lost their belief in the Invisible, and believe, and hope, and work only in the Visible."[16] Profit and utility were now the order of the day.

The Industrial Revolution met with aesthetic censure as well. Revulsion at the dirt, smell, and noise became a constant complaint. Already in the late eighteenth century, the physical appearance of industry's first utilitarian forms drew reproach. Critics then and later thought such stark construction impinged on the integrity of the natural landscape,[17] often ruining scenic locales. Chief among this opposition stood the theorists of the picturesque. One awarded the "palm of ugliness" to several large, brutally functional industrial buildings in Derbyshire:

When I consider the striking natural beauties of such a river as that at Matlock, and the effect of the seven-story buildings that have been raised there, and on other beautiful streams, for cotton manufactories, I am inclined to think that nothing can equal them for the purpose of dis-beautifying an enchanting piece of scenery. . . . They are so placed, that they contaminate the most interesting views.[18]

This objection had its roots in a doctrine that exalted "anachronistic or disappearing industries" while eschewing evidence of productivity, direct economic activity, and anything that was not "underutilized."[19] Steam-driven industry's large-scale, regimented structures, built for a single purpose, were disruptive and intrusive to the picturesque temperament, which instead favored art as "a form of disengagement from the real world."[20]

Pleasing prospects were not the only casualties of industry. An American visitor to Britain in the late 1840s described how "in the manufacturing town, the fine soot or *blacks* darken the day, give white sheep the color of black sheep, discolor the human saliva, contaminate the air, poison many plants, and corrode the monuments and buildings."[21] In 1830 the poet Chauncey H. Townsend declared it a "pity that our recent improvements upon old inventions should all most universally be unpleasing to the eye." He found the traditional lumbering horse-drawn road carriage "more glorious to behold than a steam-coach with its boiler." For the steamboat he reserved special odium:

> Amongst the modern deformities that disfigure the pure element of water, the steam-boat claims pre-eminence. Every variety of ship, boat, or vessel, is beautiful except this. . . . What beauty, what gladness, is there in yonder shapeless hulk that carries the smoke, together with the vulgarity of the metropolis, into the dominion of the awful ocean?[22]

Such views eventually lost much of their resonance as practical and beneficial technologies became more familiar and appreciated. Despite pockets of resistance, Britain seemed unusually receptive to the new changes. During the eighteenth century there emerged a "greater respectability attaching to an interest in economic issues," especially when it was realized that the nation's well-being gained thereby.[23] The early nineteenth century saw the great learned journals fully engage the modern realities. The *Edinburgh Review* combined its commitment to governmental reform with a devotion to issues of political economy as well as scientific innovation. The rival *Quarterly Review*, conspicuous for its veneration of the established order, also considered questions involving technological advancements and factory conditions.[24]

Furthermore, industrialism was highly compatible with native English practicality. This quality, extolled for giving rise to "the architecture of the spinning-mill, that most matter-of-fact, most utilitarian, most workaday architecture," led logically to the Great Exhibition at the Crystal Palace.[25] By that time the most influential elements in early nineteenth-century society, beneficiaries of "the

marvelous inventions of science and technology, the increasing mass and variety of material goods, the growing speed of movement and convenience of everyday activities," fully espoused the "new religion of progress."[26]

Despite its eventual triumph, the Industrial Revolution engendered a debate that made artists wary. Artistic renderings of forges, kilns, and mill towns were not uncommon in the late eighteenth and early nineteenth centuries,[27] but such images did not befit the realm of higher aesthetics—the collections of the great connoisseurs or the annual exhibitions at the Royal Academy—in which major artists like Turner made their reputations. There were exceptions, to be sure, such as Joseph Wright's paintings of Arkwright's Derbyshire mill and Philip James de Loutherbourg's *Coalbrookdale by Night* (discussed in Chapter 4), depicting Reynolds's Shropshire ironworks. But these had a limited bearing on the thought and taste of the time. Wright's works were specific commissions for a successful manufacturer and were not widely exhibited; Loutherbourg's startling oil was his only industry-inspired work on so grand a scale.

The situation began to change in the early decades of the nineteenth century, with steamers and mills making their tentative way into the watercolors and prints of artists like John Sell Cotman, David Cox, and Clarkson Stanfield. Although artists of nascent industrialism could have taken encouragement from Stendhal, who in an 1825 issue of *London Magazine* enjoined the painter to be "the historian of the physical world before him" and art to "keep pace with the progress of society,"[28] most still would not accord industrial technology serious treatment—particularly in exhibited oil painting, the chief mark of visual expression during the Regency and Victorian periods.

Turner proved a singular exception. He waited, however, for the popularity of the new technology to take firm hold of Britain's consciousness before exhibiting his earliest steam works, first as watercolors and later as oil paintings. Although he was susceptible to the romantic urge to engage the grotesque[29]—a quality that many believed industrial forms possessed in ample measure—his success with machine subjects rested more on an appreciation of their inherent merit, especially their emotive qualities.

Turner's ability to convey this last attribute was important, for industry's steam and fires appealed to the romantic emotions of the age. Already in the late eighteenth century, Richard Reynolds of Coalbrookdale—perhaps the most famous of the early industrial sites, because of its innovations in coke-fired smelting and its proximity to the Ironbridge spanning the Severn—betrayed an almost naive exhilaration when writing of the "roaring of the blast furnaces," the spectacle of "long beds of glowing coke, the jets of flame and showers of sparks" that held him spellbound.[30] Comparable sentiments characterize Louther-

bourg's 1801 *Coalbrookdale*, a classic painting of industrial activity so new, dynamic, and remarkable as to defy specific analysis.

Even the machines held their own special enchantment, as Somerville remembered when she toured the Watt and Boulton works near Birmingham: "The engines, some in action, although beautifully smooth, showed a power that was almost fearful."[31] Disraeli, speaking through his protagonist Coningsby, described how industrialism, when contemplated on a much larger and more advanced scale, also could captivate. As Coningsby passed through Lancashire, he found his "mind excited by strange sights . . . the plains where iron and coal supersede turf and corn, dingy as the entrance of Hades, and flaming with furnaces." Manchester stirred him with "illumined factories, with more windows than Italian palaces, and smoking chimneys taller than Egyptian obelisks." Here stood the matrix of modern enterprise, "the great metropolis of machinery itself."[32]

Like others of his generation, Turner considered the rise of industry against a crucial aspect of contemporary romanticism: a deeply felt relationship with nature. What could be said, for example, to those who boasted that humanity had finally acquired the means to realize an ancient dream of taming unruly nature with machine technology?[33] Carlyle, with a touch of derision, summed up the prevailing enthusiasm this way: "We remove mountains, and make seas our smooth highway; nothing can resist us. We war with rude Nature; and, by our resistless engines, come off always victorious, and loaded with spoils." The romantics, on the other hand, considered nature "a live vessel of spirit, a translucent source of mystery and revelation"; their early ambivalence toward innovative science soon developed into antagonism.[34] For an artist like Turner, imbued with thoughts of nature as the ultimate source of creativity, as splendidly and fearfully omnipotent, the simplistic optimism embodied in Carlyle's words would have appeared misguided. Nature, appreciated and evaluated with new insight, offered to his mind a timely alternative to being subsumed in the increasingly dominant industrial ethos.

At a time when the sterile regularity of machines and the pretentious claims of science seemed to affirm victory on all fronts, the grandeur and mystery of nature inspired Turner and his contemporaries, stimulated their subjective consciousness, and recalled their humility. The English-born painter Thomas Cole, an admirer of Turner's, dedicated his intellect and art to exploring alternatives in nature. In his 1836 "Essay on American Scenery," he voiced a common complaint of his day: "In this age . . . a meager utilitarianism seems ready to absorb every feeling and sentiment, and what is sometimes called improvement in its march makes us fear that the bright and tender flowers of the imagination shall all be crushed beneath its iron tramp." Cole, who found his personal solace in

the vast landscapes of his adopted America, advocated cultivating "that oasis that yet remains to us," namely the world of unspoiled "*Rural nature,*" which stirred and overwhelmed the soul through "the loveliness of verdant fields, the sublimity of lofty mountains, or the varied magnificence of the sky." Painters and poets could find here "the exhaustless mine" from which might "be awakened . . . a deeper feeling of the works of genius, and a keener perception of the beauty of our existence."[35] Nature provided essential inspiration for the human spirit while cautioning people to recognize their limitations.

Although Turner knew Cole only from the latter's brief visit to his studio in 1829,[36] he would certainly have shared his reverence for nature. When one of Turner's traveling companions remarked on the artist's "intense regard for nature,"[37] he barely hinted at a quality so pervasive it influenced all his work, including his industrial art. Favorite lines of James Thomson offered sentiments to match Turner's thoughts:

> He looked and Nature sparkled in his eyes
> He caught the truth of Nature and her dyes[.][38]

In 1832 a writer in the *Athenaeum* lauded Turner's ability to awaken the energy of the natural environment through art, declaring that "the whole kingdom of inanimate nature is his: his whirlwinds have words, his tempests speak, and the air which he breathes over his matchless landscapes has something of the creator in it."[39] The paintings suggest a "craving for what was most extreme in nature"—catastrophic avalanches and devastating storms, on land and at sea—by which Turner exposed "the pathetic inadequacy of human beings in an ineffably beautiful and terrible universe."[40]

Indeed Turner went beyond the modest homage to nature voiced by contemporaries such as Cole, presenting instead a "pessimistic and catastrophic" outlook that left humanity little hope.[41] In canvases evoking nature's ferocity, human beings paled into chaotic insignificance, becoming diminutive figures struggling for their lives. To the 1810 painting *The Fall of an Avalanche in the Grisons* (Tate Gallery, London), a depiction of a humble hut crushed by an enormous boulder, Turner appended several revealing lines of his own verse:

> The downward sun a parting sadness gleams,
> Portentous lurid thro' the gathering storm;
> Thick drifting snow, on snow,
> Till the vast weight burst thro' the rocky barrier;
> Down at once, its pine clad forests,

And towering glaciers fall, the work of ages
Crashing through all! extinction follows,
And the toil, the hope of man—o'erwhelms.[42]

This belief in the superiority of nature did not recede with the apparent miracle of mechanization. Turner would not have agreed with the horticulturist Thomas Whately, who earlier observed that the "stupendous" power of machinery stood comparison with the "extravagances of nature," or a modern critic who, in writing of Cotman's watercolor of *Bedlam Furnace,* sees how "industry overpowers nature."[43] While enthralled with the novel vitality of machines, he came to depict them in the same light as so many other human endeavors—restricted in their capabilities and vulnerable to natural forces. In so doing, he achieved "the apotheosis of the Romantic view of industry," portraying steam "amidst the atmosphere and light of nature"—and at the same time, one might add, dominated by nature.[44]

Machine power, with it optimistic promise, made human interaction with nature more acute for Turner. He relished the interplay between timeless and recent forces and would have understood his fellow painter Benjamin Robert Haydon, who, in watching a steamer negotiate rough weather, admitted to enjoying the "tremendous idea of the power of Science, contesting as it were with the defying contempt, the Elements of God." Yet his sympathies coincided even more with those of George Head, the inquisitive traveler who, reflecting on the "noble sight" of machines viewed during his tour of England in the 1830s, concluded that "science will never, probably, wholly avert those catastrophes which, either by combustion or explosion, in the melancholy reverse of fortune, serve to remind man of the finitude of his wisdom."[45]

Turner's romantic response to nature owed a partial debt to the concept of the sublime, much discussed in the Georgian and Regency periods. Cole used the word to describe Niagara Falls: "In its volume we conceive immensity; in its course, everlasting duration; in its impetuosity, uncontrollable power. These are the elements of its sublimity." Terror was another such element, for as Edmund Burke had written almost eighty years earlier in the most thorough examination of the term, "whatever is in any sort terrible . . . is a source of the *sublime,* that is, it is productive of the strongest emotion."[46] Turner was influenced by various theories of the sublime; he used the term in writing and expressed it in his art.[47] But at the same time his art went beyond such theories, which were somewhat dated when the young artist began to make his mark.

By the second decade of the nineteenth century, the sublime had become an increasingly imprecise idea, suffering repeated dissections and expansions at the

hands of a multitude of intellectuals.[48] Finally, by the mid-nineteenth century it received scant attention. John Ruskin confirmed its obsolescence in a mere three pages in the first volume of *Modern Painters*. By suggesting that "anything which elevates the mind is sublime" and that "sublimity is . . . only another word for the effect of greatness upon the feelings,"[49] he acknowledged how the word had, by the 1840s, become little more than a cliché. For Turner, romanticism proved a far more useful concept, especially in the face of the unprecedented forces produced by the Industrial Revolution.[50]

Turner's quest for insight into the dominance, beauty, and destructiveness of nature, his interest in scientifically conceived forces, and his program of expressing in art the root potency of such phenomena all became salient features of his romanticism. He allied to this a propensity to view the world not in objective terms but as a stimulus for personal, intuitive understanding. His ideas coincided with the romantic movement's focus on individual feeling, human susceptibility, and reverence for nature. This last trait contrasted with the Enlightenment era's goals of human control and standardization—concepts also central to the Industrial Revolution. Never content to depict bare facts, Turner delved beneath the surface to express the source of the energy he sensed in the thing observed. At the same time he sought to communicate the experience, if not the exhilaration, of encountering natural or mechanical power.

With intuition and the senses thus demanding expression, Turner learned to deftly enhance what he saw with what he felt, bringing subjective awareness and deep personal involvement to pictures of readily identifiable objects. The naturalism that won him early acclaim in a painting like the 1815 *Crossing the Brook* (Tate Gallery, London) gave way eventually to a freer style, with less attention to detail and more concern with underlying character, as in the 1844 *Rain, Steam, and Speed*. Verisimilitude receded before loose brushwork and dynamic color to suggest deeper meaning and greater complexity.

Turner's romanticism, while a highly personal way of looking at the world, shared much with other intellectual currents then developing in art, thought, music, and letters in Europe and America. In 1846 Charles Baudelaire described romanticism as something "situated . . . in a mode of feeling," encompassing "intimacy, spirituality, color, aspiration towards the infinite." Northern Europe seemed most attuned to this outlook, according to the French poet, shrouded as it was in a gray atmosphere, longing for liberation in color, and open to the insights of subjective understanding. Perhaps with Turner in mind, because of his affinity for a bright palette, he placed England in this group, as "that home of fanatical colourists."[51] A similar trend can be seen in romantic music, where

color, rather than being "applied like a veneer to form," instead brought "new forms into being."[52]

Application of intense visual color was one way, along with freedom of line, that Turner transformed objective reality so as to reveal the essential, hidden dynamic of the thing observed. What hostile critics identified as Turner's exaggerations, in color or drawing, were often results of his probing for the defining force that ultimately manifested itself in outward appearance. In landscapes, for example, the golden color of blazing bursts of sunlight transform an entire canvas; thickly painted arcs and circles representing clouds and whirlwinds suck everything toward a focal point of energy. Industrial scenes presented similar possibilities. Turner could suggest the power source of a locomotive or a steamer by applying rich color to intimate the light of hot, smoking engines.

This central trait in Turner's art, revealing with broad areas of color an integral yet elusive transforming power, enhanced his industrial paintings. In his search for essence he betrayed a further affinity with the romanticism of his age, as found in the writings of several early nineteenth-century German philosophers. August Wilhelm von Schlegel spoke in his 1808 lectures of the "contemplative" and "inward" tendency of modern art; Friedrich Wilhelm Joseph von Schelling, around the same time, wrote of the artist's "intuitive" characteristics that could unlock "the spirit of nature working at the core of things."[53] G. W. F. Hegel further scrutinized the issue in his *Lectures on Aesthetics* (1816). Speaking of what he called the romantic tendency, the emphasis on the power of the soul that emerged with early Christianity, Hegel investigated qualities of "absolute internality." Romantic art, he believed, addressed itself "to the subjective inwardness, to the heart, the feeling, which . . . seeks and finds its reconciliation only in the spirit within. It is this *inner* world that forms the content of the romantic, and must therefore find its representation as such inward feeling."[54] Hegel believed that especially painters enjoyed unique gifts in evoking these essentials and in capturing, with the aid of imagination, insights that reached beyond the artist's immediate social and political existence.[55] Heinrich Heine voiced like sentiments in his *Romantic School* (1836) when he praised the artist's ability to see past the surface to "a special significance . . . concealed beneath."[56]

Many of Turner's literary compatriots pressed similar claims for probing introspection as a means to understand fully the true nature of phenomena. To some extent German thinkers aided British romantics in this quest. Although the former had a limited audience before the 1840s, their effect can be seen in a number of British writings. Thomas Love Peacock's *Nightmare Abbey* (1818) boasted a hero who evoked Immanuel Kant in his romantic musings. Turner

and other readers of the *Edinburgh Review* were exposed to more recent trends in German literature through the articles of Carlyle, first published in 1827. This critic saw in German poetry, especially, a way of coming to terms with the peculiar, pressing problems of modern life. Distressed to think that "the Nineteenth Century stands before us, in all its contradiction and perplexity; barren, mean and baleful," he looked to the "poet's spirit" to reveal "its secret significance," to expose the "life-giving fire" within.[57] Many of Carlyle's contemporaries, most notably Samuel Taylor Coleridge, found in German intellectual life an influential stimulus;[58] so too did Turner, whose German travels inspired several works and who deeply admired Johann Wolfgang von Goethe's *Theory of Colors*.[59]

British artists and intellectuals also attained their own insights into subjective understanding, armed with words such as "instinct" and "intuition," as well as a more popular term, "imagination"—one that became particularly relevant to Turner. Many Britons would have undoubtedly concurred that "imagination was in some sense the whole of existence" for romantics.[60] The Scottish thinker Dugald Stewart, in his *Philosophical Essays* of 1810, lauded imagination for its "power of *representing* to ourselves the absent objects of our perceptions." This facility accented and enlarged perception: "Imagination, by her powers of selection and of combination, can render her [nature's] productions more perfect than those which are exhibited in the natural world."[61] Wordsworth too recognized its force, which he identifies in the *Prelude* (14.189–90) as the defining characteristic:

> . . . Imagination, which, in truth,
> Is but another name for absolute power[.]

In *Modern Painters* Ruskin credited imagination with achieving "a more essential truth than is seen at the surface of things" and, echoing the Germans, viewed it as "the heart and inner nature, [which] makes them felt."[62]

Turner too placed great stress on imagination in the creative process. Not long ago a major Turner exhibition was mounted under the title *Imagination and Reality,* affirming the painter's link to a concept applied often to his art during his lifetime and later. In his *Discourse XIII* (1786), Sir Joshua Reynolds, the founding president of Turner's beloved Royal Academy and doyen of British aesthetic theory, had praised imagination in the visual arts as "the residence of truth" that could, when applied with sufficient taste and judgment, complement and transcend reason. The idea that painting could evoke this kind of insight undoubtedly inspired Turner.[63] Also important to Turner's thinking in this regard was Mark Akenside's mid-eighteenth-century poem *The Pleasures of Imag-*

ination, which taught him that "behind nature's appearances there existed some Platonic or archetypal truth."[64] Turner's capacity to sense such truth in things observed has been noted in his mature landscapes, which reveal a "grasp not only of the forms of transient phenomena . . . but also . . . the energy activating them."[65]

In his own verse, Turner wrote:

> What is imagination when its seats unknown
> That lights the souls resource to soar beyond
> The powers of perception yet by knowledge
> Of nature's forms and qualities feebly strong
> To pursue the unknown force that urges all[.][66]

Strong imaginative insight in painting enjoyed much in common with poetry, as Turner realized. In the 1821 *Defence of Poetry*, Percy Bysshe Shelley extolled the poet's role in voicing the imaginative qualities that could reveal the essential truth of reality. "A single word . . . a spark of inextinguishable thought" could hold the most profound insights. Poetry actualized the internal nature of things, stripping "the veil of familiarity from the world, . . . [to] lay bare the naked and sleeping beauty which is the spirit of its forms." Like a sculptor intent on realizing from a piece of rough stone an image of loveliness, so too the poet evokes the vital spirit that molds outward appearance. Going beyond Hegelian inwardness, Shelley best articulated the internal energy that defines outward reality: "The beauty of the internal nature cannot be so far concealed by its accidental vesture, but that the spirit of its form shall communicate itself to the very disguise, and indicate the shape it hides from the manner in which it is worn."[67]

Recognition and realization of this underlying power, present even in the routine, was the means by which the poet "adds beauty to that which is most deformed." In a telling phrase, Shelley applauded poetry because "it compels us to feel that which we perceive, and to imagine that which we know." He believed his argument had special relevance for his own increasingly industrial time, an era whose accelerated scientific and economic development left things like poetry "concealed by the accumulation of facts and calculating processes." The intuitive and imaginative solution offered by poetry could easily apply to painting, and the poet's unique insights could be shared by an artist also possessed of "a most delicate sensibility and the most enlarged imagination."[68]

There is no evidence that Turner knew this perceptive essay, which was not published until 1840. But certainly he knew Shelley's poems, which reflected much of the essay's argument and influenced Turner's own humble verse.[69] One

writer, sensing an affinity between the poet and the painter in Turner, called him the "Shelley of English Painting."[70] His extensive yet scattered writing spoke to a love of poetic sensibility, especially that crucial relationship between painting and poetry embodied in the concept of *ut pictura poesis*.[71] It is thus reasonable to suppose that Turner would have been in sympathy with Shelley's argument for literary imagination as a key to understanding.

So conceived, imagination, along with feeling, also enhanced the senescent idea of the sublime, which was then grafted to the more up-to-date and complex concept of romanticism. Alison realized the need for this elaboration when he argued in *Principles of Taste* that "unless this exercise of imagination is excited, the emotions of beauty and sublimity are unfelt." Stewart, in his *Philosophical Essays*, saw imagination enabling humans to conceive of greater sublimity than existed in nature, to see beyond the natural and "imagine Rocks and Mountains more sublime, . . . than the eye has ever beheld."[72]

Turner built on his love of the sublime by adding crucial elements of his imagination, so that, in his *Snow Storm—Steam-Boat off a Harbour's Mouth*, for example, he not only painted what a terrible storm at sea appeared to be but, more significantly, "what such a scene was like"[73]—thus communicating the almost incommunicable fear of the artist who claims to have experienced it. Invention of this sort had already outraged one critic in 1832, who accused Turner of posing as "a manufacturer of the Sublime by leaving out the details," requiring his viewers to emulate his creative process, "to finish his pictures by the force of imagination."[74] But this was precisely Turner's point, since it allowed him to mystify sublimity by linking it to "the sense of not knowing where the information—where the power of the vision—comes from."[75]

In this way Turner refuted those who, like Macaulay, believed that poetry alone could speak to the "heart of man" and that painting was merely imitative, limited to "only form and color."[76] A Turner canvas could more than equal poetry in arriving at probing insight into every aspect of reality. This romantic feature became particularly meaningful in Turner's industrial paintings, where ordinary, functional objects became arresting and mysterious as their underlying character was revealed in the hands of the artist.

Industrial subjects vied with nature in stimulating Turner's romantic imagination. Yet while steam technology drew from Turner ever more daring painterly approaches, it also worked to discipline his imagination. Although occasionally he would experiment with taking his technique to its logical extension of pure abstractionism, his best and most important work remained consistent with that "central Romantic paradox that liberty requires to be curtailed,"[77] giving the viewer sufficient recognizable form to share in the artist's inspiration and

receive his desired message. Like other romantics, he pursued what one critic saw as a salient characteristic of this movement, "subjectivity" grounded in "objectivity,"[78] retaining "a firmly perceived framework of human reference."[79] Industrial machines, because of their novelty, required identification, and they came to be defined either as precise, straight-edged products of manufacture or as assemblages of black-colored metal. The result was a body of art that embodied a romantic vision of the Industrial Revolution in its totality—part recognizable articles of the early nineteenth century, part sensed realizations of those energetic objects that spoke to the expectations and anxieties of the age.

2 The Allure

of the Steamboat

One of Turner's more provocative modern biographers once observed that the artist most often selected the steamboat to express his engagement with the Industrial Revolution.[1] Nautical subjects appeared in Turner's work throughout his career. The Dutch marine painters of the seventeenth century, always popular with the British, offered stimulating precedents, while the topography of Europe's coasts, rivers, and lakes provided contemporary inspiration. The arrival of steam power, however, allowed Turner's nautical art to communicate a new and intensified view of human purpose.

Turner first painted steamers in the 1820s, and what began as tentative recognition evolved into a central element in his art. Casual sketches and finished watercolors from this decade soon gave way to the concerted examination of steam power in the *Rivers of France* engravings of the early 1830s. Between 1839 and 1842 Turner gave the steamboat a principal narrative and symbolic role in two notable oils, *The Fighting "Temeraire"* and *Peace—Burial at Sea*.

Steamboats represented a significant aspect of industrial advancement. The entry for steamboats in the 1842 *Encyclopaedia Britannica* chronicled nearly three decades of progress in British maritime technology, announcing that the "application of steam-power to navigation is one of the most wonderful triumphs of human ingenuity." It went on to envision "vessels of gigantic size . . . impelled across the trackless ocean," forming a bond of "communication between the shores of the remotest regions." But complications accompanied progress. The *Nautical Magazine* reminded its readers of the steamboat's limitations on open water, where, slower than many sailing ships, its prime advantage was "regularity not velocity."[2] On rivers, where they were more successful, their motion often caused concern. An earlier issue of the same journal reported complaints

about various London steamers endangering traditional river craft with their speed, "the swell occasioned by the paddles," and, more serious, the threat of explosions from excessive steam pressure in the boilers. In 1847 the steamer *Cricket* blew up, claiming a number of lives.[3]

Despite these drawbacks, popular enthusiasm for steamboats grew. The *Quarterly Review* observed in 1839 that the number of these vessels in the British empire had increased from two to six hundred in twenty-five years. Although the rate of change was impressive, steam did not come anywhere near dominating navigation in this period.[4] Still, as with so many aspects of the Industrial Revolution, the novelty and promise of machines attracted an inordinate amount of attention. Monographs touting the benefits of steam transport poured forth. Thomas Tredgold's book *Steam Engine* (1827) was expanded in 1842 to include "steam naval architecture,"[5] and Bennet Woodcroft's *Sketch of the Origin and Progress of Steam Navigation* (1848) surveyed the first years of development. Manuals like *The Scottish Tourist's Steam-Boat Pocket Guide* (1835) and the *New Steam-Boat Companion* (1834) helped passengers make the most of a steam-powered journey. Articles extolling steam vessels appeared in some of the most sophisticated journals of the day; poets sang their praises and dancers performed to the tune of the "Steam-Boat Divertimento."[6]

The popularity of the steamboat confirmed the nation's commitment to industrial and technological progress. Britain welcomed its first steamboat in 1801, although experiments involving powered water transport had been conducted there and on the Continent throughout the previous century.[7] That year William Symington built the *Charlotte Dundas*, which in 1802 succeeded in towing two vessels on the Forth and Clyde Canal. Fear that churned water would damage the banks of the canal, however, forced further operations to be canceled. Only in 1812 would steam navigation be established in Britain, when Henry Bell's *Comet* sailed the Clyde River on a thrice-weekly schedule.[8] Despite what the Glasgow civil engineer Robertson Buchanan cited as initial apprehension "owing to the novelty and apparent danger of the conveyance" (not to mention opposition from flyboat and coach interests), regular service between Glasgow and Greenock became an accepted fact, with commodious boats supplying "newspapers, pamphlets, books, etc. for the amusement of the passengers, and such refreshments as are desirable."[9]

The new Clydeside travel provided the setting for John Galt's 1822 novel *The Steam-boat* and William Daniell's colored aquatint entitled *Steam-boat on the Clyde near Dumbarton* (Fig. 1). Published in 1818, the latter was one of the earliest illustrations of a steamer to appear in Britain. It was part of an ambitious venture depicting scenes on the entire coast, a work that eventually ran to eight

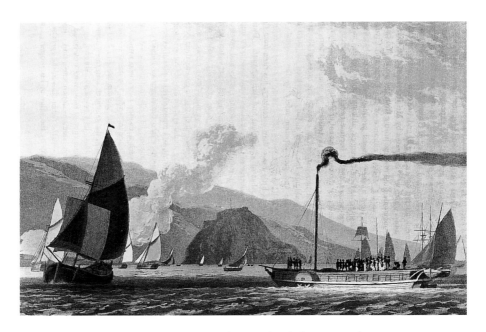

FIGURE 1. William Daniell, *Steam-boat on the Clyde near Dumbarton*, 1818. Aquatint, 20.3 × 28 cm. Courtesy the Mariners' Museum, Newport News, Virginia.

expensive volumes (published between 1814 and 1825 in a set of four) under the title *A Voyage Round Great Britain*.[10] Daniell's print brought a steamboat prominently into view, fully exposed in a broad band of sunlight in the lower right half of the composition. Clearly intended to represent something new and noteworthy, it is far better defined than the numerous sailboats to the left or the distant Dumbarton Castle sitting on a dark basaltic rock at the center. It brims with informative detail, from the exposed spokes of the paddle wheel to the dangling lifeboat. A crowd of passengers appears confidently perched atop the cabin roof, and the tall smokestack, steadied by several taut, straight lines, gives off, almost whimsically, a hook-shaped pennant of smoke. The accompanying text explained this discharge to readers, who at that early date would have been unfamiliar with the workings of such a mechanism: "It is observable that the smoke of the engine is carried off by a tall cast-iron chimney, bearing the semblance of a mast. . . . The stream of smoke from the orifice generally takes a horizontal direction, in consequence of the movement of the vessel, forming a pennant of extraordinary length and very singular appearance."[11] Although this lively print advances the claims of modernism, its success rests mostly on the new information it conveys, not on any attempt to probe the nature of machine power.

Turner knew Daniell and his work, but he took his time in following his young colleague's lead.[12] Four years separated Daniell's print from his own tentative, initial acknowledgment of this timely subject. Turner's 1816 watercolor of the manufacturing city of Leeds had already demonstrated a concern for the Industrial Revolution (see Chapter 4), but he cautiously let Daniell prepare the way before producing his first steamboat work.

Turner's consistent interest in marine painting would have made him receptive to the latest developments in nautical technology. His first exhibited oil was *Fishermen at Sea* (1796; Tate Gallery, London), and marines brought him as much recognition as did landscapes.[13] Although in many of his most famous canvases Turner emulated the northern baroque painters, whose work he had studied carefully, references to contemporary life also abound. For every painting executed in tribute to Willem van de Velde the Younger or Jacob van Ruisdael, another portrays a triumphant Nelsonian battleship or a steamer negotiating a difficult entry into port. The well-traveled painter had ample opportunity to study a variety of these unusual and increasingly popular craft, either on the busy Thames or along the British coast.

Specific incidents would also have stimulated Turner's engagement with steamers. When he visited Scotland to record King George IV's visit in the summer of 1822, he no doubt noticed the 448-ton *James Watt*—"the largest steamship of her time"—arriving with His Majesty's squadron at Leith Harbor.[14] Earlier David Cox, his friend and fellow painter, had discreetly inserted a small steamboat at the edge of his lavish and busy watercolor of the London end of this famous journey, *George IV Embarking for Scotland from Greenwich* (c. 1822–23; Walker Art Gallery, Liverpool), as if hesitant to acknowledge such a utilitarian object in the midst of all the surrounding pomp and grandeur.

A pencil sketch, possibly a record of some part of this royal event, is one of Turner's earliest representations of a steamboat.[15] His first finished and exhibited rendering of a steamer, however, appeared late in 1822 in *Dover Castle from the Sea* (Plate 1), a large watercolor recording the newly established steam service on the English Channel.[16] Amid the ships, harbor, and historic castle that command the viewer's attention, Turner drew a precisely defined steamer, with careful details of the hull, masts, flag, and engine stack. Passengers and baggage can be seen crowded on the deck and atop one of the paddle boxes.[17] According to the 1824 edition of Mariana Starke's *Information and Directions for Travellers on the Continent,* steamers had cut the Channel crossing time from half a day or more to about three and a half hours—in good weather. Turner's rendition of this steamboat points to a technology still in its infancy, confirming that the "earliest vessels were mere boxes with one deck."[18] The watercolor's

brown tones convey the wooden construction, while twin canvas-equipped masts suggest that precautions against engine malfunction were still necessary.[19] The new technology emerges conclusively in the tall, thin gray-black iron chimney, precariously steadied, it appears, with thin cables and spouting a stream of dark smoke.

Turner's cheerful watercolor affirms steam's advantages over traditional water transport. In contrast to the other boats in the port area, which seem to be struggling with a strong wind and a choppy sea,[20] the steamboat plows through the water on a level course toward the inner harbor beyond the jetty, performing in a way that would capture the imagination of the era's technophiles. In 1818 the engineer George Dodd had declared that "while other vessels think it fortunate just to keep off a lee shire, steam-boats proudly dart forward into the wind's eye." Ten years later, John Ross wrote of how a "steam vessel . . . may approach any coast or harbour without fear," possessed of the ability to evade "any shoal or danger which may appear."[21]

The first steamboat journey from England to France had taken place in 1816, when the *Margery* crossed from Newhaven to Le Havre.[22] Although other vessels soon joined the route, regular service between Dover and Calais did not begin until 1821, with the newly built steamer *Rob Roy*.[23] By the following year three new vessels took up the run between Dover and Calais or Boulogne: the *Sovereign*, the *Medusa*, and the *Union*. Several French steamers also carried passengers from the Continent to Dover during these years, while a number of packets based at other English coastal towns called at Dover on their way to or from France.[24]

Dover Castle probably resulted from one or more visits Turner made to the Dover area prior to 1822. He passed through the port on his way to the Continent (via Calais) in August of 1819: "Left Dover at 10. Arrived at Calais at 3 in a Boat from the Packet Boat," he wrote in one of his sketchbooks, neglecting to mention, however, whether this journey and his return the following January owed anything to steam propulsion.[25] In 1821 he surveyed the Dover area in several drawings preserved in the *Folkestone Sketch Book* (TB CXCVIII). The steamer pictured may have been a British mail packet controlled by the navy, whose blue ensign it flies. Since the post office had taken over these mail boats in 1821, Turner most likely based his watercolor on a vessel he saw sometime that year. The mail steamers *Arrow* and *Dasher* commenced operations from Dover in 1821.[26]

Possibly *Dover Castle* was painted for one of the print projects Turner was involved with in this period. He contributed to such undertakings throughout his career; indeed, he was most famous during his lifetime for his engravings.

Not only did prints spread and enhance his reputation, but their production brought him considerable monetary reward through sales and loans of water-colors to publishers.[27] By 1811 Turner had begun an association with William Bernard Cooke to illustrate an imposing publication entitled *Picturesque Views on the Southern Coast of England*, the first part of which appeared in January 1814. This debut came less than a month after the initial installment of Daniell's elegantly illustrated *Voyage Round Great Britain*, and in fact Cooke tried to hasten the *Southern Coast* project in order to contend with it.[28] When Daniell later boldly depicted technology in *Steam-boat on the Clyde near Dumbarton*, Turner may have finally been encouraged to ponder a similar subject. The generous size of *Dover Castle* points to Turner's never-realized *Marine Views*, another venture with Cooke that may have been an attempt to surpass the scale of Daniell's aquatints. Although *Dover Castle* would not be engraved until the year Turner died, two similar watercolors intended for that aborted series were printed as mezzotints—*Eddystone Light House* (1824) and *Sun-rise. Whiting Fishing at Margate* (1825)—in dimensions very similar to Daniell's prints but larger than what Turner had been accustomed to using, especially in *Southern Coast*.[29]

In content, *Dover Castle* shares with *Steam-boat on the Clyde* a preoccupation with detail and variety in a cheerful, sunlit scene. Both enhance interest by placing clearly articulated steamers in the midst of sailboats and beneath historical monuments. Turner, however, proved more reticent in recognizing steam power. Whereas Daniell brought the Clyde steamer into sharp focus, both in the image and in its title, Turner used more subtle methods to feature the steamer. He drew a number of diagonals to tie it into the core of the design: the downward outline of castle wall leads the eye toward the mast and smokestack; the slightly angled band of extruded smoke draws attention to its source at the left and toward the end of the central pier. Turner's first steamboat emerged as prominent but not dominant, which suggests he might have inserted it as merely an interesting, modern novelty in a complex harbor scene—one object among many that deserve our attention in a composition alive with what was described, at the time the watercolor was exhibited, as "nautical movements of all kinds."[30]

Turner used the circa-1825 *Dover* (Fig. 2) to expand his understanding of the steamboat's abilities. In this watercolor the Channel steamer is less exuberant than in his first effort but nonetheless intrepid as it negotiates the sea and wind. A drawing considerably smaller than *Dover Castle*, it was one of the views intended for an illustrated coastal survey entitled *Ports of England*. Although the project never came to fruition in Turner's lifetime, several scenes were engraved on steel as mezzotints, including *Dover*. Here the steamer is at the center of the composition—not hidden by other vessels, as in *Dover Castle*—yet it appears

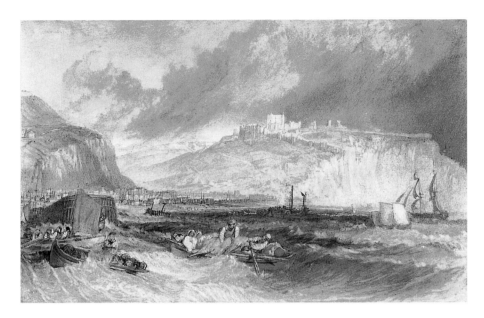

FIGURE 2. J. M. W. Turner, *Dover*, c. 1825. Watercolor, 16.1 × 24.5 cm. © Tate Gallery, London, TB CCVIII-U.

isolated, pressed close to the dark shadowed water, with its smoke blown backward, not in a broad, assertive band of color but in a "simple squiggle."[31] When the print appeared in the 1856 *Harbours of England*, the *Athenaeum* remarked on the scene's "puppet boats,"[32] and the steamer does seem toylike as it tenaciously ventures forth, toward the ominous aerial darkness and against a wind that bows the sails of the tall schooner at the right.

Turner's rather humble steamboat anticipates the Dover to Calais packets condemned at the time by the American inventor and painter Samuel Finley Breese Morse as "small, black, dirty, confined things."[33] Those integral steamer qualities are brought out in Turner's watercolor. The painter's broad, deep shadow obscures detail, reducing the vessel to a diminutive, dark, smoking machine. The steamer claims attention not only for its novelty but for its somber yet vital countenance, which, "silhouetted against the white cliffs,"[34] vies with the distant, sunlit castle.

By tentatively featuring steamers in watercolors and prints, Turner embarked on the exploration of their nature and experimented with their place in art. These works of the 1820s further exposed Turner's "insatiable curiosity," his consistent interest in human activity of all kinds, including recent advances in transportation.[35] Steamers became essential elements in his work in the 1830s and

early 1840s and would occupy his mind through his last years, as the faint watercolors of docked steamers in the 1845 *"Ideas of Folkestone" Sketchbook* attest.[36] During this period his steamboat studies became more numerous, and the vessels themselves achieved greater prominence in his compositions. He explored their mechanical energies and examined their relationship to the early nineteenth-century milieu, which witnessed the dramatic growth and popularity of steam navigation.

Turner's most sustained affirmation of steam power on water came in the *Rivers of France* books (1833–35). Influenced by his publication projects of the 1820s,[37] this series drew mostly on the experience of his incessant travels. During this decade and the 1830s, Turner collected much material for illustrated books on Europe's inland waterways, including the Danube, Meuse, Moselle, and Rhine,[38] but only the account of France's greatest rivers reached publication, appearing in three volumes under the general title *Turner's Annual Tour*. The first volume was *Wanderings by the Loire*, the second *Wanderings by the Seine, from Its Embouchure to Rouen*, and the third *Wanderings by the Seine, from Rouen to the Source*. In the second and third volumes—hereafter referred to as *Embouchure to Rouen* and *Rouen to the Source*—Turner gave steamboats greater emphasis than anywhere else in his work, portraying them in a variety of situations that allowed their nature to be studied closely, along with their connection to the surrounding environment.

Fully half the prints of *Embouchure to Rouen* feature steamers, often prominently, and still others appear in watercolors that never became engravings. Their repeated inclusion runs counter to the recent contention that Turner "judiciously edited" his views to "display elements of the most dramatically romantic allure."[39] Yet the observation of Turner's "positive fascination for tugs and paddle-steamers" on this French river only hints at his complex desire to highlight this transport technology.[40]

Turner's Seine steamers advance a middle-class presence in a newly conceived landscape. They accent the means by which the recent beneficiaries of the wealth of the Industrial Revolution (and the purchasers of Turner's books) could control a foreign locale through easy mechanized access—much as Turner's contemporary political references in the concurrent *Picturesque Views in England and Wales* offered the same "consumers a way of possessing England (the land) and hence claiming membership in it (the nation)."[41] This consciously modern view of landscape underscores bourgeois Britain's embrace of steam transport and leadership in steam technology, both at home and abroad.

The bold and dramatic juxtaposition of steamers with picturesque landscapes and historic buildings marks the Seine volumes as something new and unusual in the growth of a modern view of art that blended the functional with the timeless. Their contribution to the development of early nineteenth-century illustrated travel literature was also unique. The general title *Turner's Annual Tour* established Turner's authority as a seasoned traveler and exploited his fame as an artist and illustrator. Produced with great care, these books were expensive (the *Examiner* said their high quality merited the cost), although cheaper editions came out in 1837 and in the 1850s, following Turner's death. Proof sets of the steel engravings could be purchased separately.[42] The engravings were exhibited prior to publication and, along with the books, received considerable press attention.

Turner's handsome and informative books reflected the post-1815 popularity of British steam travel to the Continent, and especially to France. The long French wars had severely inhibited excursions abroad, but now many people eagerly took advantage of peacetime to experience the charms and delights of other lands. These were not necessarily the same individuals who had made the Grand Tour in the eighteenth century. In light of the commercial prosperity of victorious Albion, middle-class travelers began to cross the Channel in ever greater numbers. The neophytes among them could safely choose France for an excursion, it being close at hand, famous for its good highway network, and relatively inexpensive.[43] Normandy, because of its proximity and its historical associations with medieval England, became an especially favored destination.

To cater to this audience, there began to appear books whose narrative and illustration revealed the character of foreign lands. A contributor to the *Edinburgh Review* of 1817 took special note of the new phenomenon, writing that since the Continent was now as accessible as Margate or Brighton, it was not surprising "that the press should groan with many a Tour." Some of these "Tours" anticipated the modern travel guide, like Starke's *Information and Directions*, a book of practical advice for the intrepid, which Turner owned in its 1829 edition.[44] Others featured specific regional attractions, such as historic architecture, as was the case with the books on Normandy by Dawson Turner and John Sell Cotman, *Account of a Tour in Normandy* (1820) and *Architectural Antiquities of Normandy* (1822). These volumes formed a particularly attractive addition to the literature of travel by virtue of their large format and quality engravings. But in the words of the author of another work appearing at this time, the first of the Turner-Cotman collaborations suffered from a narrow concentration on buildings "without any reference to the picturesque beauties of the country," a concern that became increasingly urgent for the nature-worshiping romantic age.[45]

Correcting this omission, Rudolph Ackermann published Jean-Baptiste-Balthazar Sauvan's *Picturesque Tour of the Seine from Paris to the Sea*, in 1821, to affirm France's natural allurements and to advise the traveler. Patronized by Sir Walter Scott and Walter Fawkes, two men associated closely with Turner, it combined pertinent travel descriptions with colored prints by Auguste Pugin and John Gendall, all in a large format conceived not only to entertain but also "to prove useful to those who may be induced to transverse themselves the route pursued in [its] pages."[46] Turner would envision a similar utility ten years later in his survey of the Seine valley.

Turner prepared his French illustrations for the publisher Charles Heath, who at the time was bringing out the painter's most ambitious print project, *Picturesque Views in England and Wales*. Heath directed much of his attention in the 1830s toward "annuals," popular books suitable as gifts or "tokens of friendship," which presented short pieces of prose and poetry along with engravings by major artists. These publications owed their inspiration to Ackermann, who concocted the first one in 1822, but Heath expanded their range when he introduced the "landscape annual" the following year and employed noted artists to embellish its pages with examples of the beauties of nature.[47] Heath dedicated his enterprise to the premise that "a taste for travel and a taste for the fine arts seem to grow together."[48] The 1830s saw these books very much "in vogue,"[49] with landscape annuals published on Italy, Germany, the Low Countries, and the coast of France. Artists such as James Duffield Harding and Clarkson Stanfield provided visual material for these and other works. So did Turner, whose French books are a particularly elegant example of this genre.[50]

Turner was one of the first to display steamboat images in this kind of publication, a move that further confirmed the benefits of mechanized transport. To contemporary writers, steamers not only "rendered the intercourse of England with . . . the Continent a matter of certainty" but also, in the process, converted Britain "into a nation of travellers."[51] The Dover to Calais link soon expanded to include service from other ports. In April 1822 the *Royal Tourist* began thrice-weekly service from Brighton to Le Havre, and by 1829 a traveler could count on two packets a week from Southampton to the same port, a journey taking eleven or twelve hours. Dieppe could also be reached by steamer from Brighton.[52] Turner's painting of this popular Sussex town, *The Chain Pier, Brighton* (c. 1828; Fig. 3), depicts, at the left, the approach of what was likely one of the regular cross-Channel steam packets.[53] Once in France, the voyager could forgo the often faster (but cramped) "diligence" or stagecoach and instead join one of the many Seine steamboats that gently followed the winding river, "traversing a beautiful country," from the sea to Paris.[54]

FIGURE 3. J. M. W. Turner, *The Chain Pier, Brighton*, c. 1828. Oil, 71.1 × 136.5 cm.
© Tate Gallery, London.

Seine steamboats represented one of the few examples of steam technology in France, a country that lagged behind Britain in terms of industrial growth and innovation. France's size, wealth, and lively scientific community, which included such engineers and steam advocates as Sadi Carnot and Jean-Baptiste Marestier, did not alter the situation during these years.[55] One judgmental American visitor in 1835 explained France's economic backwardness as a combination of deficient "physical energy and . . . perseverance" and the want of "that Saxon hardiness and enterprize, which had made neighboring Great Britain the greatest manufacturing and commercial nation in the world." Indeed, the Industrial Revolution in France, in the century after 1750, "was fostered by English inventions and English capital and by the services of English entrepreneurs, contractors and skilled workers." One English traveler observed at the time, rather unkindly, that the steamboats in the Bordeaux region all used English machinery and most employed English engineers—the French contribution being the vessels' decoration and the meals served to passengers![56]

The Seine provided the ideal setting for the development of French steam navigation. The country's principal river trade route, it connected Le Havre, considered France's greatest port during this period because of its cotton business, with the manufacturing and commercial center of Rouen. It also afforded access to Paris and the growing industrial regions in the north and east. But the Seine presented problems for navigation, in the form of "shoals, rapids, fishing weirs, islands, and dangerous sand bars." Moreover, simple travel could be dif-

ficult because "its meanders made the use of sails almost impossible—expensive human or animal power was necessary."[57]

Steam offered the prospect of relief. In 1815, the forty-ton *Eagle* made its appearance, and four years later the *Triton,* praised subsequently by Sauvan as "a handsome vessel, . . . fitted up with elegance and every possible accommodation," began service between Le Havre and nearby Honfleur.[58] By 1826, twenty-six steamers operated on the lower Seine and two more above Paris. Throughout much of this period, French river steamers continued to rely on imported English engines and operators.[59]

Travel guides on France lost little time in acknowledging the introduction of powered transport on one of Europe's most important communication arteries. *Galignani's New Paris Guide* of 1829 informed its readers that "agreeable," inexpensive biweekly steamers departed from Le Havre to Rouen, with more frequent service on to Paris. By the late 1820s a handy pocket guide had come out, designed specifically for the steamboat traveler in Normandy. *Voyage historique et pittoresque du Havre à Rouen, en bateau à vapeur* demonstrated, in an unillustrated text, that a trip by river steamer could please almost every taste, placing one in easy contact with splendid monuments of nature and humanity.[60] Turner, who owned a copy of the third edition (1829), may have used this guide during his journey to Paris that same year and been influenced by its timely approach to travel.[61] Not only did it celebrate the availability of extensive and reliable steamer service, but it also pointed out many noteworthy sites that could be viewed from the river.[62]

Publishers of illustrated travel books and landscape annuals, however, hardly rushed to celebrate the virtues of steam power in their art. Landscape illustrations featuring steamers remained atypical—Sauvan omitted them entirely from his plates. When steamboats did appear, they often occupied minor or subordinate roles in the scene. In Pugin and Heath's *Paris and Its Environs* (1831), for example, a steamer offers only incidental interest in a view of the Pont de la Tournelle, with attention focused on the noteworthy bridge.[63]

Heath eventually came to acknowledge the steamer's place in the illustrated literature of modern travel, despite misgivings about its appearance and operation, which he harbored until the publication of Turner's first Seine volume. In 1833, the text for *Travelling Sketches on the Rhine* recommended the choice of sailing ship over steamboat for the return trip from Rotterdam to England:

This [sail-powered] mode of conveyance is more uncertain, but the motion is pleasanter; . . . your feelings, while dancing over the bosom of the deep, are higher and finer. And this is not fancy, for in addition to the smoke and unpicturesque

funnel of a steam-ship, there is ever and anon a jerk conveyed by the machinery which gives one the idea of restraint.[64]

But the following year Heath evidently had a change of heart about the noxious steamship, since he brought out two separate volumes in which they figured prominently: Turner's *Embouchure to Rouen* and later Stanfield's *Travelling Sketches on the Sea-Coasts of France*. In the latter, the reader learned that in a trip across the mouth of the Seine, from Le Havre to Honfleur, "steamboats . . . afford at present an elegant and commodious mode of conveyance."[65] Probably the increasingly ubiquitous steamboats made the cautious publisher realize what Turner and others already knew—that these technological marvels deserved notice, especially in books devoted to expeditious and enriching travel.

Turner's 1834 book proclaimed its utility at the outset. A prefatory note stated that the book could serve as "the narrative of a Pedestrian Tour on both banks" of the lower Seine and as a "guide to the traveller in the more usual excursion by the steam-boat."[66] What followed in words and pictures reinforced this object. The text, by Leitch Ritchie—a novelist and sometime resident of Normandy who had written a sentimental history of France[67]—included appropriate advice for the early nineteenth-century British traveler, as well as descriptions of the river's natural beauties. Ritchie's narrative betrayed a keen nationalism by spotlighting historic sites that, in the words of one contemporary critic, had "associations in the minds and hearts of Englishmen" attuned to their Norman heritage. At the same time, he displayed what a recent writer has called a "supercilious" attitude toward "French manners and morals."[68] Turner's illustrations with steamers echoed this perspective more subtly, reminding the artist's countrymen that the mechanized transport they had grown accustomed to at home would carry them efficiently to and through the country of their less-developed neighbor.

The book's small frontispiece vignette, *Light Towers of the Hève* (Fig. 4; see p. 34), pressed this timely argument. It depicts the northern entrance to the Seine estuary at Cape Hève, where two majestic lighthouses dating from the time of Louis XV surmount high cliffs, casting beacons visible more than twenty miles out at sea.[69] On the water beneath, Turner singled out a small steamer; "thrown into admirable relief,"[70] it is the center of attention, despite competition from giant rocks and tall-masted sailing ships. Taking great care with this first illustration, Turner made several studies of the location; in one, circa 1832, the steamboat is emphasized in the same burst of light that falls on the cliff-top towers (Fig. 5; see p. 35). The artist also employed what was becoming his standard

procedure for accenting steamers, giving the boat a dark generalized appearance and patches of extruded smoke that allow it to dominate its surroundings. Both this drawing and the final printed version evoke a scene familiar to steamboat travelers approaching northwest France, as borne out in the American author James Fenimore Cooper's description of his own approach to this coast in 1826, aboard the Le Havre–bound steamer *Camilla:* "The boat was running along beneath some cliffs. The moon was shining bright, and her rays lighted up the chalky sides of the high coast, giving them a ghostly hue. The towers of two light-houses, also, glittered on a head-land nearby."[71]

Turner brought more steamers into view throughout the harbor of Le Havre, the great commercial center that one midcentury writer called "the Liverpool—of France."[72] In *Havre: sunset in the port* (Fig. 6; see p. 36), a print of somewhat larger scale than the frontispiece but consistent with the engravings that follow it, he included a steamer at the quay. In a scene of crowded, modern commerce, the only attempt to reveal the historic or picturesque is the partly hidden sixteenth-century tower at the left. The steamboat, although blocked from full view by other vessels and crowded wharves, is a compositional focus, balancing the tall sailing ship to the left and anchoring a long line of facades and docks that leads the eye backward, into the picture, toward the intense sunset that casts a warm, gentle glow over what would otherwise be a rather mundane port scene. The steamer further demands notice because a thin pipe beside its tall, straight funnel gives off white steam, as if, as Ritchie's text suggested, the engine's condensers were being vented prior to departure for nearby Honfleur. Turner and Ritchie evidently found this scene interesting, for a version with a slightly altered perspective was published in *The Keepsake for 1834*.[73]

Despite its title, *Havre, Tower of Francis I: twilight outside the port* (Fig. 7; see p. 37) focuses as much attention on steam as on the Renaissance citadel. Here the steamboat, leaving the harbor, has churned up white water and released a long stream of black smoke, drawing the eye from the lighted sky toward the entrance to the shipping channel. Its somber outline, as prominent as that of the Hève steamer, shares the central space with the partially illuminated stone walls of the tower. If the juxtaposition of architecture and shipping evokes Claude,[74] the steamer points to a decidedly contemporary awareness. This feel for the modern character of the great harbor displeased some critics. The *Examiner* complained that Turner exhibited "a most cruel sacrifice of effect to fidelity" in depicting "a murky steamer . . . just emerging," and the *Gentleman's Magazine* declared flatly that there was little to admire in Turner's depictions of the "dirty town of Havre."[75]

Turner might have wanted to include more engravings inspired by Le

FIGURE 4. John Cousen after J. M. W. Turner, *Light Towers of the Hève*, 1834. Etching and engraving, 20.4 × 13.3 cm. Yale Center for British Art, Paul Mellon Collection.

Havre–area steamers. He had painted two intricate watercolors in about 1829, never engraved, that present close-up views of docked steamboats. In both, the broad, flat expanse of water and the absence of steep riverbanks suggest a scene somewhere in the Seine estuary, perhaps at Le Havre or Honfleur. One depicts a quayside steamer from the front, with people moving along a gangplank connected to the deck (Fig. 8; see p. 38). The other shows the stern, with cabin windows, hanging lifeboat, passengers, and smoking engine stack clearly visible between two large paddle boxes that extend like huge wings, churning up water (Fig. 9; see p. 39). A second, stationary, steamer lingers behind, to the left, and two sailing vessels opposite, under full canvas, provide contrast. But because

FIGURE 5. J. M. W. Turner, *Study for "Light Towers of the Hève,"* c. 1832. Watercolor, 19.7 × 15.9 cm. Board of Trustees of the National Museums and Galleries on Merseyside (Lady Lever Art Gallery, Port Sunlight).

these views depict steamers for their own sake, Turner might have found them unsuitable for a project that emphasizes their place in a varied, overall setting.

The steamboats in *Embouchure to Rouen* also confirm the tangible advantages these vessels offered travelers in overcoming some of the Seine's peculiar obstacles. Steam assisted navigation on the river's lower reaches, where strong tides and shifting sands proved troublesome and sometimes dangerous. At Quilleboeuf, where the river narrowed and began to wind inland, moving sandbanks and submerged rocks greatly impeded shipping. Turner recognized these impediments and a more formidable natural danger, which he explained in a note to his 1833 oil *Mouth of the Seine, Quille-Boeuf* (Fundação Calouste Gul-

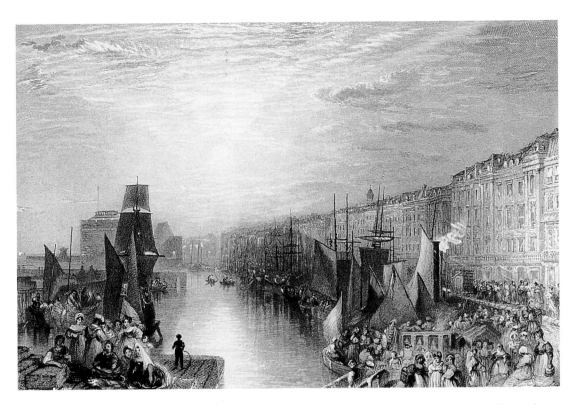

FIGURE 6. James B. Allen after J. M. W. Turner, *Havre: sunset in the port,* 1834. Etching and engraving, 9.4 × 14.1 cm. Yale Center for British Art, Paul Mellon Collection.

benkian, Lisbon) as "the *'Mascaret'* or *'Barre,'*" in effect a "rising tide, which rushes in one wave."[76] Steam vessels mitigated such phenomena both because they were independently maneuverable and because they could tow ships to the waters above Quilleboeuf, where conventional sailing became easier.[77]

The activity of Seine steam tugs, or *remorqueurs,* was almost certainly what Turner depicted in *Between Quilleboeuf and Villequier* (Fig. 10; see p. 40), the most focused and animated steamboat study in the entire Seine series. Boldly and convincingly, it proclaimed the utility and excitement of industrial technology. Monochromatic steam tugs, all the more striking for the white canvas sails flanking them, bespeak efficiency, while the smoke and steam they extrude suggest a controlled energy source housed belowdecks, at once wondrous and frightening in its astonishing ability to drive the boats forward.

The marked contrast between the soft, static surroundings—calm water, gently sloping hills, and a three-masted ship with slack sails—emerges even more

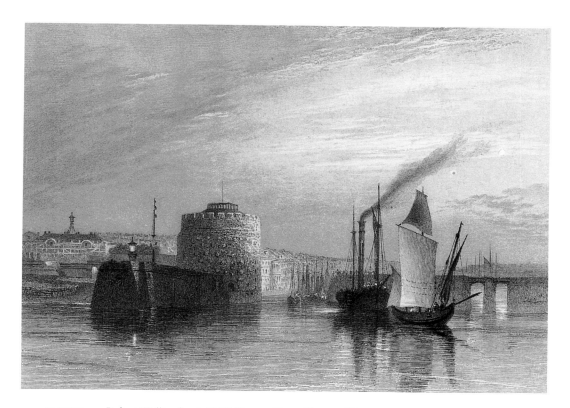

FIGURE 7. Robert Wallis after J. M. W. Turner, *Havre, Tower of Francis I: twilight outside the port*, 1834. Etching and engraving, 10.2 × 14.1 cm. Yale Center for British Art, Paul Mellon Collection.

provocatively in the original watercolor sketch (c. 1830; Plate 2). Turner painted it, like the rest of the Seine series, with body color on blue paper. This cool background set off the tugs and their smoke—starkly black, with some brown to indicate bow and masts—to even greater effect than in the print. With such intensity of color, and the corresponding lack of drawn detail, Turner pressed the engraver throughout the series to "better and more sensitive . . . interpretations" of his work.[78] In the watercolor of *Between Quilleboeuf and Villequier* the tugs received the strong coloring and slight detailing that translate well onto the steel plate, resulting in appropriately generalized, dark machine forms that command the whole scene.

According to John Murray's 1843 *Handbook for Travellers in France*, which reflected over ten years of French travel experience, *remorqueurs* had "diminished the delay and risque" in this turbulent area, thus reducing the frequency

FIGURE 8. J. M. W. Turner, *A Steamboat and Small Craft by a Quay, with a Sailing Ship Beyond*, c. 1829. Watercolor, 14 × 18.9 cm. Tate Gallery, London, TB CCLX-35; photo © British Museum, London.

of shipwrecks. Turner situated *Between Quilleboeuf and Villequier* near Vieux Port, about halfway between the towns mentioned in the title, and at a bend in the river where the dangerous *barre* rushed through with such powerful regularity as to provide fishermen with a catch in their nets from both up- and down-river.[79] Since hills marked the south and marshlands the north bank at this point, Turner most likely portrayed one or more tugs helping a sailing ship negotiate this awkward turn in a journey downstream—hence the positioning of the rigged vessel almost in full profile and the *remorqueurs* churning forward and slightly toward the left.[80]

Ritchie went out of his way to extol Turner's engraving for conveying the "beauty of the scene . . . enhanced by the vessels whose reflections are seen so strikingly contrasted in the calm wave." It won praise from the critics as well, with the *Athenaeum* declaring it a favorite of the entire series and *Arnold's Magazine* calling particular attention to Turner's success in making vital and interesting subjects out of coarse steamers: "We do not generally admire masses of smoke, or consider steam-boats as delicate instances of the picturesque, but every subject here is so highly managed, that we must be cautious lest we in-

FIGURE 9. J. M. W. Turner, *Two Paddlesteamers and other Craft*, c. 1829.
Watercolor, 14 × 18.9 cm. Tate Gallery, London, TB CCLX-36;
photo © British Museum, London.

cur the charge of being fastidious. Mr. Turner has positively given the appearance of motion to the vessel, and the letting off the steam in the boat a-stern is excellent."[81]

Visually interesting, aesthetically acceptable, and highly functional steamboats played a significant part in Turner's scenic tour of the Seine valley. His paintings reveal the varied functions of these smoking machines and communicate an affective understanding of their working energy. Further inland, in the Norman countryside above Villequier, the boats share attention with the beauty of the surroundings in a way that argues for an early nineteenth-century form of landscape painting, one in which the clear presence of mechanization confirms the reality of a new human interaction with the environment. In *Caudebec* (Fig. 11) Turner captured the ageless charm of what Sauvan had earlier described as "hills, which seem to rise from the water, their sides enriched with woods and overhanging pleasure grounds,"[82] together with a distant steamer not at all out of place in such a setting. Although it is but a dark speck on the water, smoke and steam from its robust engines create a broad atmospheric canopy that announces its presence.[83] Turner skillfully integrated it, as a harmonious rather

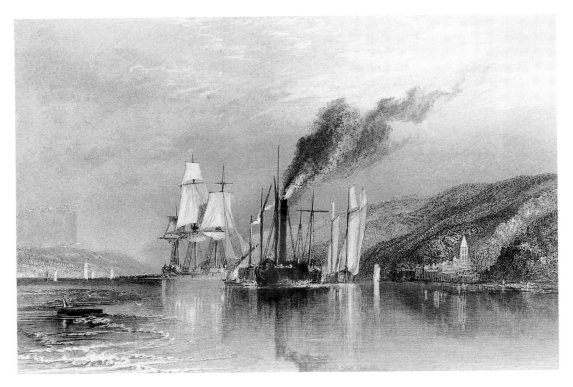

FIGURE 10. Robert Brandard after J. M. W. Turner, *Between Quilleboeuf and Villequier,* 1834. Etching and engraving, 9.3 × 13.3 cm. Yale Center for British Art, Paul Mellon Collection.

than an intrusive element, in the pictorial environment: its smoke plume rises to meet the low-hanging clouds.

Caudebec demonstrated the steamer's ability to convey travelers through some of the most beautiful and appealing French countryside in a comfortable, unhurried way. Cooper declared such travel splendid: "We came up the Seine in a steam boat to Rouen, and a most delightful passage it was. . . . We saw Chateaux innumerable, and some splendid ruins." The lethargic upstream pace made the voyage more enjoyable. Another American, Heman Humphrey, remarked in 1835 on his fellow passengers' complaints about "the snail-like progress of our boat," which pleased him because it presented greater opportunity "to see the country" between Le Havre and Rouen. But he could not avoid one perennial grievance of the steamboat river traveler: while "looking at some fine chateau, or rocky battlement, or getting a glimpse of some enchanting vista on one side of the river, other objects equally interesting were almost sure to escape me on the other."[84]

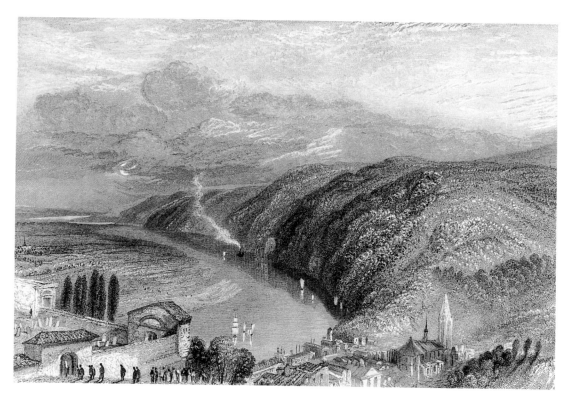

FIGURE 11. James B. Allen after J. M. W. Turner, *Caudebec*, 1834. Etching and engraving, 9.6 × 13.9 cm. Yale Center for British Art, Paul Mellon Collection.

Turner made mechanized transport an integral part of the most dramatic illustration in the book, *La Chaise de Gargantua* (Fig. 12). Not only did this engraving show how close the modern river traveler could pass to the curious geological formation rising above the busy waterway, but it also demonstrated the steamer's tenacity in violent weather. Although Turner indicates a strong wind that tilts some of the neighboring sailboats, the steamer seems to be moving perpendicular to the surface of the water, with only its smoke blown to the side. As in the book's other prints, the steamboat enlivens the composition. The smoke that rises to the right, a thin echo of the large lightning bolt at the left, produces what has been termed an exchange between nature and humanity.[85] Silhouetted against the gray hills, it shares attention with the white "Giant's Chair," to which it is linked by the sunlit shoreline.

For his view of the medieval abbey in *Jumièges* (Fig. 13), Turner's departing steamboat again marks the pleasures of modern travel. Although Ritchie's text

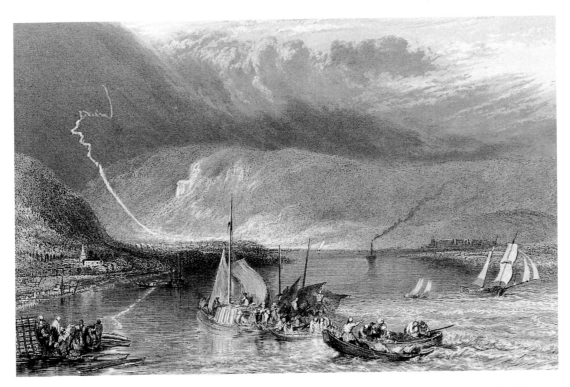

FIGURE 12. Robert Brandard after J. M. W. Turner, *La Chaise de Gargantua, near Duclair,*
1834. Etching and engraving, 9.3 × 13.3 cm. Yale Center for British Art, Paul Mellon Collection.

mentions the "sacred . . . solitude" of the place, Turner's engraving vaunts its
accessibility to tourists on a steamer.[86] With smoke and steam emanating from
beyond the page,[87] rising toward the rainbow that arches over the abbey, the
boat moves off to the right, its stern crowded with colorfully dressed people.
The image suggests what an earlier steamboat traveler described as a relaxed
and "beautiful sail thro fine scenery" on the Seine.[88]

A similarly relaxed view of steam travel's convenience appeared in the third
volume of the French series, *Rouen to the Source*, published in 1835. In *Con-
fluence of the Seine and the Marne* (Fig. 14), Turner studied in some detail a
steamer maneuvering in mid-river. The landscape here, unlike that in most of
his other Seine illustrations, is flat and uninteresting, save the junction of the
two placid waterways. Ruskin commented later, with some disapproval, on how
"the repose of the wide river [is] stirred by the paddles of the steam boat, (whose
splashing we can almost hear, for we are especially compelled to look at them
by their being made the central note of the composition—the blackest object in

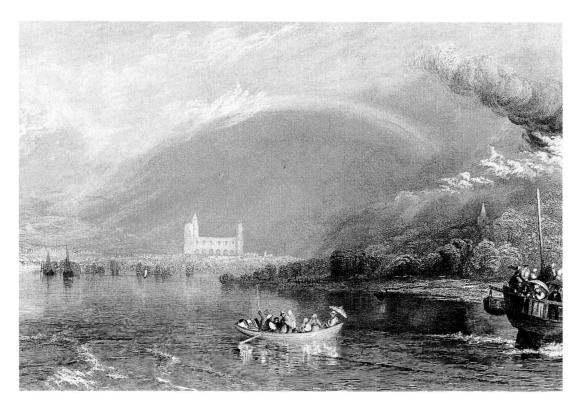

FIGURE 13. James C. Armytage after J. M. W. Turner, *Jumièges*, 1834. Etching and engraving, 10.2 × 14.4 cm. Yale Center for British Art, Paul Mellon Collection.

it)." For others, less hostile to machine technology, the engraving succeeded very well. To the *Spectator*'s critic, the steamer did not seem out of place, gently "ploughing her way" through the calm water with only a hint of smoke floating over its tall funnel.[89]

But these words also suggest the staid appearance of one of Turner's more prosaic steamers. Lacking the loose handling and concern for technological effect—pronounced displays of smoke, fire, and steam—of some of his other Seine vessels, it harks back to the packet in *Dover Castle* and a host of steamers drawn by other, lesser, artists. As in *Jumièges*, the vessel seems a welcome and friendly presence, its deck accommodating numerous clearly delineated figures sitting atop the paddle box, below the great central smokestack, and on the stern, where a man embraces a woman. Ever informative, Ritchie's text recommends this steamboat for "the idle wanderer"[90] or for the sensitive traveler journeying on to Melun, a town Turner drew complete with a docked steamer

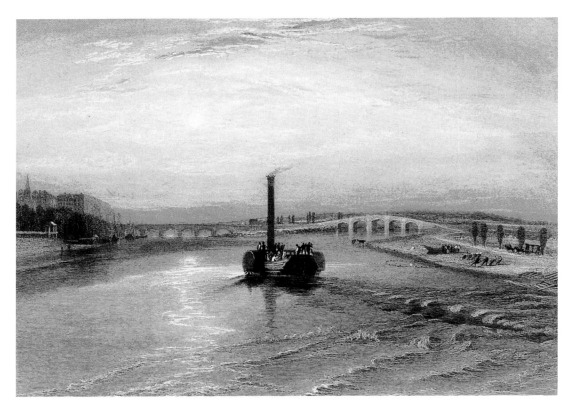

(Fig. 15). Presumably those in a hurry could join the far less open and spacious
diligence, such as the one moving along the winding road at the right of
Confluence.

The *Athenaeum* sounded a familiar note in commending Turner here for "dar-
ing to press one of those vituperated craft called steam-boats into his service,
to render it effective and picturesque."[91] But the most significant praise for
Turner's innovative mingling of technology and nature, here and in the entire
Seine series, came two years later, in an article on modern poetry in the pages
of the *Quarterly Review.* The reviewer of the 1836 edition of Thomas Camp-
bell's poems (published a year before the famous version illustrated by Turner),
probably William Henry Smith, a Victorian poet and writer on "abstract
thought,"[92] singled out steam power as a phenomenon deserving both poetic
and artistic expression. Smith noted Campbell's timely allusion to "the upright
and indomitable march of the self-impelling steam-boat" in the poem "On the

FIGURE 15. William Miller after J. M. W. Turner, *Melun*, 1835. Etching and engraving, 9.8 × 13.4 cm. Yale Center for British Art, Paul Mellon Collection.

View from St. Leonard's." In Smith's eyes, Campbell had succeeded in taming the steamboat in the interests of art, throwing "over it the protection of his polished verse," so that "however strange the intrusion might at first have appeared to eyes poetical, the steam-vessel must now be considered as naturalized upon the ocean." It had become that "new object of admiration,—a new instance of the beautiful." To reinforce the point, Smith singled out Turner for using his art to achieve a similar purpose in his Seine books.

> We have been struck . . . with the admirable manner in which Turner, the most ideal of our landscape painters, has introduced the steam-boat in some views taken from the Seine. The tall chimney, the black hull, and the long wreath of smoke left lying on the air, present, on *his* river, an image of life, and of majestic life, which appears only to have assumed its rightful position when seen amongst the simple and grand productions of nature.[93]

Turner may have planned steamboat-oriented books on other European rivers, for the French volumes were billed by Heath as the first installment in an am-

FIGURE 16. J. M. W. Turner, *Ehrenbreitstein*, 1841. Watercolor, 23.7 × 30 cm. © Tate Gallery, London, TB CCCLXIV-346.

bitious Continental series.[94] The strong public interest in such works should not be underestimated—one notable book, Samuel Prout's *Sketches in Flanders and Germany*, inspired the Ruskin family to take their Rhine journey in 1833—[95]but their proliferation, along with the collapse of Heath's finances, may have helped to frustrate these plans. Yet Turner did produce a number of striking drawings that indicate that a Rhine journey might have been his next project and that steamers would have appeared alongside that river's most picturesque sites. Like the Seine, the Rhine was becoming ever more accessible because of the steamboat. The first steamers began operations on its lower reaches soon after the Napoleonic wars, and by the end of 1832, powered navigation was possible all the way up to Basel.[96] One writer exclaimed around 1840, "Steam is our willing slave, . . . and places *Cologne but a day's journey from London; as near as*

FIGURE 17. J. M. W. Turner, *Ehrenbreitstein,* 1841. Watercolor, 24.2 × 30.2 cm. © Tate Gallery, London, TB CCCLXIV-319.

the English Lakes." Beyond Cologne the steamboat traveler would make for the busy river port town of Koblenz, with the fortress of Ehrenbreitstein opposite, immortalized by Lord Byron and called by Murray's 1836 *Handbook for Travellers on the Continent* the "Gibraltar of the Rhine."[97]

Turner depicted steamboats opposite the fortress in two watercolor sketches from 1841, both known by the title *Ehrenbreitstein.* One (Fig. 16) shows a steamer in the foreground, while a second (Fig. 17) is a free play of color, with steamers, just beyond the open bridge,[98] indicated at the left by wide, dark vertical stains of smoke, in striking contrast to the pale yellow background of the high riverbank. As with his earlier Seine views, Turner insisted on injecting a clear indication of the early nineteenth-century presence into the most poetic of settings.

Steamboats brought travelers into contact with some of the finest natural

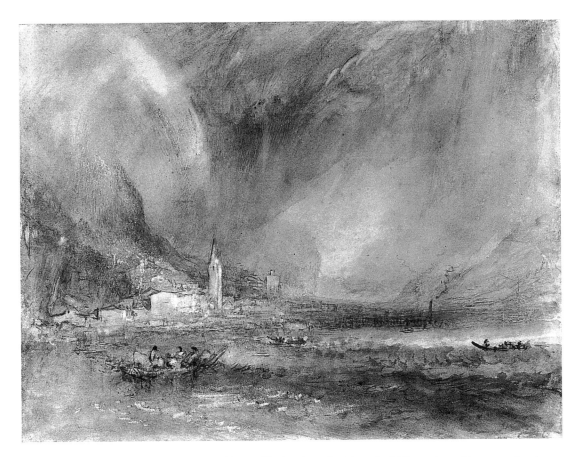

FIGURE 18. J. M. W. Turner, *Flüelen, from the lake,* 1841? Watercolor, with some red and black ink, 23.2 × 30.2 cm. Fitzwilliam Museum, Cambridge.

scenery in Europe when they commenced operations in Switzerland, a development Turner acknowledged in several watercolors of the 1840s. The steam service that began on the Swiss lakes in the early 1820s proved a boon for tourists, who, crossing the cantons' great inland bodies of water, could contemplate in ease and comfort the surrounding Alpine grandeur.[99] British tourists took advantage of the improved transportation to visit in ever greater numbers. In fact, one writer complained that in Switzerland "John Bull is everywhere to be seen."[100]

Turner loved the mountains and lakes of Switzerland and northern Italy. The availability of steam service must have pleased him, for it allowed "an unlimited and ever-changing experience of water and mountains," especially by his

later years, when the exertions of travel would have proved burdensome. The watercolorist William Lake Price recalled seeing Turner sketching on a Lake Como steamer in 1843.[101] A typical steamer on Lake Lucerne adds an element of modernity to *Flüelen, from the lake* (c. 1841; Fig. 18).[102] Here the generalized areas of mountain and atmosphere give way to a more defined hillside, town, and docked steamboat. A tall spire, white in a burst of sunlight, counterbalances the small, dark smokestack farther to the right. This slight vessel, rendered simply as a black funnel and trail of smoke, seems drawn toward shore by a dark triangular area of land, pier, and water that makes it part of the picture but subordinate to its turbulent and grandiose surroundings. Steamer service began between Flüelen and Lucerne in 1837, much to the consternation of the local boatmen (some of whom are seen plying the waters in the foreground of the picture), who feared a decline in business. Murray's 1838 Swiss *Handbook* announced that the steamer *La Ville de Lucerne* made the three-hour Flüelen-to-Lucerne run eight times a week in the summer.[103]

For all their significance, Turner's sketches of steamboats on the lakes and rivers of Europe and along the British coast were surpassed by the oil paintings he displayed at the principal London exhibitions. These most tellingly convey his connection to steam power. His first oil painting with a steamer appeared in 1832, and several similar works emerged from his studio in that decade. But it was between 1839 and 1842 that Turner produced some of his most memorable steamboat paintings.

One painting from this three-year period uses an almost negligible sign of steam power to reflect the acceptance of the new technology. *The New Moon; or, "I've lost My Boat, You shan't have Your Hoop"* (Fig. 19), presents a beach scene at twilight, with children and animals playing at the left and, in the middle distance, the faint indication of a steamer (or steamers) whose engine smoke rises over the horizon. This painting has been linked to a contemporary controversy over the wedding of Queen Victoria and Prince Albert and the "childish" dispute over matters of precedence and the prince's income.[104] But a more revealing contemporary reference is its inclusion of steam. The critic for the *Spectator* found the integration of technology and seascape in the work effective, especially when viewed from a few feet back, for the "sun setting in a rock of clouds, the crescent moon, the surf of the waves and the smoke of the steamers, are then visible; and an effect of space, twilight, and atmosphere, is conveyed to the mind."[105]

This arrangement coincided with contemporary observation on steam's

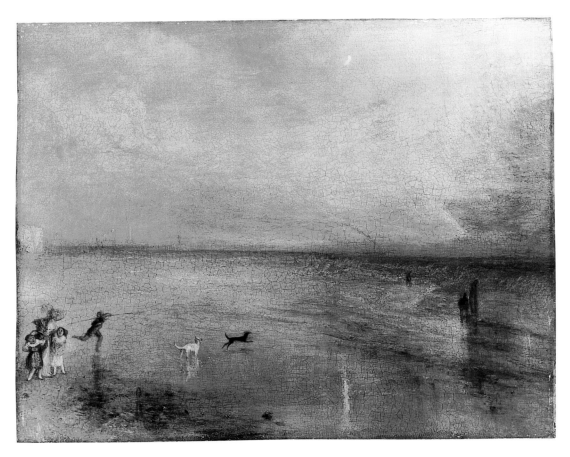

FIGURE 19. J. M. W. Turner, *The New Moon; or, "I've lost My Boat, You shan't have Your Hoop,"* 1840. Oil, 65.5 × 81.5 cm. © Tate Gallery, London.

growing prominence. In an 1839 article, Francis B. Head, author of the widely discussed *Steam Navigation to India,* praised the "distant breath" of engine smoke as an embodiment of progress, which announced the availability of a new and dependable mode of transportation for the peoples of the earth. Consequently, "a modern hieroglyphic has now become one of the well-known characteristics of the ocean, and on almost every portion of the aqueous globe the appearance of a slight horizontal stain in the atmosphere designates, according to its colour and its form, that a steamer is or has been beneath it."[106]

In Turner's most renowned steamboat image, *The Fighting "Temeraire," tugged to her last berth to be broken up, 1838* (Fig. 20), exhibited at the Royal Academy in 1839, the dramatic power of steam is closely observed and the con-

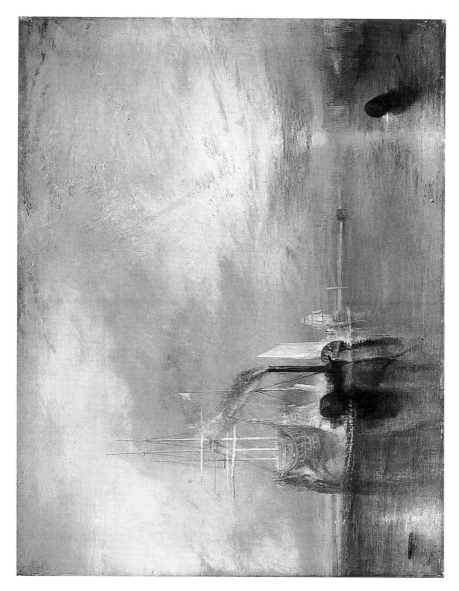

FIGURE 20. J. M. W. Turner, *The Fighting "Temeraire," tugged to her last berth to be broken up*, 1838, 1839. Oil, 91 × 122 cm. Courtesy the Trustees, The National Gallery, London.

sequences of its presence affirmed. The artist's friend and admirer R. C. Leslie described it as Turner's "first, strong, almost prophetic idea of smoke, soot, iron, and steam, coming to the front in all naval matters."[107] A finished oil, the same size as most of his paintings of this period, it was reproduced in 1845 as an engraving; eliciting considerable critical acclaim, it struck a responsive chord with the public and quickly became the artist's most popular canvas.[108] More than any of Turner's previous works, *The Fighting "Temeraire"* recognized the unassailable status of steam power. The title specifies the steamer's task of demolition in a way that acknowledges both the *Temeraire*'s past heroism and its present obsolescence. Change and the passage of time preoccupied the artist at this moment, as evidenced by two other paintings he exhibited at the Academy the same year, *Ancient Rome* and *Modern Rome* (both Tate Gallery, London). *The Fighting "Temeraire"* offered these ideas in a particularly early nineteenth-century manner, with steam power operating on the commercial river of the largest of modern industrial cities.

Its conspicuous tug claims pride of place, although small in comparison to its charge—one of the last ships of Nelson's fleet at Trafalgar. Positioned prominently in the left foreground, at an angle that exposes both of its large spinning side wheels, the steamer moves forward up the placid Thames. A tall, thick, shiny black funnel shoots smoke and steam back toward the bare rigging of the lofty, pale *Temeraire*. This discharge also leads the eye from the battleship's masts down to the right, toward a source of intense color, the bright setting sun that casts a brilliant reddish orange glow over the entire canvas.

The steamer Turner depicted in *The Fighting "Temeraire"* demonstrated a prime use of steam power on the Thames. Although steam tugs had been operating on the river for just over twenty years, moving ships of all sizes from estuary to piers,[109] by 1838 their numbers had grown considerably. Images of tugs leading larger sailing ships often caught the eye of nineteenth-century artists working in London or elsewhere. Turner had already painted such an occurrence in *Between Quilleboeuf and Villequier*; in the 1850s the French photographer Gustave Le Gray felt drawn to a similar incident, this time off the Channel coast, in his *Seascape with Yacht and Tugboat, Normandy* (Fig. 21).[110] Period sources suggest that Turner altered many details of the towing operation in *The Fighting "Temeraire,"* such as the number of tugs involved, the arrangement of smokestack and mast on the steamer, and the inclusion of masts on the *Temeraire*, which would have been removed by this time in its career, as a contemporary print indicates (Fig. 22).[111]

Turner made the steam tug the painting's most conspicuous feature—all color and movement, in contrast to the anemic and nearly static *Temeraire*. Although

the critic of the *Art-Union* termed it "the paltry steam-boat . . . the mean thing . . . the petty steamer," an attitude that has lingered into recent times,[112] others at the time responded positively to this compact technological marvel that so easily managed the great wooden hulk. The reviewer for the *Spectator* considered the tug a most worthy element in the painting, writing that its "fiery glow and activity and small size make a fine contrast with the majestic stillness of the old line-of-battle ship, like a superannuated veteran led by a sprightly boy." William Makepeace Thackeray, writing for *Fraser's Magazine*, hid admiration in invective when describing the tug's dynamism: "The little demon of a steamer is belching out a volume (why do I say a volume? not a hundred volumes could express it) of foul, lurid, red-hot, malignant smoke, paddling furiously, and lashing up the water round about it."[113] The tug's below-deck engine, fed vast amounts of cheap coal to maintain the power needed to press ahead, sends up orange smoke through the black stack (and a small jet of steam through the attached pipe) that explodes into the atmosphere.[114] These "rich-coloured vapours," produced by sun rays hitting the condensing steam, create a technologically induced intensity that vies with the light of the great setting sun.[115]

The painting's references to industrial-technological London further evoke the new machine age. A second steamer, marked by a gentle trail of engine smoke, operates in the right distance. And on the riverbank, "we see dim through the blue vapoury twilight a factory, and masts and chimneys."[116] Nearly twenty years had passed since Turner unobtrusively introduced a steamer into a traditionally picturesque setting in *Dover Castle*. Now he reversed the emphasis with a majestic eighteenth-century ship, rendered insignificant by the developments of the new century, set incongruously in the uncompromising environment of early nineteenth-century London. Tradition finally gives way to the new.

The Fighting "Temeraire" presents one of many London events that Turner used as subjects for paintings. Five years earlier he had painted two oils of the fire he had seen destroy the old Houses of Parliament. Although Turner probably did not witness the *Temeraire*'s transfer to the wreckers at Rotherhithe, he could have drawn on published reports of the event.[117] He may have lamented the fate of this relic of Nelsonian England, but his preoccupation with the tug suggests that he was more struck by the remarkable incongruity of the outdated vessel delivered up to modern, steam-age London. A reporter for the *Times* noted how the "majestic appearance of this fine ship excited much interest and curiosity; every vessel she passed appeared like a pygmy, and the steamboat passengers were surprised as well as delighted at the novel spectacle of a 98-gun ship in the Pool." In 1836 a House of Commons committee heard evidence that

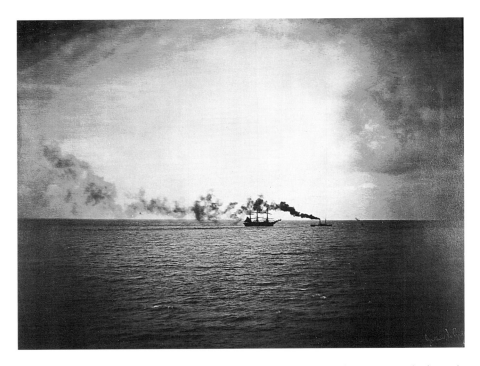

FIGURE 21. Gustave Le Gray, *Seascape with Yacht and Tugboat, Normandy* (formerly *Seascape at Cette*), c. 1850. Calotype. Courtesy the Board of Trustees of the Victoria & Albert Museum, London.

over a million passengers passed Blackwall on steamboats every year;[118] any sorrow for the outmoded *Temeraire* must be considered in this context. The *Times* later reported briefly on the actual breakup of the *Temeraire* in an edition that carried several stories lauding the latest accomplishments of maritime steam technology.[119] But for those inclined to nostalgia, Turner's juxtaposition of steam and sail could certainly evince regret for the loss of the *Temeraire* and resentment of the steamer, cast in the role of the warship's "executioner," as the critic for the *Athenaeum* put it.[120]

The contrast also had more affirmative connotations, however, as further testimony to the nation's technological development. Francis B. Head's January 1839 article on Irish railroads (which Turner may have read when he painted *The Fighting "Temeraire"*) made this point. It hailed steam power, especially the animated traffic on London's great waterway. Speaking of the steamboats— "reckless of wind or tide, and with velocities proportionate to their different horse-powers"—passing Greenwich Hospital (home to Britain's retired sailors), the author could "hardly help reflecting with what astonishment . . . Nelson, if

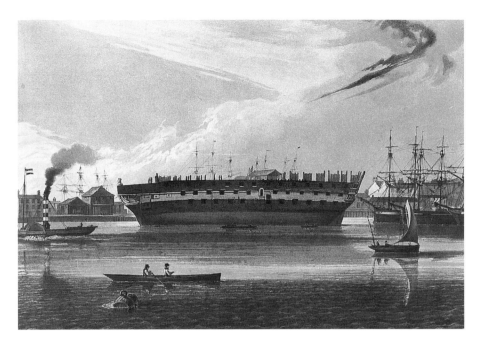

FIGURE 22. R. G. and A. W. Reeve after J. J. Williams, *"Temeraire," Ship of the Line, Broken up by Beatson at Rotherhithe*, c. 1838–39. Aquatint, 22.3 × 32.3 cm. Courtesy the Mariners' Museum, Newport News, Virginia.

he could be conjured up . . . would gaze upon this wonderful picture of the march and progress of human reason!" Moreover, steam-driven vessels possessed, to these Victorians, considerable patriotic qualities. As Turner's *Fighting "Temeraire"* attracted attention on a wall of the Royal Academy, a writer in *Tait's Edinburgh Magazine* declared that "steam is the arm of Britain's power," the means by which the island's industrial and naval strength could be most effectively brought together in service of its great empire.[121] Considered in this context, the painting carried a message of past greatness and an even greater future.

Turner used a far larger steamer to play the central role in recounting another contemporary event in *Peace—Burial at Sea* (1842; Fig. 23). A slightly smaller oil than *The Fighting "Temeraire,"* it shows a vessel in full profile and as the painting's dominant element. A tribute to the then recently deceased painter Sir David Wilkie, who was buried at sea from the *Oriental*, the painting depicts, nearly lost in a burst of fiery light behind the funnel stack and paddle box, the lowering of the artist's body into the ocean. But despite Turner's sincere response to this specific event, the painting is foremost a dramatic visual realization of an early Victorian oceangoing steamer complete with enor-

FIGURE 23. J. M. W. Turner, *Peace—Burial at Sea*, 1842. Oil, 87 × 86.7 cm.
© Tate Gallery, London.

mous side wheel, smokestacks, and sail-draped masts. With the exception of
this oil, Turner confined his pictures of steamboats to the far more ubiquitous
river or coastal steam craft. He did not embark on any long sea journeys dur-
ing his career, so it was unlikely that he had much firsthand experience of a ship
of this dimension. Yet the creator of *Picturesque Views on the Southern Coast*

and *Ports of England* would almost certainly have seen many examples of these great steamships during his extensive travels.

Steam-powered ocean travel developed slowly during the artist's lifetime. Although a steamer crossed the Atlantic as early as 1819, this feat had been accomplished under sail, with steam-driven paddle wheels only supplementing the wind. As late as the 1830s, significant problems still remained to be solved before mechanization could fully come into its own on the high seas, and not until after midcentury could steamers efficiently carry freight as well as passengers.[122] The heavy engines in the early oceangoing vessels retarded motion (because of the increased draft they produced), took up an inordinate amount of space, and required a huge supply of fuel. One engineer at the time estimated that the requisite machinery and its coal occupied as much as three-quarters of a ship's below-deck space. Consequently, steam could serve as the sole source of power only on trips of less than three weeks. Moreover, it remained essential to employ "the wind . . . as the principal moving force," with steam used "in those cases, where the failure of the wind or of its being contrary, would cause delay."[123] Important advances in steamer technology by 1838, however, enabled ships like the *Sirus* to cross from Cork to New York in just over eighteen days under continuous steam and Isambard Kingdom Brunel's *Great Western* to make the same voyage in fifteen days, thanks to its superior hull design and its innovative Maudslay, Sons and Field engines.[124]

The *Oriental* was characteristic of this formative period in steamship history. Constructed of wood at Glasgow and originally intended for the Atlantic steam trade, she was the 1,787-ton pride of the newly formed Peninsular and Orient Steam Navigation Company, offering, in Wilkie's words, "splendid accommodations."[125] The Peninsular and Orient line inaugurated weekly steam service between Falmouth and Gibraltar in the late 1830s and in 1840 extended operations across the Mediterranean to Alexandria.[126]

Wilkie, returning from a journey to the Levant, died on board the *Oriental* on 1 June 1841, and the crew consigned his body to the water off the Spanish coast late that same day (quarantine regulations at Gibraltar prohibited a burial on shore).[127] Turner, like other artists, marked the passing of his friend and fellow Royal Academician with a painting, choosing as his vantage point the deposition of Wilkie's body "as it must have appeared off the coast."[128] Turner may not have actually seen the ship he placed at the center of his finished composition, but details of Wilkie's ocean burial had appeared in the press, sparking much discussion in the months that followed.[129] Had Turner required a specific visual guide to the ship's appearance, there were at least two prints available to assist him: W. Jefferson's *Peninsular and Oriental Steam Naviga-*

FIGURE 24. W. Physick after N. J. Kempe, *The Steamship "Oriental,"* 1840. Colored lithograph, 13.4 × 22 cm. National Maritime Museum, London.

tion Company's Steam Ships at Sea and N. J. Kempe's *Steamship "Oriental"* (Fig. 24), both from 1840. Each pictured the ship in full profile, as did *Peace*, but Turner made his steamer more dominant by emphasizing the vertical elements of masts and smoking funnel while at the same time reducing the length of its hull. The almost square dimensions of the canvas underscored these aspects.

Although *Peace* has been variously interpreted, little has been said about its relationship to early nineteenth-century marine technology or the artist's romantic interest in industrialism.[130] Ultimately, the image of a great, dark steamer overshadows the burial. As the writer for the *Art-Union* put it at the time, "In substance, this picture is only a steamboat temporarily at rest. . . . As to 'Burial at Sea,' the spectator must imagine that."[131] Wilkie's funeral attracts only faint notice in the midst of the confused torchlight at the ship's side. The incident might have been entirely forgotten had the work not been billed as a memorial to the dead painter and had Turner not attached to it the verse lines:

> The midnight torch gleamed o'er the steamer's side
> And Merit's course was yielded to the tide.[132]

Turner presents the steamer both objectively and subjectively. He delineated the outlines of a typical seagoing steamer of the early 1840s, a recently constructed hybrid of two eras. Masts, hanging canvas, and schooner profile underscore the ship's transitional character—still evolving from total reliance on sails.[133] The great funnel, with a smaller venting apparatus nearby, appears above one of the two huge paddle wheels (the screw propulsion pioneered by Brunel still lay in the future). The large trail of black engine smoke blown off to the left forms a lively counterbalance to the limp sails characteristic of traditional navigation.

Turner's painting of this stark yet splendid steamer reflected the same awe and captivation with new technology as did much of the writing of the period but little of the art. His haunting, nocturnal image resembles the "great dark mass" of a packet steamer described by Dickens while en route to Boston that same year, 1842. Turner's *Oriental* also recalls the reverential description of the *Great Western* as it steamed through New York harbor in the spring of 1838, a "huge thing of life, with four masts and emitting volumes of smoke. She looked black and blackguard . . . rakish, cool, reckless, fierce, and forbidding in somber colours to an extreme." A traveler drawn belowdecks to the engine room of an Atlantic liner in 1847 observed the "glow of fires and piles of coal, and black, vulcan-like-looking men, replenishing and stirring the fires with enormous implements of iron seemingly too ponderous for human strength to manage."[134]

The *Oriental*'s uncompromising blackness strikes out powerfully, heightened by Turner's highly original compositional device of "massing . . . darks around a central light."[135] This concern with the rich, pervasive coloring of darkness seems to have developed in tandem with similar experiments involving the communication of intense, direct sunlight. In *Regulus* of 1837 (Tate Gallery, London), Turner mixed broad areas of yellow and white paint to approximate the solar energy that can transform an entire environment. In one sense the color black symbolizes bereavement over the loss of a fellow artist whose final disposition shows up illuminated by the fiery light. But the ship, with its mechanized power, readily lends itself to this achromatic treatment, emerging as the key temporal element in *Peace*. The reviewer for the *Times* of May 1842, for whom Turner had succeeded too well, wrote sarcastically of the *Oriental* as an "object resembling a burnt and blackened fish-kettle."[136] Yet its commanding character as a machine is precisely what succeeds, setting it apart from the earlier *Dover Castle* steamer—essentially a simple wooden boat with prosaic funnel pipe and side wheel—and demonstrating Turner's mature understanding of technological power and how to communicate it.

FIGURE 25. J. M. W. Turner, *Seascape with a boat*, c. 1835? Watercolor, 14.2 × 19.3 cm. Sheffield City Art Galleries.

Rendered as a silhouette, this steamer stands aloof from its moonlit surroundings in its bold blackness, a "sublimity of darkness,"[137] of which Turner was very proud. "I only wish I had the means to make [the sails] blacker," he is said to have remarked. Indeed, the opportunity to experiment with black, a color not conspicuous in his work, may have been one reason for his pronounced interest in steamers.[138] The black in this painting points to the Industrial Revolution as much as to human mortality, marking the achromatic effect of encrusted soot from long, active mechanical service. Early steamers were notorious for this ever-present covering of filth.[139] Over time the heavy smoke, which rises thick out of the *Oriental*'s center as it prepares to depart for England,[140] would have left a vile residue everywhere, from hull and masts to the sails, which hang flat and limp as if laden with some weighty foreign matter.

The bright flame in the midst of all this darkness provides a focus for the disposition of Wilkie's body. At the same time it becomes emblematic of the rest-

less yet hidden power of the great ship's engines, the harnessed dynamos of modern technology, at the boat's heart. A vortex of sorts produced by the painting's original octagonal shape (the corners of the canvas were folded under the frame) helps direct the eye toward this area. The torchlight reveals some of the elements of this energy—the side wheel and the smoke and steam stacks, one of which is crowned with a faint crimson flame. Smaller touches of white and yellow on deck suggest a connection to the myriad activities confined behind the thick wooden hull, the mechanical life and energy that counterpose the extinction of Wilkie's artistic energy.[141] In earlier works Turner had similarly developed this idea of controlled technological power, defined in dark, iron-clad or brick-lined chambers. He placed a speck of light just beneath a billowing funnel of the somber, generalized steamer in the 1832 oil painting *Staffa, Fingal's Cave* (see Chapter 3), while in the circa-1835 watercolor *Seascape with a boat* (Fig. 25) he painted a steamboat enveloped in deep, cool blue tones but punctuated at the side by touches of orange light that indicate inner activity.

Turner used the steamer in *Peace* to symbolize death in a wholly modern sense. Advances in the development of steam technology had not been achieved without attendant disasters and loss of human life; during the 1830s alone, over five hundred fatalities were associated with steamer accidents, most resulting from wrecks, collisions, and exploding boilers. Many had indeed been spectacular, such as the loss of the *President*, which in March of 1841 disappeared in an Atlantic storm with 136 aboard.[142] Turner would have known of such calamities, and he was especially attracted to those in which modern steam technology succumbed to the fury of nature. Some of his most provocative steamboat paintings probed this theme.

3

Humanity and Nature

in the Steamboat Paintings

At the 1829 Royal Academy exhibition Turner presented his *Ulysses deriding Polyphemus—Homer's Odyssey* (National Gallery, London). This radiant, golden canvas illustrated one of the most famous stories of the Greek epic, that of the final encounter between the Ithacan king Ulysses and the terrible Polyphemus. At the same time it put forth a theme of fundamental concern to the painter, that of human arrogance and the folly of challenging superior cosmic forces. Here Ulysses (in the Alexander Pope translation used by Turner) proceeds to make good his escape from the island and its deadly inhabitant. Sailing his ship toward the other Greek vessels and eventually the open sea, he heedlessly mocks the Cyclops, disregarding his crew's entreaties not to further provoke the still-fearsome creature.

> But I, of mind elate, and scorning fear,
> Thus with new taunts insult the monster's ear.[1]

Not only does the enraged Polyphemus nearly swamp Ulysses' ship with the water thrown up by huge rocks he hurls from above, but he also utters a curse that will doom Homer's hero to the many disasters that make up the rest of the story. Ulysses' "deriding" of this superhuman figure, this manifestation of the combined forces of nature,[2] exemplifies a human challenge to the elements that Turner would explore in a notable group of paintings of threatened steamboats executed during the 1830s and 1840s.

The arresting, ubiquitous steamboat, so much the tangible emblem of early nineteenth-century mechanical prowess, became for Turner the ideal subject for

reaffirming, in pointedly contemporary terms, his belief in nature's incomprehensible supremacy over humanity. Unlike the era's many technophiles, who blithely predicted steam's triumph over wave and storm, Turner realized that recent nautical advancements offered no truly effective antidote to environmental calamity. By depicting steamboats in a variety of perilous situations, he issued a telling corrective to the inflated optimism of the time. Regardless of Turner's demonstrated attraction to these machines, in his view they, like all invention, had to submit to nature's unfathomable plan. Throughout his career he explored the theme of maritime danger in canvases that featured storm-tossed packets or tragic shipwrecks. Steamers, with their promising mechanical capabilities, heightened the drama of this timeless struggle.[3]

That powered navigation could not significantly overcome the dangers of water travel became obvious to many at the very time that the benefits of steam received widest attention. Despite notable gains in speed, maneuverability, and comfort, disasters continued to occur, attracting great public interest. Press reports, artists' illustrations, and entertainments for the masses, such as London's *Eidopusikon* and *Diorama,* confirmed this repeatedly. One of the more spectacular steamship disasters to grip the public's imagination took place in 1831, when the Liverpool-based steamer *Rothesay Castle* broke up in a gale, with the resultant loss of over one hundred lives.[4] The following year, Ackermann published a print by Joseph F. Ellis of the steamer on its side off a rocky, moonlit coast, awaiting its demise (Fig. 26). Turner probably knew of this widely reported event, in addition to similar occurrences, and, like the popular illustrators whose work he often amplified, he found such incidents suitable subjects for his art. By the early 1830s he had begun a series of oil paintings and watercolors that pondered the operation of steamers amid various hazards.

Wreckers,—Coast of Northumberland, with a Steam-Boat assisting a Ship off Shore (Plate 3) brought this theme before the public in a painting that was widely exhibited. In this oil Turner built on his knowledge of stormy seas, which he had portrayed earlier in paintings such as *Fishermen upon a Lee-Shore, in Squally Weather* (1802; Southampton Art Gallery, Southampton) and *The Shipwreck* (1805; Tate Gallery, London). Only now he added the modern factor of mechanized power, a topic he was investigating at this time in his two Seine books. This dramatic 1834 canvas pictures clearly, in a sunlit area, a group of "wreckers"—specialists in plundering cargo from distressed ships—on the beach, struggling with assorted debris that has been washed ashore. Nearby a two-master seems carried by wind and tide precariously close to the deadly rocks at the base of Dunstanborough Castle.[5] Further in the distance a small but distinct steamboat can be seen, emphasized as a clear manifestation of self-

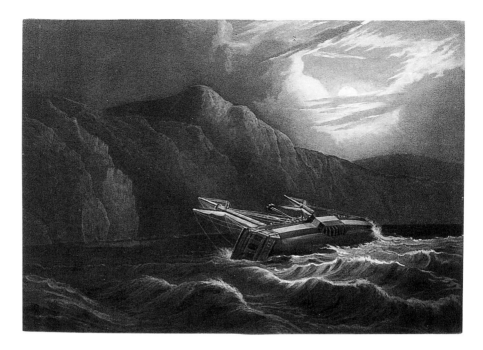

generating human energy. Turner placed this "assisting" steamer off to the right, in a darkened half of the canvas, ingeniously etching its form and atmospheric discharge on the somber horizon by whitening its black, metallic surface with the reflected light of the vanishing sun, which continues to illuminate the shore and castle in the left half of the painting.

This oil drew on Turner's familiarity with the character of England's northeast coast. He knew Northumberland well, having paid earlier visits to Alnwick and Holy Island. He painted Dunstanborough Castle on at least four separate occasions.[6] In September 1822 he traveled by sea past the castle, and at the end of the decade painted a watercolor that, unlike the later oil, focused squarely on the old fortress. It was engraved for the *England and Wales* series.[7] *Wreckers* may have come out of an 1831 journey, his return from a highly fruitful visit to Scotland, where, incidentally, he had traveled on steamers and portrayed them in his work. In fact, Turner might have exhibited *Wreckers* in 1834 in part to remind the public of his Scottish activities, much in the way that *Staffa* did two years earlier, as we shall see. The final volume of Sir Walter Scott's *Poetical Works*, with illustrations by the artist, had been issued just a month earlier.[8]

Turner may have taken a steamboat from Leith on 18 September, because he was in London by the 23d.[9] By the early 1830s regular steam packets to the northern kingdom had become popular with visitors, who, according to one period guidebook, had come "to prefer this mode of travelling to the more fatiguing conveyance by coach." Steamers hugged the shoreline, thereby revealing the "bold and imposing nature of the East Coast,"[10] where the splendid castles of Lindisfarne and Bamburgh, just north of Dunstanborough and recently famous as the subjects of two illustrations in the 1822 volume of Daniell's *Voyage Round Great Britain*, stood guard high above the sea. On his progress south, Turner could have seen or heard about an incident similar to the one depicted in *Wreckers*. Shipwrecks occurred regularly in this area, especially off the Farne Islands, a few miles north of Dunstanborough. Here the steamer *Forfarshire* met its end in 1838, an incident remembered for the rescue work of Grace Darling.[11]

Turner presented *Wreckers* to the Royal Academy along with four other works on favorite topics—a Venetian scene, two classical compositions, and one other English view. The fact that three of these paintings were about as large as *Wreckers* implies a desire to elevate a machine subject to the same level as more familiar fine art themes. For the first time, Turner underscored the all-important presence of recent technology by including the identification "steam-boat" in the title. He would exhibit the work twice more during his lifetime: in 1836, at the British Institution, and in 1849, at the Royal Scottish Academy. It eventually found an appropriate buyer in Elhanan Bicknell, shipowner and whale-oil merchant.[12]

Wreckers did not have difficulty winning favor with the critics, who accepted the steamboat's notable inclusion in what was otherwise a type of marine painting familiar in both British and earlier Dutch art. For most, Turner had succeeded in communicating the essentials of a highly dramatic occurrence. The writer for *Arnold's Magazine* saw it as an intensely believable example of a tragic incident, while the *Literary Gazette* praised its strong overall impact, born of a realism grafted to a "high imaginative quality, that imparts an interest which mere imitation can never excite." For the *Examiner* reviewer, who called attention to the "shadowy sublimity of the entire effect," the human elements presented the chief interest, especially the dichotomy between "the anxiously striving wretches on the beach" and the steamer, the "one glimpse, . . . of humanity in the distance." Yet the steamboat, instead of acting the role of savior, added the final note of despair, for this "struggling light . . . is soon itself to be quenched by the storm."[13]

Steam power here is caught in an overall conception of natural disaster, as if introduced into this broad panorama to complete an arrangement of three clas-

sic stages of maritime destruction: first an offshore ship (the steamer) meets the storm's fury, then a second vessel is carried to the rocky shoreline where it is about to break apart, and finally, dismembered pieces are pulled onto the beach by scavengers. Little in the work suggests that the presence of mechanized aid will alter this pattern of doom. Turner placed the steamer in the distance, isolated beneath a frightening black sky, its smoke and steam pushed landward by the increasingly ominous storm. Its stern, just visible against the stark backdrop, could be linked by cable to the ship in distress. Yet it does not seem to be offering aid, and the painting's turbulence gives the impression that the steamer will soon abandon its mission of mercy if it, too, hopes to avoid running aground.

A more concentrated examination of the steamer's battle with nature is *Staffa, Fingal's Cave* (Plate 4), a painting that occupies an exceptional place in Turner's oeuvre. The painter's first exhibited oil to include a prominent steamer, it premiered the machine-versus-nature theme on canvas.[14] Shown at the Royal Academy two years before *Wreckers*, it may also have been the earliest of his works to elicit specific critical comment about this new nautical technology. Turner remembered the circumstances of *Staffa*'s inception in a letter written some time later to its American purchaser that reveals much about the artist's emotional involvement with this remarkable steamboat journey. Painted on the same scale as *Wreckers*, *Staffa* accorded greater visual prominence to the steamboat, which here occupies a salient narrative and symbolic role. Turner placed it between the Staffa cliffs and the setting sun, in front of a gray-black pillar of clouds. Its limpid, serpentine engine smoke points up toward the illuminated island at the left and then drifts down in the direction of the yellow sun just above the horizon.

Staffa recorded the artist's 1831 visit to the west coast of Scotland, an area famous for its turbulent seas, changeable weather, and notable literary and geologic landmarks. This trip was part of a wider excursion to collect material for an edition of Scott's *Poetical Works*. *Staffa* may have been intended to kindle public interest in the project and perhaps boost book sales.[15] Ever alert to innovations in transportation, Turner planned to make use of the newly available steamer service to alleviate "much of the difficulty" in touring the remote Western Isles.[16] Possibly he was acquainted with one or more of the era's travel guidebooks that trumpeted the benefits of recently introduced steam communication. *Lumsden & Son's Steam-Boat Companion* (1831), produced for the benefit of travelers in Scotland, stated in its introduction that steamers (along with improved roads) "diminished, if not wholly removed, those obstacles which formerly caused a tour in Scotland to be considered irksome and laborious."[17]

For his west coast excursion, Turner booked passage on a steamboat at Glasgow and ventured first to Oban, then to Mull, Skye, and Staffa, and then prob-

FIGURE 27. J. M. W. Turner, *Dunstaffnage*, c. 1833. Watercolor and gouache,
12.1 × 15.2 cm. © 1997 Indianapolis Museum of Art, Gift in memory
of Dr. and Mrs. Hugo O. Pantzer by their children.

ably back to Oban. A few miles north of this port he may have steamed past
Dunstaffnage Castle, a historic site easily visible from the water.[18] The circa-
1833 watercolor *Dunstaffnage* (Fig. 27) resulted partly from sketches made at
the time of the trip;[19] it confirms the fact of steam access in this rugged area.
Despite its position at the left edge of the page, the dark steamer stands out, its
precise vertical chimney giving off a broad patch of smoke that is blown sharply
landward, toward the ruined castle, thus linking the modern offshore traveler—
perhaps Turner himself—with the picturesque historic site.

Recent technology improved transportation to the more distant parts of the
windswept Inner Hebrides also—to Iona, with its ancient Christian ruins, and
especially to Staffa, that tiny island of sculpted black rock described by Scott
as "one of the most extraordinary places I ever beheld."[20] It figured in Scott's
Lord of the Isles, several lines from which Turner attached to his exhibited paint-
ing, as well as the earlier Ossian poetry of James Macpherson. Such literary as-
sociations were a magnet for educated early nineteenth-century travelers, as was

the island's peculiar geological character: Felix Mendelssohn made the journey in 1829, an experience that gave rise to the turbulent music of the *Hebrides Overture*, while Wordsworth left four poems recalling his Staffa visit in 1833.[21] To the people of this age, Staffa represented wild, curious, monumental, capricious nature.

Fingal's Cave figured prominently in the 1818 volume of Daniell's *Voyage Round Great Britain*. The text for this book called the interior of the cave "grand beyond description," its creation being far beyond human capability and understanding: "Here nature has shown, that, when she pleases, she can set men at naught." By 1831, after the introduction of powered navigation, the author of *Lumsden & Son's Steam-Boat Companion* would write of the same humbling effect: "When the boat approaches close to it, the beholder is, for some time, either lost in silent admiration and wonder, or utters some involuntary ejaculation expressive of his feelings." Turner did not attempt to match these words but instead produced simply what Ruskin later called an "accurate" view of the interior, small and precise in its concern with detail, and noticeably lacking in grandeur.[22] It was engraved by Edward Goodall and published in Scott's *Poetical Works*.

The surging waters surrounding Staffa added to the rock's allure. Daniell had called attention to the "remoteness of the place, and the difficulties to be apprehended from the precarious state of the weather in these seas," specifically, "sensations of terror . . . produced" by the "rolling of an agitated sea among the rocks and caverns." Rough seas had characterized Mendelssohn's trip and, in the previous century, had prevented Samuel Johnson and James Boswell from alighting on the island. Steam transport did not eliminate such risks. *Lumsden & Son's Steam-Boat Companion* reminded its readers that "even in the calmest weather, it is sometimes difficult to land" because of the surging waves.[23]

Nature evidently played havoc with Turner's steam journey to Staffa in 1831. *Staffa, Fingal's Cave* reveals the intense individual reaction of an early nineteenth-century man who, despite his reliance on the most up-to-date marine technology, found himself in significant peril before the onrush of the elements. His painting *Life-Boat and Manby Apparatus going off to a Stranded Vessel making Signals (Blue Lights) of Distress* (1831; Victoria and Albert Museum, London) spoke to his interest, at this time, in new methods of reducing the dangers of sea travel. The actual event that served as Turner's inspiration for *Staffa* must have been profound, because fourteen years later he could still recount the genesis of the painting to its American purchaser, James Lennox, the philanthropist son of an immigrant from Kirkcudbright (on Scotland's west coast), in a letter filled with arresting detail:

We left the Sound of Mull in the Maid of Morven [steamer], to visit Staffa, and reach Iona in due time; but a strong wind and head sea prevented us making Staffa until too late to go on to Iona. After scrambling over the rocks on the lee side of the island, some got into Fingal's Cave, others would not. It is not very pleasant or safe when the wave rolls right in. One hour was given to meet on the rock we landed on, a vote was proposed to the passengers: 'Iona at all hazards, or back to Tobermory.' Majority against proceeding. To allay the displeased, the Captain promised to steam thrice round the island in the last trip. The sun getting towards the horizon, burst through the raincloud, angry, and for wind; and so it proved, for we were driven for shelter into Loch Ulver, and did not get back to Tober Moray before midnight.[24]

Turner's letter points to the dangers in the cave and, what is more consequential, the steamer's battle with the sea and the weather. His words sum up all the romantic fears of the elements: intimidating waves and a sun endowed with the human qualities of anger, the bringer of a wind soon to be furiously unleashed against humanity. Much like Ulysses in the 1829 painting, the steamer taunts nature by chancing several circumnavigations of the island and its Cyclopean cavern. On the canvas these features receive strong amplification, with sky, rocks, and sea bulking large and the feeble human presence registered only by the diminutive steamer.

Although Turner recalls traveling on the *Maid of Morven* to Staffa, that vessel usually operated only on the route from Glasgow to Oban.[25] Still, the memorable *Maid of Morven* may have provided Turner with a prototypical steamboat for his painting. It would attract the attention of another traveler to western Scotland just a few years later. George Head, during his second "home tour," met the boat at Glasgow. Before he saw it, its "poetic appellation" had led him to imagine an elegant craft, "an airy swan-like galley." Instead he found a dirty and crowded vessel, "a very Cinderella in her working dress—as black as a Newcastle collier," which "bespattered the passengers' clothes with her spare steam." The somber energy that Turner had portrayed was evident as the ship carried Head down the Clyde, "with the sounds of puffing, blowing, and panting of the engine, and the sights of ashes, fire, and smoke."[26]

Turner accented many of the characteristics that Head found so loathsome, and in the process made a virtue of steam, smoke, movement, and blackness, pitting them against larger counterparts in nature—Staffa's great basaltic cliffs, the ocean's swelling water, the huge, onrushing clouds bringing darkness and rain. The steamer's chromatic character contrasts vividly with the various shades of brown-black sea and somber gray clouds, all rendered as generalized forms,

each of which, in its own way, conveys a sense of enigmatic power that would be less effective were this self-propelled vessel absent.

The *Maid*'s mechanized animation comes through in horizontal touches of white on both sides of the boat to show the churning of the paddle wheels, with like-colored water splashing off the bow. A slight daub of crimson just beneath the smokestack signifies more than the "human life and activity" or "an alternate sun" alluded to by recent writers.[27] Rather, this fire suggests the workings of mechanical power (as it would later in *The Fighting "Temeraire"* and *Peace*), the coal-burning below deck that drives this vessel through choppy water, rendered all the more mysterious and engrossing when hidden from view. Such "vivid fires," in the words of the reviewer for the *Morning Herald*, produce a "black off-spring" of thick, dense smoke[28]—remarkable in its volume, as if a sign that the steamer must tax its engines to the maximum in order to pull away hard and outdistance the storm. The long trail of smoke forms an arch echoed at the far right by the curves reflected around the sun and by the huge storm cloud extending from behind the steamer, up and over the island—a pattern that perhaps acknowledges the vaulting of the obscured Fingal's Cave of the title. An interplay of machine and nature emerges in the juxtaposition of the steamer's vertical funnels, "that special architecture of the technological age," with Staffa's "columnar structure" of basalt and the shape of the "dark-edged storm-cloud. . . . echoed in the banner of smoke from the steamer."[29]

The superiority of nature over human beings remains, however, the ultimate message. The setting sun, whose broad, deep radiance contrasts with the slight red light on the steamer's deck, has the power to turn the engine smoke at the left a light tan and the island's black cliffs a combination of white, brown, and light blue. (The sun in *Wreckers* would similarly transform that steamer.) Critics who saw this painting in May of 1832 found that the combination of these various components produced "a fine mixed effect" and even a feeling of "wild grandeur."[30] Certainly the work's overall impact benefited enormously from the inclusion of the steamer, which then set the stage for the penetrating encounter between nature and machine—two powerful sources of energy: one current and blithely assured, the other eternal and omnipotent. The vessel inspires little confidence as its twin paddle wheels feverishly churn the water in a struggle to evade the uncertainty of a stormy evening: "cutting its way through the swelling surge," it may valiantly hold its own for the moment, but the full force of nature remains to be felt.[31] As Turner's letter made clear, however, the steamer eventually was "driven for shelter" to the temporary haven of Loch Ulver to wait out the storm before proceeding, behind schedule, back around Mull to Tobermory. *Staffa*, therefore, validated the twin aspects of Turner's romantic vision, reflecting

FIGURE 28. J. M. W. Turner, *The first steamer on Lake Lucerne,* 1841? Watercolor, 23 × 28.9 cm. College Art Collections, University College, London.

the vitality of early nineteenth-century technology while insisting on nature's grandiose terror—a trait that could oppose and overwhelm all human invention.

Turner further inquired into the steamer's encounter with hazardous weather in watercolors from the 1830s and 1840s. A drawing from a Swiss journey known as *The first steamer on Lake Lucerne* (1841?; Fig. 28) placed a small steamer in the distance,[32] dwarfed by surrounding mountains and threatened under a sky of swirling clouds, rendered with broad areas of thin, opaque coloring. Turner, the seasoned Swiss traveler, must have known the dangers that could beset powered vessels on this huge expanse of water. A contemporary guidebook warned: "[The] winds on the lake are singularly capricious and variable. . . . The most violent is the south wind, . . . which often rushes so furiously down the bay . . .

FIGURE 29. J. M. W. Turner, *Venice from the Laguna*, 1840. Watercolor, 22.2 × 32.1 cm.
The National Gallery of Scotland.

as to prevent the progress of any row-boat, and renders it doubtful whether even
a steamer will be able to face it."[33]

Venice from the Laguna (1840; Fig. 29) shared with *Staffa* the idea of im-
minent danger.[34] It depicts an intrepid steamer, its bow and forward sections
clearly outlined while its indistinct stern seems sunken to the waterline, press-
ing toward a storm on the lagoon. Leaving behind the still-sunny Venetian piers
to the right, it advances into the dark unknown. Small boats ahead, their sails
deeply bowed by the same rushing wind that blows the steamer's smoke and
steam back, flee toward land. At the left the sky is a deep, ominous blue. Clouds
have blocked most of the sunlight and turned the sea here black with streaks of
gray. Turner seems to predict trouble for the steamboat by pointing it toward
the converging diagonals in this somber-colored composition. The downward-
sloping storm clouds meet lines of black and gray radiating back to the right
over the water, whose turbulence is evoked by the vigorous cross-hatching of
light and dark brushwork at the lower left. The resulting vise-like arrangement

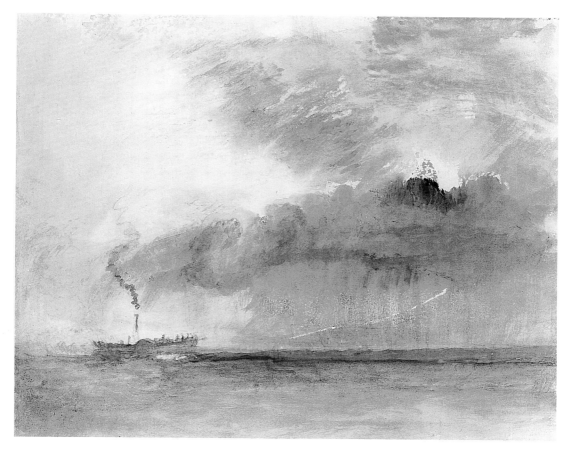

FIGURE 30. J. M. W. Turner, *Steamboat in a storm*, 1841? Watercolor, 23.2 × 28.9 cm. Yale Center for British Art, Paul Mellon Collection.

seems to draw the small vessel into its grip, to become part of a drama destined to be played out beyond the edge of the paper.

The watercolor *Steamboat in a storm* (1841?; Fig. 30) captures a more specific idea of anxious solitude on the open water.[35] The character of the vessel is apparent from the clear outline of its stack, paddle wheel, and brown superstructure, while upward-floating smoke and the white water churned alongside it attest to its mechanization. The forbidding storm cloud to the right, a purple-blue puffy mass that blocks the sun and rests on a pedestal of rapidly falling rain, adds a frightening element. Although still off to the distance, it appears to pursue the steamer. Its wind bends the floating engine smoke forward while a long bolt of lightning, scratched into the colored paper, darts along its pillared

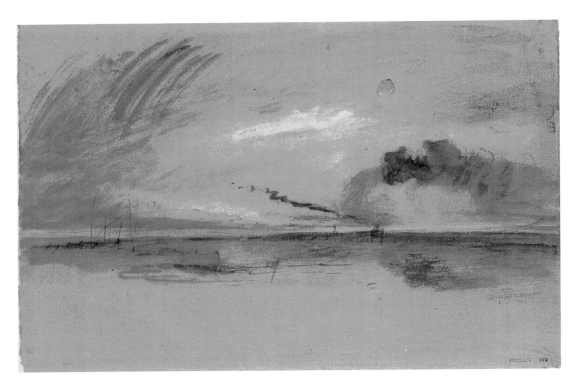

FIGURE 31. J. M. W. Turner, *Steamer at sea*, c. 1840. Watercolor, 19.2 × 27.3 cm.
© Tate Gallery, London, TB CCCLXIV-292.

base toward the departing steamboat (in a manner reminiscent of the thunder-bolt in *La Chaise de Gargantua,* from *Wanderings by the Seine, from Its Em-bouchure to Rouen*), as if reaching out to arrest the escape of the lumbering craft.

A similar sense of lonely vulnerability pervades the watercolor *Steamer at sea* (c. 1840; Fig. 31), which presents the steamboat as a tiny, boxlike form, rendered with touches of the same gray used for its smoke and the surrounding shadows on the water. It is discernible only by virtue of the faint outline of its funnel and the ever-present smoke trail. Overhead and to the right, a black cloud curves toward the ship, like some huge, grasping claw. The wind drives the engine's exhaust sharply to the left, while broad, dark shadows mark the surface of the water. The arched cloud, formed by monochrome dabs that are darkest at the top and opaque as it curves downward, casts its reflections on the sea, producing a giant ring of which the steamboat has become an unwitting element. Turner was fond of such vortices as a compositional device, which he

would develop to even greater effect elsewhere in his steamer studies. Here it points to the complex array of forces existing in nature, the various arrangements of elements from sky and ocean that can join to form new and terrifying configurations, entirely beyond human expectation and comprehension.

Rockets and Blue Lights (Close at Hand) to warn Steam-Boats of Shoal-Water (Fig. 32) amplified this theme in a new way. This 1840 oil is badly preserved today but was widely exhibited in its time: first in 1840 at the Royal Academy, then in 1841 at the British Institution, and finally in 1850 at the Royal Birmingham Society of Artists. At the Royal Academy it joined two other Turner paintings of contemporary interest, *Slavers throwing overboard the Dead and Dying* and *The New Moon* (see Fig. 19), along with classical and Venetian canvases. *Rockets and Blue Lights* considers the plight of steamers confronting foul weather, rough seas, and shallow coastal water.[36] Reminiscent of *Life-Boat and Manby Apparatus* in its familiarity with maritime distress signals and with *Wreckers* in its shoreline setting and distant smokestacks, this painting parted company with its predecessors by substituting atmospheric effect for clarity of detail. In this way Turner could take the viewer more fully into the midst of nature's chaos, a point reinforced in the similarly turbulent *Snow-Storm, Avalanche and Inundation—a Scene in the Upper Part of Val d'Aouste, Piedmont* (1837; Art Institute of Chicago), with which it was exhibited at the British Institution; that slightly larger canvas is dominated by generalized, curved patterns of white paint to simulate the downward crush of snow.

Although *Rockets and Blue Lights* has suffered harsh treatment over the years,[37] the subject matter is similarly vague in an 1852 chromolithograph copy (Fig. 33). Indeed, Turner produced sufficient visual confusion in the exhibited oil—wide swatches of thick white and brown-gray paint to create the tumult of swelling water, crashing waves, and streaked sky—to drive most of the contemporary critics nearly to despair. The writer for the *Morning Chronicle* found it "impossible to distinguish earth from heaven"; his counterpart at the *Spectator* likewise complained that "nothing is distinguishable." The role of technology in the scene seemed equally obscure. The *Athenaeum* critic thought the blue lights (the traditional signal of welcome haven) yellow and could identify only "a solitary stick or chimney" of one steamer, while the *Morning Post* jested that these lights "to guide steamers might more easily mislead them."[38]

The bewilderment these writers voiced comes from the depiction of machine power and natural power each churning out vast displays of energy in opposition to each other. The taxed steamers, in their desperate drive for safety, emit an enormous amount of engine smoke, which the wind twists and pulls upward into cyclonic patterns. Part of the funnel and mast of one ship appear in the dis-

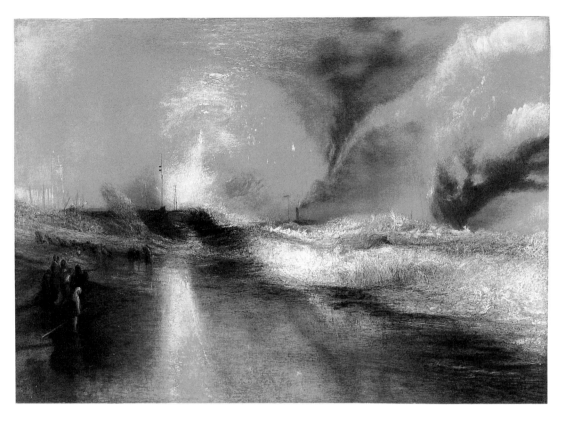

FIGURE 32. J. M. W. Turner, *Rockets and Blue Lights (Close at Hand) to warn Steam-Boats of Shoal-Water,* 1840. Oil, 91.8 × 122.2 cm. © Sterling and Francine Clark Art Institute, Williamstown, Massachusetts.

tance, while the other vessel seems almost lost behind a cresting wave to the right. Flares launched in aid from the shore illuminate the left center of the painting like a fire or sunburst. While some figures on the beach struggle to pull ashore bits of debris, a group of onlookers stand off to the left, immobile and apparently transfixed by the drama in which they are powerless to intervene.

The action of the steamers conferred a key modern element to the painting, raising the intensity of the drama while contributing to the most frightening aspect of the scene, the centripetal arrangement of smoke, steam, clouds, and water that the fury of nature has wrought. Turner applied sweeping areas of paint to create a vortex at the center of the canvas: the curved water at its base is drawn upward with the breaking wave to become an arch of reflected light against the sky; this light is then drawn over and down into the willowy smoke

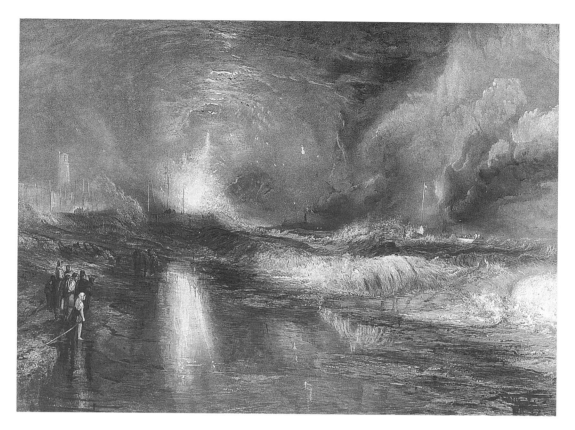

FIGURE 33. Robert Carrick after J. M. W. Turner, *Rockets and Blue Lights (Close at Hand) to warn Steam-Boats of Shoal-Water,* 1852. Chromolithograph, 76.2 × 57.1 cm. Yale Center for British Art, Paul Mellon Collection.

trail, returning finally to the sea, where the cycle repeats. With the funnel stack placed to the left of the floating smoke, it seems the steamer is about to be pulled into this whirlpool. Embryonic vortices appear to the right, as some of the steamer's smoke moves to meet the discharge of its sister ship, which sends its own smoke further to the right and off the canvas. This arcaded arrangement not only carries the viewer's eye across the horizon but also points to the location of the steamers. At the same time, the arched bridges encourage "the spectator [to fill] the void with his own definition."[39]

Nature as the steamboat's nemesis became a pronounced theme in Turner's work of the 1840s. This was the most abstract and imaginative phase of his career, a period during which he fully applied bold color and loose texture to communicate the intensity of nature's terrible power and humanity's perpetual

vulnerability. Vortices served an essential function in realizing this vision, providing a concepual framework for humanity's absorption into violent, all-consuming natural disasters. Although Turner had used vortex arrangements as early as 1812,[40] their renewed prominence and heightened intensity in his later work suggest a greater awareness of the actual workings of natural phenomena, born of years of keen observation. They further imply some familiarity with new discoveries about weather patterns that were gaining currency during this time.

The early nineteenth century witnessed decisive developments in meteorology, a scientific discipline that was to achieve full recognition only by 1830.[41] In 1833 the second edition of Luke Howard's pathbreaking *Climate of London* appeared, charting in detail the weather of the city. Howard's observations won considerable fame and influenced both Goethe and Constable. Other works published at the time concerned more dramatic weather, chiefly the behavior of severe storms at sea, many of them characterized by vortex configurations. James Capper, at the beginning of the century, had written on the circular nature of storms, and in the 1830s and 1840s the American William C. Redfield and the Scot Sir William Reid suggested consistent patterns for these dangerous rotary movements of atmosphere.[42] Although such investigations were predictably arcane and largely confined to the pages of scientific publications,[43] discussions highlighting the fruits of this research found a wider audience in some of the less specialized, but learned, journals of the day.

An extended article on these storms appeared in the *Edinburgh Review* of 1839. Written by David Brewster, it adopted the manner of an ever-hopeful Victorian, certain in the belief that an understanding of the weather could ameliorate the human condition. To Brewster progress in this field was long overdue: "It is mortifying to the pride of science, and a reproach to every civilized Government, that we know so little of meteorology," he wrote. Yet the situation still existed in which "man trembles upon his own hearth, the slave of terrors which he cannot foresee, the sport of elements which he cannot restrain, and the victim of desolation from which he knows not how to escape." Acknowledging that pioneers like Reid and Redfield had not "succeeded in discovering the origin of these scourges of the ocean," he still saw some limited attainment in the ability to "deduce infallible rules, if not to disarm their fury, at least to withdraw us from their power." Such judicious retreat, born of improved knowledge, left Brewster optimistic enough about the prospects for modern humanity: "If the bolts and bars of mechanism cannot secure our sea-borne dwellings from the angry spirit of the storm, we may at least track his course and fall into the wake of his fury."[44]

Similar sentiments had wide currency,[45] but the *Edinburgh* essay is particularly important because it could have been seen by Turner, who enjoyed reading that journal especially. Turner also knew Brewster from an 1834 dinner meeting in the Scottish capital. In addition, the artist's residence in London, a city that had become the focus for discussion and demonstration of scientific and technological developments, gave him many other opportunities to learn of the latest advances in meteorology.[46] The Athenaeum Club, an organization dedicated to bringing together authors, scientists, and artists, could claim Turner among its original members. His associates in the scientific community, such as the chemist Michael Faraday, who served with Turner on a committee to examine proposals for purifying the water of the Thames, may have told him of the latest work on vortex storms; Faraday exhibited an interest in meteorology and evidently discussed aerial phenomena with Turner.[47] Turner also attended the soirées of the Royal Society, gatherings initiated at the end of 1830 to bring about the "useful intercourse of wealth and talent of men of rank and men of genius."[48]

On another level, some popular entertainments of the time, such as the National Gallery of Practical Science Blending Instruction with Amusement, presented an approximation of scientific knowledge to an enthusiastic public,[49] one which could have included Turner. All these contacts, together with his reading, no doubt sharpened Turner's existing interest in vortex weather patterns, presenting him with a far more precise picture of the workings of such systems than he would have otherwise had.[50] This awareness gives credence to the remark that Turner "visualized man as being dwarfed by immense forces over which he had no control but which nevertheless he had discovered."[51] Consequently, Brewster's article, especially his evocation of "the raging tempest" that "sweeps over the earth with desolating fury, driving beneath the surge, or whirling into the air, the floating or the fixed dwelling of man,"[52] as well as his citation of specific examples of horrific weather recently observed, would have greatly appealed to Turner.

Up-to-date meteorological data no doubt proved useful to Turner in two seminal works of the early 1840s: the watercolor *Yarmouth Roads* and the oil painting *Snow Storm—Steam-Boat off a Harbour's Mouth*. In the former (Fig. 34), a vessel is enveloped in a convergence of blue-green water and atmosphere at the extreme left of the paper. The long smoke trail takes the eye toward the machine source, although only the craft's stern and mast are discernible as it tilts headlong into the dark confusion, produced by the application of broad stains of color, on the crest of a wave. At the same time the steamboat confronts a further, more potent, expression of nature's energy in the vortex.[53] Elliptical in this

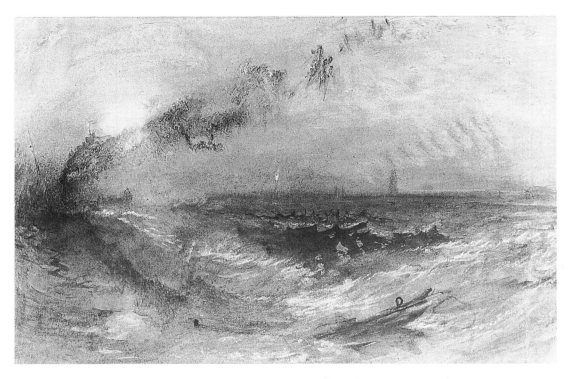

case, the form consists of the wind-driven smoke moving from the left upward, where it intersects with the more gentle downward diagonals of the distant clouds, which in turn take the pattern down to the sea and on to the deep trough of water that swings back upward on a wave to carry the boat off to the left. This last section also carries a grim reminder of humanity's fragility: in the center foreground floats a section of wooden wreckage, with wrought-iron eye-screws protruding above the surface, a small but potent focus in the overall arrangement. As in the earlier *Wreckers*, Turner sets up a cycle of nautical demise: here the sunlit shore and the lighthouse, representing safe haven, fade behind the steamer in distress and the fragment of debris.

Turner's investigation of the steamer's battle with nature culminated in the 1842 painting whose full title is *Snow Storm—Steam-Boat off a Harbour's Mouth making Signals in Shallow Water, and going by the Lead. The Author was in this Storm on the Night the "Ariel" left Harwich* (Fig. 35). This work came at the end of a roughly three-year period during which he examined

FIGURE 35. J. M. W. Turner, *Snow Storm—Steam-Boat off a Harbour's Mouth making Signals in Shallow Water, and going by the Lead. The Author was in this Storm on the Night the "Ariel" left Harwich*, 1842. Oil, 91.5 × 122 cm. © Tate Gallery, London.

steamers in various guises, either as powerful agents of change (*The Fighting "Temeraire"*) or as threatened vessels (*Rockets and Blue Lights*). It matched closely the dimensions of *Staffa, The Fighting "Temeraire,"* and *Rockets and Blue Lights*. It reached the Royal Academy in the company of that other prominent steamboat painting, *Peace—Burial at Sea*. While analysis of the latter usually provokes comparison with its companion, *War. The Exile and the Rock Limpet* (Tate Gallery, London), Turner might have intended it to be considered with *Snow Storm*, to contrast its great, dark, smoking, stationary machine with another, smaller, powered vessel ensnared in an environmental nightmare. *Snow Storm*, like *Peace*, also represents Turner's high emotional involvement with his subject. According to its title, *Snow Storm* drew on an experience in the artist's life; he even claimed he was tied to the mast to feel the full effect of the hazard. This autobiographical reference has been largely discounted, as has the existence of a Harwich packet christened *Ariel*, which may instead refer to Shakespeare's *Tempest* and "the mechanical magic of steam locomotion" or to the ship that brought Prince Albert to England in 1840.[54]

Although Turner could have "invented a story (with himself as hero), of which this picture is an illustration,"[55] his considerable experience at sea (often on steamboats) should have left him with enough harrowing memories to make such a painting ring true. Such subjects were also highly popular at the time, especially in the hands of illustrators and proprietors of dioramas and theaters. The artist Stanfield, Turner's friend, had long been associated with staged amusements that often depicted steamers. The Egyptian Hall theater, which competed with Stanfield, featured in 1839 a "Pictorial and Mechanical Exhibition" of the wreck of the *Forfarshire*, complete with details of Darling's heroism.[56] On another level, *Snow Storm* continued Turner's interest in the collusion of technological enterprise and a natural environment now understood to be more threatening than ever, thanks to recent scientific speculation and observation.

Turner's romantic perception of sensational vulnerability also permeates the work—the feeling of danger faced and survived, the realization of human inadequacy, and the necessity to bear personal witness to the unique, stimulating event. The detailed title, anticipating in its gloom and defeatism Turner's 1845 letter recalling the genesis of *Staffa*, explains the scene's multiple hazards. While there could be little doubt that the canvas pictured a steamer in some distress, Turner implied further dangers, with the words about "the lead" and "making signals" adding concerns about going aground or colliding with other ships. But *Snow Storm*'s drama plays closer, in a more focused way, than that of earlier works, revealing salient details so that the viewer can feel heightened involvement and share more in the author's experience. The central subject, the

steamboat, receives unusually clear definition for a painting from this late in Turner's career. Its outline of brown-gray deck, smokestacks, pennant-topped mast, and most of all, its distinctive, semicircular paddle wheel, make its identity unmistakable. The turbulent sea, the snowstorm—a favorite theme for danger and disaster, building on earlier paintings, like the 1812 *Snow Storm: Hannibal and his Army Crossing the Alps* (Tate Gallery, London) and *Snow-Storm, Avalanche and Inundation*—obscuring visibility, a crew frantically trying to avoid shoals with "the lead" and "making signals" that become the bursts of light around the mast to warn off other ships or to seek aid, and the absence of any safe port or assisting vessel, all combine to raise the tension in the painting.

The vortex motif plays a decisive part in this work, giving truth to the view that "Nature entered Turner's work—or rather his imagination—as violence."[57] A vital element in the detailed chaos of the invading army in *Hannibal*, it now became more dominant and conceptual here and in two paintings of 1843, *Shade and Darkness—The evening of the Deluge* and *Light and Colour (Goethe's Theory)—the Morning after the Deluge—Moses writing the Book of Genesis* (both Tate Gallery, London). He used it adroitly in *Snow Storm* to create a vision not of an ordinary storm but of an extraordinary natural phenomenon, all-consuming in its power and destructiveness, what has been described as "the idea of Nature's eternity through cyclic continuity."[58] Turner united the individual forces of wind and water into one comprehensive configuration of sea, spray, snow, cloud, and smoke, an integration that creates systems new and more powerful than their separate, individual components. Before such a configuration, humanity becomes more helpless than ever. In the words of the 1839 *Edinburgh Review* article on storms, "man trembles, . . . the sport of elements which he cannot restrain," as the maelstrom entraps people and their technology, twisting and tilting all randomly toward the centripetal center, the hurricane's "eye,"[59] whose momentary calm (of blue sky and sunlight streaking the parallel slats of the paddle wheel) perhaps heralds a brief, tantalizing respite before the storm again lashes the vessel with even greater force. The vortex acts like a focus of intensity, somewhat in the manner of Turner's blazing sunsets or furnace fires,[60] except that here instead of blurred suggestiveness, specific details define the center.

The steamer's efforts at survival, more desperate visually than in the title of the painting, seem severely tested. The vortex pulls fire and smoke from the stacks of this frantically overtaxed machine, in the cyclonic manner of *Rockets and Blue Lights* or the watercolor *Fire at Fenning's Wharf, on the Thames at Bermondsey* (see Fig. 57), where the intense oxygen-absorbing combustion draws and twists a steamer's smoke into a similar funnel pattern. In *Snow Storm* the

semicircular paddle wheel (with several white, water-covered paddles just visible), partly obscured by darkness and foam, appears to turn furiously, and in so doing poses a weak counterpoint to the natural curves of the giant rings of snow and water that frame it.

At the same time the painting unites multiple perceptions into one convincing whole. The detailed steamer emerges from the distance, as if observed from a nearby companion vessel, while the whirling elements register the confusion of the terrified passenger on the heaving deck. Unlike *Rockets and Blue Lights,* which lacks cohesion because of its complicated theme of two steamboats, coastal onlookers, lighthouse, and aerial fireworks, as well as the obscurity born of the attempt to fuse all these elements into one narrative composition, *Snow Storm* is tight, direct, and enormously effective. Moreover, it points to an acute, novel understanding of the early nineteenth-century world.

The bedlam Turner communicated in this canvas won him bitter criticism from much of the press. One writer called the painting "soapsuds and white-wash," while the critic for the *Athenaeum* charged that Turner had executed it with his "whole array of kitchen stuff." The *Literary Chronicle* accused the artist, like the vessel portrayed, of "going by the lead." The arts reporter for the *Morning Post,* after terming *Snow Storm* laughable, did praise Turner's overall artistic vision: "Some new touch of nature has occurred to him, which he has introduced with all the freshness of studentship. It may be a failure, but still he looked for it in nature." Yet the abstractness so condemned by the critics may have produced the desired effect, even on unwilling eyes, of conveying the confused terror of the incident. *Blackwood's* commented sarcastically that if Turner had indeed been on the steamer "he may have been very nearly lost then, and quite lost afterwards," while the *Art-Union,* more to the point, expressed clear empathy with the unsettling scene so boldly communicated to the viewer: "Through the driving snow there are just perceptible portions of a steam-boat labouring on a rolling sea; but before any further account of the vessel can be given, it will be necessary to wait until the storm is cleared off a little. The sooner the better."[61]

As this last writer correctly understood, the painting concerned itself with the moment of ultimate vulnerability, not the eventual survival of painter and vessel, which may or may not have been due to steam power. Turner supposedly remarked, "I did not expect to escape, but I felt bound to record it if I did."[62] Modern technology seems to add nothing, at this particular point, to mitigate what one Victorian called one of the "most terrible phenomena of nature—a snowstorm at sea."[63] Indeed, Turner seems to have taken care that the viewer realize it is a steamer at the center of the storm, both by the title and by the de-

tails of line and color, which temper the painting's abstractness sufficiently to confirm the piteous envelopment of a modern, machine-powered vessel. Whereas sailing ships (such as the *Temeraire*) may represent "co-operation between man and nature,"[64] the steamboat, especially the one in *Snow Storm,* forsakes such harmony. Closely observed, this engine-driven mechanism competes desperately, yet in vain, against the vastly superior might of nature. The message is one of human ambition checked: "Rather than the industry encircling, controlling, and conquering the earth, elemental Nature . . . transcends and encompasses the project."[65] In *Ulysses,* thirteen years earlier, Turner had invited "a glimpse into the eye of annihilation."[66] In *Snow Storm* he took the viewer into the very heart of a drama that owed much of its potency, both conceptually and technically, to the presence of early Victorian technology locked in the grip of unyielding environmental forces.

4 Urban Industrialism

Leeds, Newcastle, Shields, and Dudley

The Industrial Revolution made its most consequential impact on the land. Steamers generated their share of excited comment and railroads would transform communication, but technical innovation and economic expansion occurred most noticeably in the mills, forges, and mines and amid the new urban sprawl that began to mark the map of Britain. In about 1808, Turner wrote some verse lines entitled "The Extended Town," pondering this dimension of the steam revolution in Regency England.

> The extended town far stretching East and West
> The high raised smoke no prototype of Rest
> Thy dim seen spires rais'd to Religion fair
> Seen first at moments th(r)o that World of Care.[1]

Awareness of the implications of change and the enlargement of population centers beyond traditional limits pervades these words, as Turner takes note of the workplaces of relentless and disciplined human endeavor, of potent machinery emitting soot and steam skyward in disregard of the ancient symbols of intemporal faith.

Turner probably composed this poem to describe his home city of London.[2] Yet it lends itself to broader application, for countless other British towns of the early nineteenth century experienced marked social and economic transformation when they took advantage of steam technology. Sheffield, Coventry, Dudley, and Newcastle all attracted this painter with their mix of prodigious industrial novelty and traditional setting, but his first vivid, urban panorama was devoted to Leeds.

Executed in watercolor (Plate 5), signed and dated 1816, and reproduced as a lithograph in 1823, *Leeds* presents a timely and detailed picture of early nineteenth-century industrial urbanism. In *Leeds* Turner captured the diverse vitality of a large, expanding city, one increasingly given over (especially on its periphery) to pockets of concentrated labor in great multistory utilitarian buildings, a busy workplace driven by the latest steam technology. Small wonder that this work has been termed "one of the richest images in British art of a sprawling industrial town in operation."[3]

The work surveys the valley of the River Aire, with Leeds pictured clearly on a broad central horizontal axis in a way that exposes its industrial development. By cropping the view abruptly at the left and leaving the area to the right open and partially hidden under a cloud of smoke, Turner suggests a city of almost limitless energy and scale. The Yorkshire hills act as both a backdrop to the urban sprawl and, at the base of the composition, a vantage point from which to study the full range of this remarkable agglomeration of human endeavor. The architecture of industrialism—boxlike mills, tall chimneys, furnaces, kilns— claims the viewer's attention, while the vestiges of traditional Leeds, with terraced residences and church spires appearing behind the workplaces, struggle to emerge from a sea of machine-generated pollution. The immediate foreground displays wide patches of green punctuated by isolated or clustered buildings, some of which sit along a meandering highway that climbs from the center of the picture to the bottom right corner; all await certain acquisition by the seemingly insatiable demands of swelling industry.

As preparation for this watercolor, Turner produced what Ruskin called one of the artist's "most minutely finished drawings" (Fig. 36), probably executed in September 1816, during one of the painter's frequent trips to the West Riding.[4] The final version added chromatic and atmospheric effects and confirmed Turner's preoccupation with the industrial landscape, to the virtual exclusion of other features of the locale. In clear focus stands the vast array of chimneys, tall, functional buildings, and squat, wide-mouthed structures, with but a vague outline to suggest the old city spread along the base of the distant hill. The most conspicuous feature of this backdrop is an assemblage of four church spires—"raised to religion fair"—identifiable, from left to right, as St. Paul's, Park Square; St. John's, Briggate; Holy Trinity, Boar Lane; and St. Peter's (Parish Church), Kirkgate. Just to the right of the central mill building, and also enveloped in pollution, stands the Wesleyan Chapel, Meadow Lane. This building, crowned with a triangular pediment, reflects another facet of modern Leeds: the growth of Methodism and the zeal of its inspiring leaders to meet the religious needs of a new citizenry, one less imbued with the established faith and less prone to conformity.[5]

FIGURE 36. J. M. W. Turner, *Sketch of the Town of Leeds*, c. 1816. Pencil, 16.6 × 36.6 cm. © Tate Gallery, London, TB CXXXIV-79 and 80.

Leeds's exuberant industrialism evoked considerable comment from a host of Turner's contemporaries. When the American Louis Simond arrived at Leeds from York late one March evening in 1811, what struck him immediately was the "multitude of fires issuing . . . from furnaces and constellations of illuminated windows (manufactories) spread over the dark plain."[6] Only slightly augmented when Turner saw it five years later, Leeds was a major center of the Industrial Revolution and a busy administrative and commercial hub of West Yorkshire life, a town that had grown from 53,000 in 1801 to between 70,000 and 80,000 by 1815.[7] Its position astride the River Aire, and the adjacent Aire and Calder Navigation and Leeds Canal, made it easily accessible to the ports of Goole and Hull in the east and, thanks to the Leeds and Liverpool Canal (completed in 1816), to harbors in the west.[8] The country surrounding Leeds abounded in the natural resources required by industry, including coal to fire steam engines and clay for the potteries and brickworks.

Mills for grinding corn and producing oil added to the manufacturing character of the city, as did glassworks and iron foundries—the first locomotive was constructed in Leeds.[9] Textile manufacturing accounted for some of the city's largest enterprises, including John Marshall's flax-spinning mill in Water Lane and Benjamin Gott's great wool factories at Armley and Bean Ing, not to mention his Burley Mill for blankets, located near Kirkstall.[10] Fittingly, when the American John Griscom appeared in Leeds a short time after Turner's visit, he made immediately for one of the city's newest landmarks, "a large cloth manufactory." One witness in 1815 described the prodigious new developments in wool-making: "At a manufactory I saw the different operations from the beginning to the finishing of a piece of cloth. The whole machinery was put in force by a steam engine which cost the proprietor one thousand guineas."[11] On adjacent sites wool would then be washed, cleaned, dyed, and finished. At the time of Turner's watercolor this industry had flourished by meeting production needs associated with the long French wars as well as the augmented clothing demands of domestic and foreign customers.

Like other emerging cities, such as Manchester, Birmingham, and Sheffield, Leeds had lacked importance during the previous two hundred years but was now among the largest towns in the country. The implications of this transformation stimulated a wide range of contemporary comment.[12] Edward Baines, using arguments consistent with this age of improvement, wrote a spirited defense of the modern industrial city in 1843. A leading figure in Leeds, Baines was the son and namesake of the local writer and publisher of the *Leeds Mercury*. His *Social, Educational, and Religious State of the Manufacturing Districts* answered those critics of the factory cities who, he believed, bore re-

sponsibility for the "general impression that the Manufacturing Districts are scenes of vice, ignorance, sedition, irreligion, cruelty, and wretchedness." While avoiding the temptation of pointing to "all the evidences of ignorance, immorality, and degradation which might be found among the rustics," Baines asked for a less superficial reading of settings like that portrayed in Turner's watercolor: "I admit that the Manufacturing Districts have a repulsive exterior. The smoke that hangs over them,—their noisy, bustling, and dirty streets . . . the hum and buzz of machinery in the factories . . . are little calculated to gratify 'ears polite,' or to please the eye accustomed to parks and green fields." Like so many other supporters of industrialism, he pointed to the progress embodied in such unsightliness: "Beneath this unpleasing exterior, there moves steadily on that energetic and persevering industry . . . *the main spring of all the foreign commerce of England.*"[13]

The greatest champion of the urban environment, however, was probably Robert Vaughan, a minister, historian, and professor of theology in Manchester and a man often cited by Baines, his contemporary.[14] His *Age of Great Cities* summed up his feelings about this singular aspect of his own times. For Vaughan, current scientific development, and its social and economic corollaries, was "irresistible"—fortunately so, because modern, enterprising cities would become synonymous with the "wealth and power of nations."[15]

Turner's conception of Leeds was very much the visual equivalent of the words of Baines and Vaughan: a community of energetic mechanization, one defined at its perimeters by great textile enterprises, structures that "epitomized the startling rapid progress of the Industrial Revolution."[16] A newly erected manufacturing belt, situated astride the river at the edge of the city, became the appropriate focus for Turner's watercolor. Here prodigious, functional buildings arose, for available open space permitted innovative construction as well as convenient expansion, and essential water transport for raw materials and finished goods was within easy reach. The artist drew several mills in revealing detail, accenting their tall, geometric forms, their flat, utilitarian exteriors, and their regimented fenestration patterns. Mill design derived from the requirements of production, with interiors described as consisting of "long galleries and rooms, filled with machines attended by operatives of both sexes and various ages."[17] Efficient use of space required that the mills, especially in the cloth industry, be high, long, and rather narrow—between thirty and forty-five feet wide. Machinery had to connect to a central power shaft, and workers needed access to a good external light source,[18] although the gradual application of gas lighting made this less essential. Turner's choice of color for the facades of the buildings was also based in fact. The mills' walls radiate a soft pink glow, indicative of

their ordinary brick construction (no doubt the bricks of local kilns)—unfaced by a more genteel stone and new enough to be spared the effects of coal soot.

Judging from the positioning of the mills and Leeds's four church spires, Turner chose for his vantage point a spot to the south of the city, on Beeston Hill.[19] Conventional from a compositional standpoint (see his watercolor *Oxford from Headington Hill* [c. 1803; Ashmolean Museum, Oxford]), the location served a current purpose. In the far left foreground, laborers carry out the tentering process, the drying of the wool after it has been worked and cleaned.[20] At the center of Turner's watercolor, just below and to the right of the pinnacle of Holy Trinity Church and to the left of the Methodist Chapel, stands the Benyon and Bage flax mill in Meadow Lane, Holbeck, of 1802–3;[21] a tall and imposing structure, it boasts dual chimneys and an all-important white clock tower—the symbol of the regimentation of the industrial workforce. Charles Fowler included the plan of this mill at the bottom center of his contemporary map that showed "the Recent Improvements."[22] In keeping with the latest technological innovations of the age, Charles Bage, an engineer and associate of the Benyons,[23] built it with "cast iron internal frames supporting vaulted brick floors." Thomas and Benjamin Benyon had been customers and then partners with Marshall, the pioneering flax manufacturer of Leeds, before they went their own way and built their mill in Meadow Lane, making them one of the area's leading flax producers.[24]

Marshall's mill was west of the Benyons', in the area to the left in Turner's watercolor—between the two towers of Holy Trinity and St. John's and, at the far left, St. Paul's—where vague silhouettes surmounted by smokestacks sit under a cloud of smoke. Beginning production in 1792 and processing local and imported flax brought in from Hull on the Aire and Calder Navigation, Marshall's initially used a 20-horsepower steam engine (replaced after 1815 by an impressive 70-horsepower unit) to run specially developed new machinery. The mill employed approximately one thousand workers and prospered during the French wars by selling yarn to other manufacturers.[25] Foundries and other facilities for the casting and assembly of machines and steam engines marked the vicinity of this great enterprise. Murray, Taylor and Wordsworth, an especially prominent metals firm in this neighborhood, may have contributed to the enveloping smoke depicted in this part of the drawing.[26] In 1812 Murray built his pioneering locomotive, which was used to haul coal from the nearby Middleton Colliery to Leeds.[27]

Gott's Bean Ing factory appears at the far left of the watercolor, its slender chimney rising from the right side of a rectangular base and pointing toward the tower of St. Paul's Church. Started by Gott in 1792, Bean Ing, also known

as Park Mills, rapidly became one of the marvels of the early industrial age, by virtue of its great size and the fact that it concentrated nearly all aspects of wool manufacturing under one roof. As the elder Baines wrote in 1817, at Gott's "the whole process of the manufacture of cloth, from the first breaking of the wool to the finishing of the piece ready for the customer," took place at Park Mills. Hydraulic and later steam power, provided initially by a 40-horsepower Boulton and Watt engine, drove machinery in the four-story building that stretched for 200 feet along the southern side of the factory.[28] The adjacent rectangular structure that completes Turner's industrial panorama, cropped abruptly at the edge of the paper just to the left of Bean Ing, housed J. and R. Glover's Airedale Woolen Mill.

The watercolor reveals other examples of period industrial activity to the right and below Benyon's, almost at the center of the paper. Several wide-mouthed kilns, of the type used by commercial potters, stand out conspicuously. Late in the previous century John Aikin had commented on the numerous Leeds potteries that prospered on the abundant local clay deposits and the easy availability of coal. In this case Turner depicted the Hunselt Hall Pottery, which had kilns at this time, while farther to the right, additional kiln silhouettes mark the Leeds Pottery.[29] Glass-making, especially of crown glass and bottles, also flourished in the community of Hunselt during these years, and the smoking cones from that industry could be adding to the haze near the Leeds Pottery.[30]

Atmosphere has as much to do with Turner's composition as the specific details of manufacturing. His panoramic approach challenges the viewer to contemplate this aerial by-product of the region's vibrant industrialism. Above broad stretches of the city hangs a thick canopy of coal smoke, produced largely by the numerous mills and furnaces of modern Leeds. Besides the startling efficiency of the machines in the area's enterprises, contemporary observers most often commented on the city's pollution. In 1803 Edward Daynes wrote of a Leeds "rendered rather unpleasant by the smoke arising from the furnaces of smitheries and other works," while at the end of the next decade Griscom would remark that the approach to Leeds "is black with coal dust and smoke." Another witness thought Leeds more smoky than other towns of similar size, with "the air . . . vitiated in a greater or less degree for four miles round." As a result, vegetables for the Leeds market had to be brought in from as far away as Wakefield and Pontefract.[31] This smoke drove many Leeds residents from their homes. When Gott built his Bean Ing Mill on the western edge of town and installed steam power in the form of "the largest and most powerful engine of its type ever built at that date," prevailing southwest winds carried smoke from this and similar equipment over the then-fashionable homes around Park Square, near the

rounded pinnacle of St. Paul's Church in Turner's painting. After their lawsuits against Gott failed, residents with sufficient means departed en masse for more salubrious regions.[32] An 1816 history of Leeds noted that northern sections of the city had consequently become fashionable. Small wonder that the national government launched an official inquiry in 1819 about the injurious effects of smoke and steam throughout the kingdom.[33]

Turner produced a telling examination of this urban-industrial phenomenon, one that identified both its cause and effect. The sources of pollution stand out clearly, mostly in the center-left section of the watercolor, while the results merge to become a vast, dense area of opaqueness to the right, enveloping almost everything save the tops of the old church spires. To the uninitiated it would appear as if the town were on fire. Instead, this unwholesome effluent proclaims the harnessed, controlled burning of the engines inside the great mills. Turner must have been amazed, like so many of his contemporaries, by the novelty and the consequences of such powerful vitality. The watercolor affirms this with its several colors of smoke, in various thicknesses, which leave their mark as new forces dominating in a complex environment. The focus on steam-driven business and its effects, to the exclusion of more traditional subjects, and on the dynamic manner in which industry has conquered the Aire valley makes this work an essential document of the industrial age.

Modern Leeds also represented a new form of arduous human labor that had wide and frequently pernicious social implications. Automation in the textile industries had already resulted in a number of Luddite (machine-breaking) outbreaks in the city and surrounding areas, particularly in 1812,[34] as technology displaced traditional crafts. At the same time factory conditions could often be exploitative and deplorable. Joseph Ballard, visiting in 1815, told of children "imprisoned" in the mills, made to work thirteen hours a day. He described their faces "besmeared with dirt and grease arising from the wool . . . these poor little wretches are confined in these Hells . . . deprived of education and buried in these dark, noisy and unwholesome dens."[35] Such practices prompted the famous protest of the local Tory reformer Richard Oastler, who published his "Yorkshire Slavery" letter in an 1830 issue of the *Leeds Mercury*. Turner's watercolor, however, conveys nothing of this human degradation. The few laborers he depicts in the foreground seem busy but not downtrodden. Yet his awareness of what he termed earlier the "world of care" may have been in his mind when he contemplated a city such as Leeds, and while not specifically delineated in line and paint, it might be sensed beneath the industrial smoke and behind the brick walls.

Turner embraced the most striking aspects of the innovation in Leeds. The

scale and power of the visible technology evidently captivated him, especially the big enterprises of Marshall and Gott. Yet mills of over a thousand workers were unusual, and towns like Leeds still depended for the most part on small-scale operations. Steam was also slow in becoming the primary source of motive power. Bean Ing relied on steam for only some operations, with tasks such as weaving and spinning still performed by hand.[36]

Turner may have intended *Leeds* for inclusion in Thomas Dunham Whitaker's *Loidis and Elmete,* a book for which he had already supplied several sunny, nonindustrial views. This history of Leeds appeared initially in 1816, so presumably Turner planned *Leeds* for the second edition, of 1823.[37] The artist might have prepared this new work as an antidote to Whitaker's conventionally conceived book celebrating bucolic country seats. Whitaker gloried in the naturally picturesque while loathing modern industry and what he considered the despoliation of the environment. As a consequence, he would have rejected *Leeds* out of hand,[38] leaving Turner to wait for later projects, like the *Rivers of England* and *Picturesque Views in England and Wales,* to juxtapose industrial and pastoral settings.

Turner also may have intended *Leeds* for other buyers. At that time several of his present and former patrons either lived or owned property in the Leeds area. This group included Walter Fawkes, the Earl of Harewood, and Earl Cowper. Fawkes and Harewood, at various times, represented the West Riding in Parliament, and the city of Leeds, although it did not itself return a member in the pre-Reform era,[39] swayed elections by virtue of its commercial and industrial wealth. Fawkes, a reformist Whig politician and a crusader for the abolition of the slave trade, could have been interested in a contemporary view of the city. Cowper, on the other hand, had land in this part of the West Riding that he hoped to develop.[40] Perhaps Turner believed that one of these men would favor this urban panorama that so effectively pressed the claims of a modern, mechanized Leeds.

The 1823 print version of *Leeds,* Turner's sole lithograph, was the work of James Duffield Harding, an artist much interested in this new reproductive process, as was Turner, who owned Alois Senefelder's pioneering *Complete Course in Lithography* (1819).[41] Publication of the print, if not connected with the Whitaker project, may have been gauged to take advantage of an ongoing resurgence in Leeds civic pride, a movement begun earlier in the century that was manifest in the numerous guides, maps, and views of the expanding industrial city that were then becoming available. John Ryley brought out his *Leeds Guide* in 1808, and directories by the senior Baines followed in 1809 and 1817. Artists offered their contributions, with Joseph Rhodes's *Leeds from the Mead-*

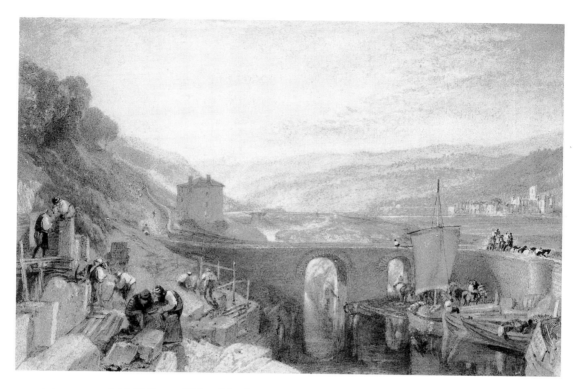

FIGURE 37. J. M. W. Turner, *Kirkstall Lock, on the River Aire*, c. 1824. Watercolor, 15.7×23.3 cm. © Tate Gallery, London, TB CCVIII-L.

ows (c. 1820–25) and Robert Buttery's *Leeds Taken from Beeston Hill* (1833).[42] Each boldly underscored the growing prominence of Leeds as one of Britain's leading manufacturing centers.

Turner also produced views of the industrial infrastructure of Leeds, specifically the canal system, which linked the city to markets and raw materials. *A Canal Tunnel Near Leeds* (c. 1799; Richard Ivor, London) depicted a flat-bottomed canal boat passing through what may be the "great tunnel" of the Leeds and Liverpool Canal at Foulridge, 1,648 yards long and completed in the mid-1790s.[43] Twenty-five years later he painted *Kirkstall Lock, on the River Aire* (Fig. 37), a watercolor that appeared as a mezzotint in *River Scenery* in 1827. Like *Leeds*, it considered the interplay of modernism and history, here in the form of a lock on the Leeds and Liverpool Canal situated opposite the picturesque ruin of medieval Kirkstall Abbey.[44] The text that accompanied the print emphasized the new commercial significance of the once-historic spot, which now possessed a waterway that "facilitates the trade of Leeds to the port of Liv-

erpool." Turner viewed this scene from Kirkstall Brewery, and he included in the picture the canal lock and, on the left, a quarry being worked, as well as a coach hurrying along the Leeds and Bradford turnpike.[45] As with *Leeds*, the overall effect is a picture of modern labor and technology rather than the traditional landscape of the type portrayed so often by Turner's contemporary Constable.

Canals carried that essential element of Britain's industrial development: coal. Leeds depended on abundant local coalfields to fuel its steam-powered mills, but other regions needed to import the mineral from elsewhere in Britain—from Cumberland, Scotland, South Wales, and the contiguous counties of Northumberland and Durham, especially the districts bordering the River Tyne. Tyneside, in addition to its enormous deposits of coal, boasted sound port facilities and the transport necessary to compete with mines in other, less accessible, regions. As early as the beginning of the eighteenth century, the pits of Northumberland had earned the nickname "Black Indies," because they generated wealth comparable to some of the more lucrative overseas colonies.[46]

Turner directed his attention to Tyneside not long after completing *Leeds*. His interest resulted in two finished watercolors and an oil painting that was exhibited at the Royal Academy. These three studies made Tyneside the industrial area most studied by Turner outside London. His *Newcastle-on-Tyne*, of circa 1823, focused on the urban heart of the precinct, while *Shields, on the River Tyne*, from the same year, presented the busy port of embarkation located six miles downstream, near the point at which the Tyne meets the sea. Both these views were engraved as mezzotints for Turner and Thomas Girtin's *Rivers of England* (1823–25), one of the many print projects Turner was associated with during these years. The oil painting *Keelmen heaving in Coals by Night*, a fairly spacious canvas of muted luminescence in which industry and commerce are essential, but not dominant, elements in the overall artistic conception, appeared in 1835. All three views testified to Tyneside's modernism, as well as to the specific nature of industrial development in this vibrant locale.

Industrialism had for many years provided Newcastle and vicinity with its chief modern attraction. "This beautiful river, the Tyne, is rendered highly interesting by the number and variety of the manufactures carried on upon its banks," wrote the French visitor Barthélemy Faujas de Saint-Fond in 1799. The *Traveller's Guide* of 1805 spoke of numerous industrial establishments, companies for the "considerable manufacture of broad and narrow cloths, and several soap-boileries . . . also a very capital manufactory for white lead, milled lead, &c." It pointed out as well that vessels intended for "the coal-trade, are built

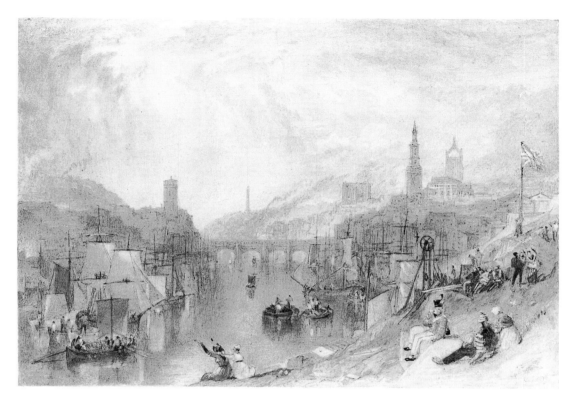

FIGURE 38. J. M. W. Turner, *Newcastle-on-Tyne*, c. 1823. Watercolor, 15.2 × 21.5 cm. © Tate Gallery, London, TB CCVIII-K.

here to perfection, with great strength." This in turn spurred the iron-making business, since colliers required anchors, chains, and other metal products.[47] Coal—its extraction and shipment—accounted for the greatest part of Newcastle's prosperity. To an early nineteenth-century visitor it was simply a city "surrounded on all sides by coal mines," while the text accompanying the engraved version of Turner's view labeled it "the great emporium of the coal-trade."[48]

Turner's *Newcastle-on-Tyne* (Fig. 38) depicted the city and the adjoining town of Gateshead, looking west, with the River Tyne running between. The text in *The Rivers of England* described it as a place of "wealth, science and enterprising spirit,"[49] a characterization in keeping with the generally sanguine view of industrial progress popular during the Regency period. In 1821 the populations of the two communities were 42,000 and 12,000, respectively.[50] The work offers a straightforward representation of both districts as an amalgam of topographical, historical, and industrial elements, not much different in execution

from the *Leeds* of less than a decade earlier. Other artists found themselves drawn to a similar perspective—most notably Thomas Girtin, in *Newcastle upon Tyne*, of 1797; and John Wilson Carmichael (a Turner admirer),[51] in the watercolor *Newcastle from St. Ann's* (Laing Art Gallery, Newcastle-upon-Tyne [Tyne and Wear Museums]), of 1835. Turner's *Newcastle*, compared with the efforts of these two artists, gave greater play to the theme of an old city-district engulfed by the choking atmospheric effects of modern industrial development and a concentrated populace, what Samuel Smiles would characterize as a town "of crooked lanes and narrow streets" that was also "a busy centre of peaceful industry, and the outlet for vast amounts of steam-power."[52]

Several specific elements in Turner's picture stand out. We see the tower of St. Mary's, Gateshead, at the left, the bridge dating from 1772 at the center, and at the right, Newcastle's three most conspicuous historic landmarks: the great eleventh-century castle and the churches of St. Nicholas, topped by a lantern of flying buttresses, and All Saints, with its 202-foot classical spire. Also visible, marking the central background, is the Elswick Shot Tower.[53] An 1838 *Athenaeum* article made particular reference to this structure, used to fabricate lead shot, and noted its attendant leadworks. The manufacture of lead "sheets, pipes, shot, white-lead, red-lead, and litharge" had been a key Newcastle industry since the eighteenth century. The metal was mined nearby, at Stella and Swalwell, and transported next to the river for processing.[54] Smoke and steam vented from this work, as well as from the machines of the collieries, whose discharge came from burning coal and from the stationary steam engines pumping water out of the mines. Together with these, residential coal burning and the aerial residue from lime kilns on both sides of the river contributed to the smoky atmosphere of Turner's drawing.[55]

In the 1830s an English traveler would describe this pollution more pointedly, remarking on how, on both sides of the Tyne, the banks "are studded with chimneys. These vomit into the air a dense mass of smoke and impurities, till nature herself seems, as it were, compelled to receive again and disperse in space, in the form of one black, huge cloud, the noxious particles and effluvia rejected by the saturated atmosphere."[56] In Turner's hands, the effluence of the 1820s casts a gray haze over the far and middle ranges of the watercolor, relieved only in the immediate foreground by elements of color—brown on the sloping riverbank, the ships' white sails, red for the soldier's uniform. In the distance the general monochromatic gloom is broken by bursts of sunlight, which reveal streams of ascending industrial smoke near the shot tower and on the hill above Gatesend.

At the center of the work is the busy Tyne. Newcastle had one of the longest wharves in England, which in the 1820s was "usually crowded with shipping,

keels, wherries, steam-boats, and other small craft." Because of the depth of the river, only ships of between 200 and 400 tons could dock at Newcastle.[57] The low Tyne Bridge restricted navigation, and consequently, a small boat, known as a keel, played a necessary role in the transport of the region's coal exports.[58] Turner includes at least two of these vessels, loaded with black cargo, at the bottom right of the watercolor. Keels were described as "tubby, grimy-looking craft, rounded fore and aft," but "strong . . . of eight caldrons [about twenty-four tons] burthen, each managed by three men and a boy styled a pee-dee."[59] Into these boats coal was loaded from staithes, or jetties protruding into the river, for transport downstream to the large oceangoing ships that would take the stock to various parts of Britain and Europe.

The chief embarkation points, "the great rendezvous for shipping taken up in the coal trade,"[60] were two communities eight miles east of Newcastle, near the mouth of the Tyne—North and South Shields. Both towns appear in Turner's 1823 watercolor *Shields, on the River Tyne* (Fig. 39), a further product of his northern trip of 1818.[61] We see the rectangular North Shields lighthouse, which Turner would depict again in a circa-1826 mezzotint for the unpublished "Little Liber" group,[62] and at the left and on the opposite bank, South Shields, with a number of artificial hills formed by the cinders from the salt and glass works and the ballast discharged by colliers.[63] From both places, to quote an earlier guidebook, "many of the largest colliers take in their lading,"[64] much of it destined for the mills and residences of London. In 1826, three years after Turner's watercolor, of the 2 million tons of coal imported to the capital, only 125,000 emanated from other sources. The growth of Britain's iron industry during this time stimulated demand for Tyneside coal, but it also created competition as other sources of the mineral were exploited.[65]

At the right of the picture, under the light of a burning brazier of coal, keelmen perform what George Head would later describe as "the laborious . . . practice on the Tyne of shovelling the cargo by hand from the keel into the vessel."[66] The red and white illumination exposes the keelmen, some seen holding shovels, as they work through the night to meet the insatiable demands for this essential fuel. Such depictions of nocturnal industrial operations gained popularity in the early nineteenth century, because they imparted exhilaration and mystery to what were usually dull and dirty activities. Unlike the rather matter-of-fact *Newcastle*, Turner's *Shields* possesses an arresting vitality born of this combustion. Turner accented the contrast of cool moonlight with "heat and bustle" in *Shields*, much as he would in his portrait of the evening iron-working in *Dudley* less than ten years later.[67]

Turner's watercolor reveals much about the early coal business, particularly

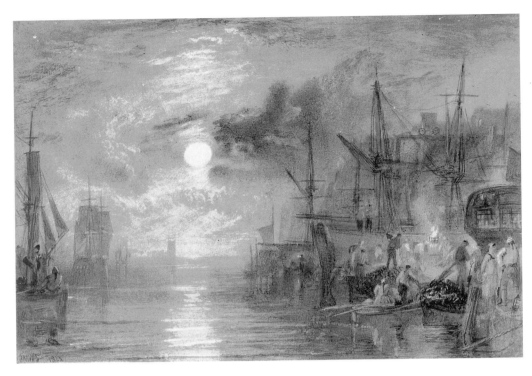

FIGURE 39. J. M. W. Turner, *Shields, on the River Tyne*, 1823. Watercolor, 15.4 × 21.6 cm. Tate Gallery, London, TB CCVIII-V.

advances in transporting the mineral. Head observed later that the "hardy . . . race of keelmen" were slowly, but inevitably, being "deprived of their ancient occupation . . . by means of new appliances" designed to speed the coal to ship by land.[68] By the time of Turner's visit, nearby mines had already begun sending buckets of coal on primitive railways to the riverbank, a practice bitterly resented by the keelmen,[69] who had to be satisfied with bringing coal from the upper reaches of the Tyne. Turner included one of these wheeled containers, on a wooden platform, at the top right of his watercolor.[70] After 1800 an apparatus called a drop was used to transfer these loads to the waiting vessels— "a simple mechanism" by which "they are let down in a few seconds to the ships."[71]

Twelve years later, Turner again depicted this lower Tyne area in his oil painting *Keelmen heaving in Coals by Night* (Fig. 40). While owing much to the earlier *Shields* watercolor in terms of subject, composition, and lighting, the work may have also reflected Turner's renewed acquaintance with this port. His 1831 steamer journey from Leith to London, which brought him near Dunstanborough Castle, would have taken him along the coast, past the lighthouse at

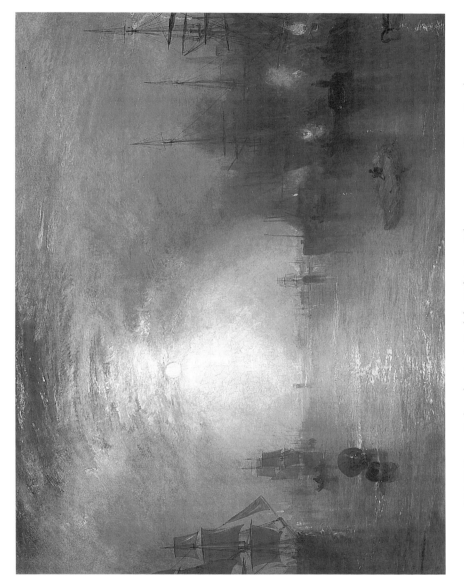

FIGURE 40. J. M. W. Turner, *Keelmen heaving in Coals by Night*, 1835. Oil, 90.2 × 121.9 cm. © 1995 Board of Trustees, National Gallery of Art, Washington, Widener Collection.

Tynemouth and the towns of North and South Shields.[72] The finished *Keelmen* quickly found its way into the collection of the Manchester cotton manufacturer Henry McConnel, who in 1834 had acquired Turner's *Venice*. This patron may have been interested in the contrast between the mercantile city of the past and Britain's thriving northern port—in fact McConnel claimed that Turner had executed the two paintings at his "special suggestion."[73] *Keelmen,* more muted and mysterious than the clear and sparkling *Venice,* presents a subdued industriousness absent in its companion. Yet the symmetry embodied in the shared theme of ports conspicuous for their dependence on small vessels—gondolas and keels—reinforces the contention between these two oils. If McConnel did advance the idea for *Keelmen,* he may have had the earlier *Shields* print in mind, since its wide dissemination in *Rivers of England* would have made it one of Turner's more widely known and arresting industrial views, at least prior to the publication of *Dudley* in 1835.

Keelmen's genesis in *Shields* is unmistakable, although the former's perspective is broader, placing the viewer further away from the shoreline so that the river and the sky receive greater prominence.[74] This oil presents a modern marinescape instead of simply a detailed examination of coal loading. Complex and methodical human activity, especially in the layers of keels, ships, drops, and smokestacks on the right, buttresses the great atmospheric arch produced by the ascendant moon. The keelmen are still clearly visible beside their baskets of burning mineral; Turner has actually included more of them than before. He also conveys here a far greater sense of a truly multifaceted industrial environment, one of individual enterprises and integrated manufacturing. Whereas the 1823 *Shields* is largely concerned with coal and its shipment, the later oil features a setting in which "everywhere is life, work, and activity." Already in 1822 this entire riverside area boasted "three glass houses for the manufacture of crown glass, four for that of bottles, and one white glass manufactory."[75] Other lucrative activities included shipbuilding, salt- and soap-making, and brewing.[76] The manufacture of chemical products also claimed influence, especially at South Shields, where the Cookson firm was located. In 1839 this company, which may be lurking in the right background of Turner's oil, provoked severe criticism for its pollution of the Tyneside atmosphere.[77]

Such details of this industrial and commercial hub, with its conspicuous aerial effluence, gave *Keelmen* a particularly documentary character. On the South Shields bank are two large chimneys, probably connected to stationary steam engines, protruding out of the smoky gloom, and at the extreme right edge of the canvas stands a long, slender venting shaft releasing white engine steam into the air. In the distance clouds of smoke drift up toward the center of the can-

vas. They were possibly the product of the heavy coal burning associated with salt- or glass-making—South Shields was long prominent for its bottles and window glass.[78] On the left, the more distant North Shields shore, more stacks are in evidence, one conical and capped with a yellow flame—probably another glass house, with the cone acting as a "giant chimney for the furnace, creating a sufficiently strong updraught to enable an adequate temperature to be maintained." Abraham Rees, in his authoritative reference work on industry of 1819–20, noted that the flame from this operation could be seen "passing out with the smoke through the top of the dome,"[79] just as depicted by Turner.

The moon, which the critic for the *Spectator* said "pours a flood of silver radiance that fills the scene, excepting the dusky line of colliers,"[80] fails to penetrate the industrial haze sufficiently to reveal the many details of industrial activity. Yet the sense of relentless human enterprise beneath the opaque covering, carried on here through the night, is not lost on the viewer. The illuminated motions of the keelmen are only the most obvious indication of the labor that generates such transforming aerial waste.

In *Keelmen* Turner presented a routine industrial situation in a painting of aesthetic distinction. He accomplished this in a more orthodox manner than he had done in *Staffa* or would later do in *The Fighting "Temeraire."* Here the industrial expanse, broad and serene, approaches a Claudian classicism.[81] The generally positive critical reception had much to do with the unusual moonlight Turner used to give this painting of toil and commerce its sedate beauty. As so often was the case with Turner's representations of the Industrial Revolution, the matchless power of nature became the defining element, subordinating all else. The "moon . . . stands directly in the center . . . pouring a flood of light upon terrestrial objects," wrote the *Morning Chronicle,* adding that "the aerial perspective is beyond all praise." The *Spectator* spoke of this moon that "pours a flood of silver radiance that fills the scene, excepting the dusky line of colliers, with the light and smoke of the beacons on the river side." The reviewer for the *Morning Post* demurred a bit, calling the moon "common" and "pale" yet recognizing it as a key element in manipulating the eye "through the black mass of the hulls of vessels . . . down the pool of water seeking the far-distant and hazy horizon." Most found the natural lighting simply false. *Leigh Hunt's London Journal* asked, "Where have we seen so bright a moonlight?" while the *New Monthly Magazine* complained that Turner's nocturne appeared "light as day."[82]

But this moonlight, remarkable as it is, merely indicates, but does not penetrate, a great opaque screen of smoke and atmosphere. In this it resembles the nearly contemporary *Thames above Waterloo Bridge* (see Chapter 5), a canvas

similarly given over to an urban industrial setting in which light reflects off air-borne pollution, incompletely exposing what lies beneath. In *Keelmen* the ships, wharves, and chimneys become silhouettes along land that is punctuated by isolated, yet intense, fires of a workplace for which the passing of daylight brings no respite. At the same time, the lunar brilliance transforms everything into a cool, muted expanse, with dirt and toil tempered by nature's power and the artist's imagination.

Turner produced a more focused examination of industrialism in his portrayal of the smaller industrial community of Dudley. A town at the heart of England's Black Country, a district conspicuous for its dense concentration of industry, Dudley typified historic Britain's embrace of economic change. Rendered in watercolor sometime between 1830 and 1832, following a visit in the late summer and early autumn of 1830, *Dudley, Worcestershire* (Plate 6) was exhibited at the Moon, Boys and Graves Gallery in London in 1833. Engraved in 1835 by Robert Wallis (Fig. 41), it appeared three years later in the collected two-volume edition of ninety-six of the artist's prints, *Picturesque Views in England and Wales*.[83] This publication, while a commercial disaster because of its costly use of copper plates and the competition from comparable offerings, covered a wide range of subject matter—landscapes, harbor views, historic landmarks, and human activity of all sorts, from political rallies, military encampments, and urban street scenes to industrial production.[84] The suggestion that middle-class purchasers of these prints, like those who bought Turner's Seine books, sought to possess portions of the landscape through them would have particular relevance to an image like *Dudley*, which depicted a key source of Britain's newfound wealth.[85]

In both the watercolor and the engraved version of this scene, Turner captured the full dramatic intensity of prodigious industrialism in the midst of a traditional landscape. While other views in the *England and Wales* series included incidental reminders of the new machine age—for example, the small Thames steamer in *Richmond Hill and Bridge* (see Fig. 51) and the engine smokestacks in *Coventry, Warwickshire* (Fig. 42)—*Dudley* was the sole work in the group to give industrialism a principal role. In terms of its subject, its execution, and its fame, it is a central work in Turner's survey of the Industrial Revolution.

Turner's *Dudley* pictures an old west-Midland town in the throes of intense technological change, a "contested land" in which the architectural symbols of tradition and faith coexist uneasily with the utilitarian structures of the modern industrial age.[86] With battlements and steeples forming a backdrop to a complex

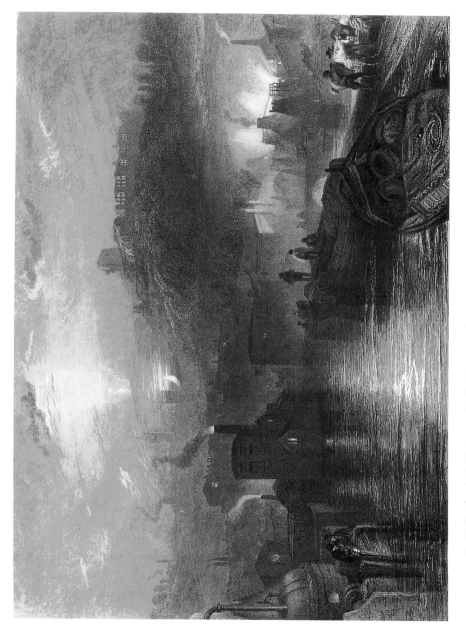

FIGURE 41. R. Wallis after J. M. W. Turner, *Dudley, Worcestershire*, 1835. Engraving, 16.3 × 24 cm. Yale Center for British Art, Paul Mellon Collection.

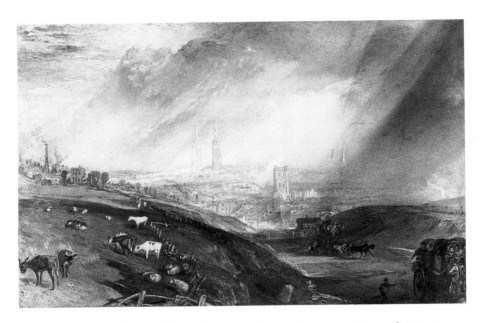

FIGURE 42. J. M. W. Turner, *Coventry, Warwickshire*, c. 1832. Watercolor, 29 × 44 cm.
© British Museum, London.

array of furnaces, chimneys, boilers, and canal boats, this work provides a visual essay on the themes of change, continuity, and adaptability in early nineteenth-century England.

When *Dudley* appeared before the public, its content excited little comment. Although the *Tatler* spoke of the watercolor as "that 'Fiery Furnace,'" the *Spectator*, in an equally brief notice, merely called attention to Turner's skill, in the engraving, of effectively capturing the luminescent effect of "the moon and . . . the furnace-fires." To subsequent writers, however, the work acquired considerable stature as a symbolic representation of the disquieting consequences of technological innovation. Ruskin, who owned the watercolor of *Dudley* for a time, despite his ever-increasing antipathy to industrialism, wrote in 1878 that he found in it a clear expression of "what England was to become," with its "ruined castle on the hill, and the church spire scarcely discernible among the moon-lighted clouds, as emblems of the passing away of the baron and the monk." In a similarly nostalgic mood, W. G. Rawlinson, in his seminal work on Turner's engravings at the beginning of this century, wrote of the print of *Dudley* as one of the artist's most "deeply poetical . . . works," in its combination of the "pathetic beauty of the once dominant, but now ruined feudal castle . . . and the busy life of the nineteenth century below."[87]

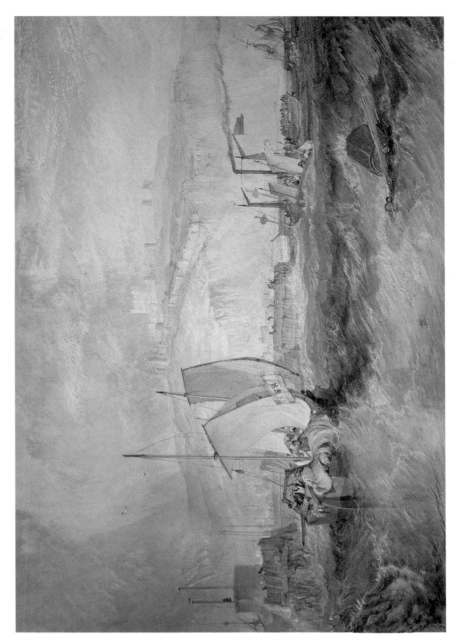

PLATE 1. J. M. W. Turner, *Dover Castle from the Sea*, 1822. Watercolor, 43.2 × 63.9 cm. Courtesy Museum of Fine Arts, Boston, Bequest of David P. Kimball in memory of his wife, Clara Bertram Kimball.

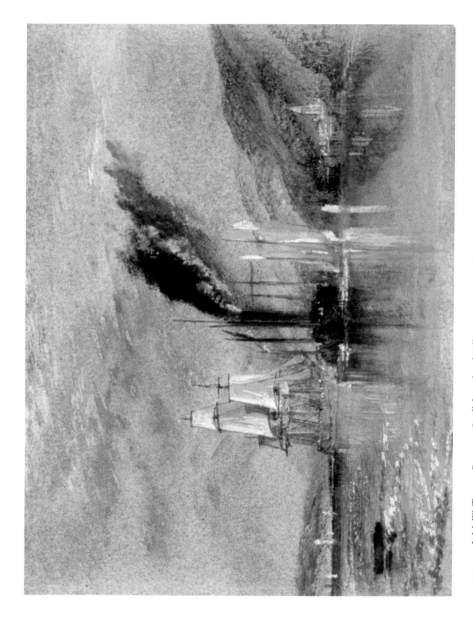

PLATE 2. J. M. W. Turner, *Between Quilleboeuf and Villequier*, c. 1830. Watercolor, heightened with body color over pencil, 13.7 × 19.1 cm. © Tate Gallery, London, TB CCLIX-104.

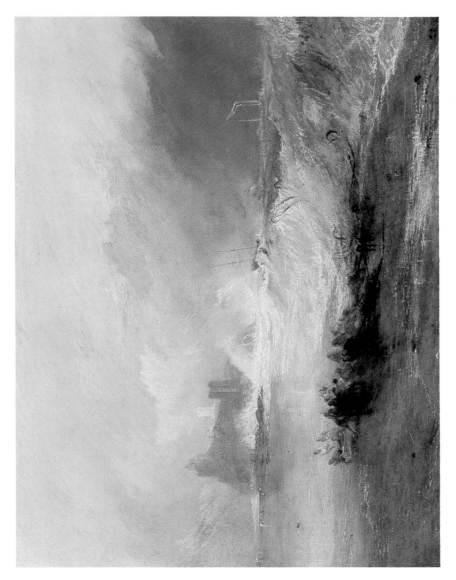

PLATE 3 . J. M. W. Turner, *Wreckers,—Coast of Northumberland, with a Steam-Boat assisting a Ship off Shore*, 1834. Oil, 90.4 × 120.7 cm. Yale Center for British Art, Paul Mellon Collection.

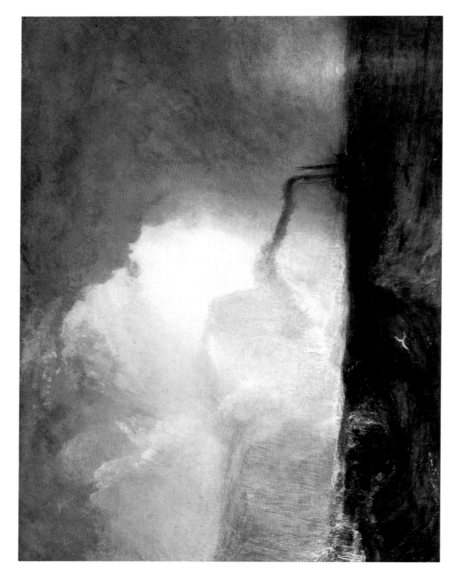

PLATE 4. J. M. W. Turner, *Staffa, Fingal's Cave*, 1832. Oil, 90.9 × 121.4 cm. Yale Center for British Art, Paul Mellon Collection.

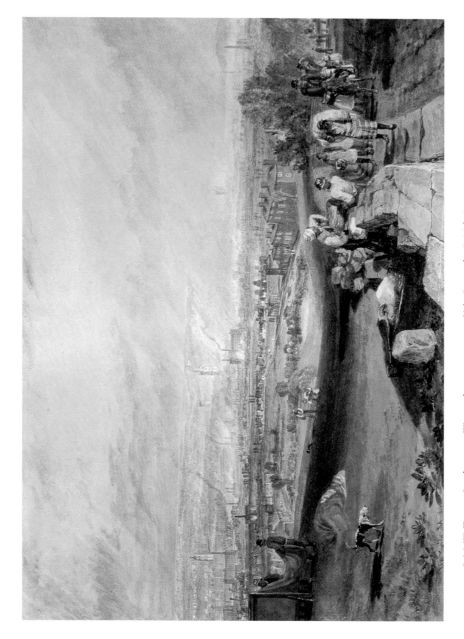

PLATE 5. J. M. W. Turner, *Leeds*, 1816. Watercolor, 29 × 42.5 cm. Yale Center for British Art, Paul Mellon Collection.

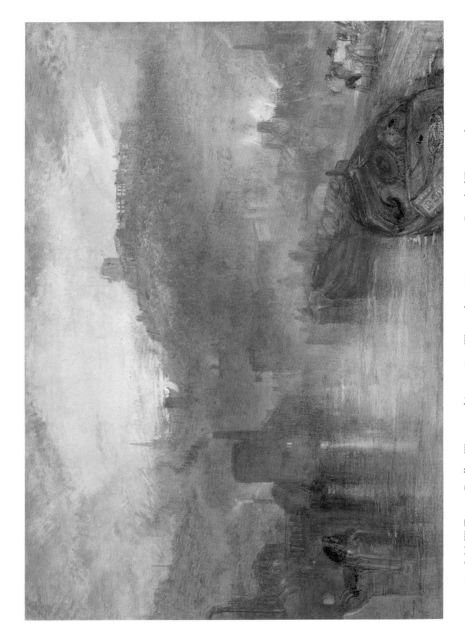

PLATE 6. J. M. W. Turner, *Dudley, Worcestershire,* c. 1832. Watercolor, 28.8 × 43.2 cm. Board of Trustees of the National Museums and Galleries on Merseyside (Lady Lever Art Gallery, Port Sunlight).

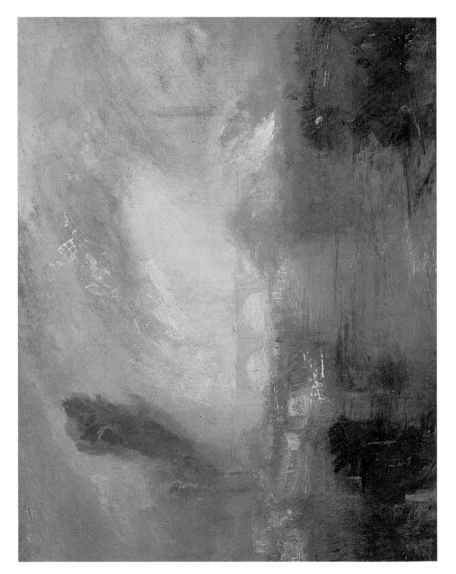

PLATE 7. J. M. W. Turner, *The Thames above Waterloo Bridge*, c. 1830–35. Oil, 90.5 × 121 cm. © Tate Gallery, London.

PLATE 8. J. M. W. Turner, *Rain, Steam, and Speed—The Great Western Railway*, 1844. Oil, 91 × 122 cm. Courtesy the Trustees, The National Gallery, London.

Although more recent critics have also viewed the work as an implicit condemnation of the social and economic changes occurring in early industrial England,[88] such interpretations may have little to do with Turner's intent. Andrew Wilton argues that the artist, in his urban studies, coupled an established "fascination with the conditions in which men live" with a certain "excitement" toward industrialism, born of the eighteenth-century doctrine of the sublime. *Dudley*, in particular, would thus represent "the most complete of Turner's essays in the 'Industrial Sublime,'" from a member of "the generation of artists for whom [such industrial scenes] were novel and immensely stimulating experiences."[89]

The aesthetics of an earlier era, to which Wilton relates *Dudley*, certainly helped shape Turner's artistic vision. Nevertheless, the work primarily expresses the artist's romanticism, as well as his positive view of Britain's expanding economy of the 1820s and the 1830s. Although for many the "optimistic view of industrial progress" would soon give way (certainly by the 1840s) to more pointed criticism of the social and economic dislocation resulting from Britain's increasingly mechanized and urbanized culture,[90] such negative sentiments are largely absent from Turner's *Dudley*. Instead, the work offers an analytical and imaginative commentary on manufacturing technology and its relationship to the traditional landscape.

Dudley is situated about halfway between Birmingham and Wolverhampton, two great manufacturing cities of the day, on the border of the counties of Worcestershire and Staffordshire. With a population of about 23,000 in 1831, Dudley sat in the midst of the Black Country, where "dense clouds of smoke . . . belched continuously from thousands of coal-fired hearths and furnaces,"[91] polluting the air and encrusting the physical environment with soot. Making his way through the region at the end of the eighteenth century, Lord Torrington remarked at the many villages, each "blacken'd with its trees, and hedges, by the forge fires." "For miles together," wrote the American traveler Robert J. Breckinridge in the late 1830s,"innumerable chimneys lift up their long tapering forms, and volumes of thick smoke issue from them."[92]

Industry in Dudley centered on the production of ferrous metals, for which natural resources were abundant. There was iron ore for smelting, coal for fuel, lime for flux, and clay for furnace linings.[93] As far back as the Middle Ages, a thriving business arose to supply iron products for Dudley Castle, and by the sixteenth century, the adjacent town and its environs had achieved prominence for nail-making and other forms of work with iron. By the reign of Charles II, industrial prosperity and growth in the area were generating more revenue than agriculture in many Midland counties.[94] Although the entrepreneur Dud Dudley, an illegitimate relative of the local baron, probably exaggerated when he

estimated that in 1665 nearly twenty thousand ironsmiths worked within a ten-mile radius of Dudley Castle, the concentration of labor nevertheless was impressive.[95]

In the century before Turner's visit, the Dudley iron industry had diversified to include casting and finishing, as well as chain-making. The early nineteenth century witnessed what one Victorian termed a "truly extraordinary" growth in the use of iron, a trend quickly felt in the Black Country, with Staffordshire achieving production levels second only to those of South Wales.[96] By this time ovens for producing pottery and glass had begun to mark the landscape with their peculiar conical shapes. Traffic on Dudley's canals, which since the eighteenth century had been used to transport both heavy raw materials and finished goods between Birmingham in the east and the river Severn in the west, continued to increase. Viewed in the light of the fiery local industries, these extensive canals, in the words of one mid-Victorian traveler writing of twenty years' knowledge of the region, twisted and crossed the landscape like "bleeding veins."[97]

If Turner wished to portray a site that epitomized English industrialism, he could scarcely have chosen a better location. More than Leeds or Tyneside, Dudley and its adjoining neighborhood were distinguished by a high concentration of manufacturing enterprises, as well as by a number of "firsts" in the Industrial Revolution. In the seventeenth century Dud Dudley claimed in *Metallum Martis* to have smelted iron in a blast furnace with coke instead of with charcoal, which at the time was the more usual (and less economical) process. Modern scholarship has confirmed the primacy of Abraham Darby's coke smelting at Coalbrookdale in 1704, but in Turner's day Dud Dudley was accorded the credit for this innovation.[98] A more tangible invention associated with the town of Dudley was the steam engine, first operated by Thomas Newcomen in 1712 to pump water from a coal mine near Dudley Castle.[99]

Ruskin saw in Turner's *Dudley,* especially its ruined castle, the demise of a historic social order in England. Yet in truth, the "baron" in this case had hardly disappeared but rather had, for many generations, adapted to the new industrialism with such success as to greatly increase the family's wealth and power. Fortress, town, and vicinity were still, in Turner's time, largely in the hands of an old and distinguished aristocratic family with deep roots in the area, the Wards. Styled Lords Dudley and Ward, they owned (but did not inhabit) Dudley Castle, which they retained as a picturesque relic while actively exploiting their immense holdings throughout the surrounding country. With the onset of industrialization, they lost little time in sponsoring enclosure bills, securing mineral rights, and financing canal construction, all to make the most of the various new economic opportunities.[100] In the late eighteenth century, John, second

Viscount Dudley and Ward, commissioned the building of a canal tunnel directly under the castle to connect his limestone quarries and kilns with the nearby Birmingham Canal. Opened in March of 1792, it was a considerable engineering accomplishment, extending 3,142 yards.[101]

In Turner's day the head of the family was John, first Earl of Dudley and fourth Viscount Dudley and Ward, a personality of immense wealth, prominent in local politics and, on the national level, a leading Tory who served briefly as foreign secretary in the Goderich and Wellington governments (1828–29), the time just prior to Turner's visit to the district. In 1833 Lord Dudley controlled ten collieries, three limestone works, and six ironworks in the Black Country.[102] A Victorian successor would acquire the unofficial title "Iron Earl of England," by virtue of his fortune derived from the blast-furnace economy of the Black Country.

Dudley and the Black Country became essential destinations for Turner and those of his contemporaries interested in experiencing for themselves the full power of England's new manufacturing culture. To many Regency and Victorian observers, the Black Country epitomized both the negative and positive aspects of the Industrial Revolution because of the variety and concentration of its industries. For some it embodied nefarious change. The poet and critic Robert Southey, speaking in 1807 through the persona of a Spanish visitor, viewed the Black Country from the Birmingham-Wolverhampton road and described as "hideous" its congested appearance, with its "streets of brick hovels, blackened with the smoke of coal fires which burn day and night in these dismal regions." He compared the English landscape of old, with its noble church spire marking a quaint village in the midst of lush, green fields, and the dreadful new panorama, dominated by the "tower of some manufactory . . . vomiting up flames and smoke, and blasting every thing around with its metallic vapors."[103]

Dickens painted an equally pessimistic picture of this region in his 1841 novel *The Old Curiosity Shop*. He had visited the Black Country toward the end of the 1830s and used its crowded and polluted appearance to mirror the despair and fatigue of Little Nell and her grandfather. Like Southey, he described it as a "cheerless region," a "mournful place" in which "tall chimneys, crowding on each other and presenting that endless repetition of the same dull, ugly form, . . . poured out their plague of smoke, obscured the light, and made foul the melancholy air." At night the scene was even more horrific. It was then that "the smoke was changed to fire; when every chimney spurted up its flame."[104]

In their moral outrage, Southey and Dickens often neglected to look beyond appearances, failing to fully appreciate the practical economic benefits of industry, an outlook more in keeping with the temper of the time. Certainly many

others found this complex Midland landscape intellectually and emotionally appealing. In 1814 the German visitor J. C. Fischer sought out Dudley in order to study Lord Dudley's nearby Level Ironworks, with its three great forty-two-foot-high blast furnaces, and he was followed to this district in 1826 by the similarly curious Prussian architect Karl Friedrich Schinkel.[105]

Most early nineteenth-century observers agreed that the best place from which to survey the Black Country's remarkable assemblage of enterprise was the hill crowned by Dudley Castle; the medieval citadel was, in the words of the engineer Joshua Field, "beautifully situated . . . and commanding an extensive view of Staffordshire." From here Field, in 1821, marveled at "the Furnace fires . . . immense fires as far as the eye could reach." During an 1830 "journey of inquiry" through industrial England, James Nasmyth, the notable Scottish engineer who would invent the steam hammer for iron processing, looking out over the land from the great citadel, stood in awe before the "extensive district, with its roaring and blazing furnaces, the smoke of which blackened the country as far as the eye could reach." Like Southey, he too reflected on the changes brought by "our vaulted supremacy in the manufacture of iron." "We pay a heavy price for it," he lamented, "in the loss of picturesqueness and beauty." But in the final analysis, Nasmyth confessed a grudging admiration for the vast extent of human enterprise that met his gaze at Dudley.[106]

The vantage point of Dudley Castle stimulated a variety of musings on Britain's chivalric history and its industrial present. When Zachariah Allen arrived in 1825 from America to collect information for his book, subtitled "the state of the useful arts, and of society, scenery, etc." in several European countries, he too climbed to the ramparts of the ruined castle. There his thoughts turned to the contrast of "the vast useless structure of baronial magnificence, . . . and the more beneficial and equally bold works of the present generation of men, whose labors are devoted to improvements in the useful arts." Nightfall excited his imagination, as it would Turner's only a few years later:

> Riveted to the spot, one continues gazing at the interesting landscape. . . . The chimneys of many remote iron-smelting furnaces are now distinctly to be seen. The fires which spout upwards from their tops are no longer rendered comparatively dim by the brighter glare of sunshine. As the obscurity increases, these fires all begin to brighten to the view, and when darkness finally prevails, the lights resemble stars reflected from the surface of a dark lake spread out before you. . . . In addition to the fires of the furnaces, the countless heaps of blazing coals, ignited for the purpose of being reduced to coke, flash up at intervals over the adjacent fields.

Allen believed this scene testified to Britain's technological and economic progress. Respectful visitors like himself had to "acknowledge . . . that the enterprise of the people who are achieving such wonderful triumphs in the useful arts, renders them worthy of the bountiful land in which they dwell."[107]

It fell to a local resident, however, to provide the most sensitive and thoughtful narrative appraisal of Dudley and its region. As if anticipating the sentiments of Turner's painting, the Reverend Luke Booker, vicar of Dudley (1812–35), published in 1825 *A Descriptive and Historical Account of Dudley Castle,* a book that celebrated Dudley's distinguished past along with its vibrant present. In the chapter entitled "Contrast," he too recalled surveying the Black Country from the ruined castle and spoke about what he saw in the visual language of this age. The citadel's broken walls, which meandered over the irregular hilltop, pleased his eye. Clumps of foliage, bits of masonry, an undulating path, all combined to produce "a fine landscape! almost perfect"—a vision that seemed to cry out for the attention of an artist: "These things, under the pencil of a [Richard] Wilson, while the setting Sun throws its mellow glories upon the mouldering Towers of the distant Citadel, would stamp the canvas . . . with Immortality."[108]

Yet for the analytical Booker, they were but "one side of the Picture," for the view over the surrounding country of modern industry presented a far different image—a thrilling surprise after such picturesque solitude. Before him were "columns of smoke, rising from a thousand fires, forges, furnaces and manufactories, [which] darken that part of the atmosphere: and whence they arise, the whole surface of the earth seems, by its black and blasted aspect, as if War and Devastation had recently been there busy in their horrid work." Booker cautioned against concluding that the contrast was between "the garden of Eden, and . . . a desolate wilderness." In fact, this land of forges, coal fires, and the "wonderful phenomenon" of steam engines represented "a region of almost exhaustless Wealth," a place rich in exploitable minerals and alive with worthy human activity. Turning his gaze toward the north, Booker saw the adjacent community of Tipton under a pall of industrial pollution. While this would no doubt have offended an earlier, nostalgic, Southey, Booker found in it a further expression of successful human enterprise. This land, he wrote, is "never more happy than when enveloped in a cloud of smoke: for *then* though the rays of the natural sun be intercepted, the sun of Prosperity gladdens its people."[109]

Such a positive opinion may have been born of a combination of local pride and a wish to please Lord Dudley, owner of the castle and much of the surrounding industry, to whom Booker no doubt owed his parish living at St. Edmund's. Yet it also suggested a sympathetic understanding of modern reality that was not uncommon for the time. Indeed, a year earlier, in 1824, Carlyle

had written of the Black Country as "a half-frightful scene!" while at the same time admitting it to be a place of prosperity for workers and one of "the sources of British power."[110] For Booker, the contrast of new and old was of equal interest, as the picturesque and the functional existed in a symbiotic relationship that celebrated the adaptability of a historic region in the throes of spectacular development.

Similar sentiments were voiced by subsequent visitors. In 1835 William Hawkes Smith, a student of the region's industrial life, spoke of the ramshackle fortress as "an isolated guest of another age" curiously set against industrial neighborhoods that "produce a mass of wealth." For Elihu Burritt, writing in 1868 of two decades' travel in the region, the castle of old provided a spot from which to contemplate a great vista of "honest labour" and honorable "human industry."[111]

Turner's depiction of Dudley echoed Booker (although he may not have known of his work), and others of like mind, in its concern with the varied character of a community that gloried simultaneously in a romantic past and an industrious present. The text that accompanied the engraved version of Turner's watercolor, written by Hannibal Evans Lloyd, a noted philologist, traveler, and translator of German texts, also paid tribute to the "grand and extensive ruin" of Dudley Castle and the view that could be enjoyed from its ramparts. Noting the hills, valleys, and "populous towns" in the vicinity, Lloyd devoted careful attention to the economic benefits that spurred population growth and local prosperity: "The neighborhood abounds in mines of coal, iron-stone, and lime-stone, which furnishes employment for a great number of the inhabitants."[112]

But here as in other descriptions, little was disclosed about the less attractive side of Dudley industrialism, particularly the often wretched working conditions of many of its inhabitants, the violent "disturbances" in the summer of 1826 over a wage reduction in the mines, or the determined calls for the limitation of working hours and the abolition of the "truck system," which paid laborers "partly in the form of goods, on which the employer made [a] profit." Eric Hobsbawm once described the metalworking areas as places that had "degenerated into barbarized and murderous villages of men and women hammering out nails, chains and other simple metal goods."[113] Many observers (Turner included), fascinated by the power and vitality of the industrial landscape in its formative period, evidently preferred to avoid reference to the attendant social ills that would occupy the minds of a later generation of critics.

Although like Booker and others, Turner had viewed the Black Country from Dudley Castle, he found it an unsatisfactory vantage point for his watercolor. Preparatory sketches in the Turner Bequest from 1829–30 indicate that he sur-

veyed the scene from various spots throughout the area. One drawing (Fig. 43) shows the town of Dudley below the hill, with the castle's fragmented keep in the foreground, the spire of St. Thomas's Church of 1815–18 at the right, and to the left the square tower of St. Edmund's, dating from the early eighteenth century.[114] Factory chimneys of different sizes are interspersed throughout the sketch. A detailed two-page sketch of the castle and town from the northeast approximates the final watercolor, without the canal pool and furnaces, which probably were not visible from this spot (Fig. 44). For the finished picture, therefore, Turner had to move a little to the south and closer in toward the castle to capture the true complexity of this varied landscape. The artist may have strayed from visual truth when he composed his finished watercolor, but the desired interplay of industry, castle, and church-spired town could have been seen from a location at or near a canal terminus at Dudley Port.[115] While words could convey a balanced description of Dudley Castle and its hellish environs from the hill, from a visual standpoint, the most effective way to present the full effect of picturesque history in the midst of the "industrial sublime" was from a point away from the town, as Turner finally realized.[116]

To see and paint what he did, therefore, Turner "position[ed] himself . . . within the present-day experience of industry," probably at Dudley Port, about one mile northeast of Dudley proper and in line with the town's two distinctive churches.[117] Here the Birmingham Canal passed by on its route northwest to just below Tipton, where it met the Dudley Canal,[118] which veered west into the famous tunnel under the castle. Since the Birmingham Canal ran roughly parallel to the castle at Dudley Port, what appeared at the right in Turner's picture was most likely a canal spur—with men and a horse on the adjoining towpath—linking the main route to several commercial enterprises. The broad pool of water covering much of the center-left foreground could have served as a holding basin for boats delivering or receiving goods at the various businesses in the area.[119] Docked at the right is a loaded vessel labeled "Dudley," carrying hoops of sheet iron destined for one of the nearby foundries or finishing shops that produced anvils, fenders, or other metalwork.[120]

To the right in the picture, exuding an orange glow, is the Dudley Port Furnace complex, placed near essential canal transport.[121] Its burning piles of coke, prepared on site for quick and easy introduction into the waiting furnaces, cast a bright light behind tapered brick structures that culminate at three wide tunnel heads. Smith, in his 1836 *Birmingham and Its Vicinity,* noted—as did Turner in his view—how these "works themselves, are, in every possible instance, situated on the banks of a canal, in order to facilitate the transit both of the materials and of the metal."[122]

FIGURE 43. J. M. W. Turner, *View of town, Dudley, Worcestershire*, 1829–30. Pencil, 18 × 10.5 cm. © Tate Gallery, London, TB CCXXXVIII-68.

FIGURE 44. J. M. W. Turner, *Ruined castle on hill, with town in distance*, 1829–30. Pencil, 35 × 10 cm. © Tate Gallery, London, TB CCXXXVIII, 65a and 66.

Some of the adjacent buildings undoubtedly housed foundries, structures "almost always connected with the blast furnace."[123] Most of the iron stone used was mined locally and rendered into bars here before being transferred either to foundries, for conversion into cast-iron articles, or to pudding furnaces, where the reheated metal was rolled into a form appropriate to the needs of Dudley's

FIGURE 45. J. M. W. Turner, *Interior of an Iron Foundry*, c. 1797. Watercolor, 24.7 × 34.7 cm. © Tate Gallery, London, TB XXXIII-B.

nail, file, chain, and allied industries. Turner knew what such enterprises were like, having earlier executed watercolor views of a tilt forge, as well as the circa-1797 *Interior of an Iron Foundry* (Fig. 45), with its emphasis on human control of the transforming prowess of the fiery workplace.[124] The numerous surrounding chimneys clearly reflect the nature of a metals industry still centered in relatively small shops. Large-scale mass production was introduced only over the course of the next twenty years, from 1830 to 1850, largely in response to the demands of the ever-expanding railways.[125]

Lime, an important flux in the smelting process, was also obtained locally—there were huge deposits under the castle—and the kilns that separated the mineral from the rock could be casting a dull glow farther back in the picture, against the central hillside, to the right just below the moon.[126] Turner had long been interested in limeworking and the lighting effects produced in extracting lime. He had recorded one such operation many years earlier and in a manner simi-

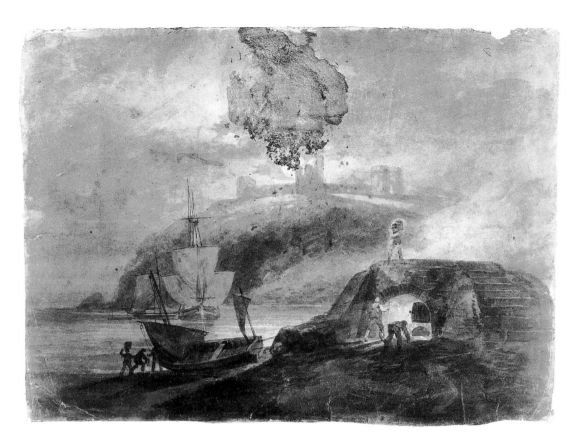

FIGURE 46. J. M. W. Turner, *Llanstephan Castle by moonlight, with a kiln in the foreground*, 1795. Watercolor, 21.3 × 28.1 cm. © Tate Gallery, London, TB XXVIII-D.

lar to *Dudley*, complete with castle and nighttime fire, in *Llanstephan Castle by moonlight, with a kiln in the foreground* (1795; Fig. 46).[127] Some of the more distant smokestacks in *Dudley* were most likely associated with the steam pumps used to draw water out of the mines at the Coneyreave and other collieries in the area. The Dudley vicinity was famous for its thirty-foot-thick seam of coal, which accounted for the "mass of pits, large and small," that existed throughout the district. According to one contemporary source, by 1840 over five hundred hands were employed in their operation alone.[128]

The community had a number of other industries that may be present in Turner's view. The Castle Foot Pottery operated south of Dudley Port Furnace in Turner's day. Glass cones were also in evidence; one rises at the left of the painting, at the edge of the pool. The Dudley Flint Glass Works was established

as early as 1766, and by 1841 at least four glassmakers were operating. Finally, completing the pattern of industrial diversification, Dudley Port had its own brewery as well as a facility for producing firebrick, and these buildings could be among the structures Turner included in his dark picture.[129]

The most conspicuous piece of industrial architecture in the composition, however, is the squat building flanked by two fiery chimneys in the left foreground. This anonymous form—difficult to identify with precision, because most industrial structures followed a generic plan to serve a variety of purposes—was probably a facility associated with one of the secondary iron industries. In the early nineteenth century, cheap coal was used to reheat the metal, producing waste gases that "streamed in sheets of bright lurid flame from the furnace throats," a common sight in the Black Country.[130] Chain-making, a business long associated with Dudley because of its abundant coke and high-grade wrought iron, could have been well accommodated in such a building. Chimneys connected to hearths, where the action of bellows would produce the high temperatures necessary for working the iron,[131] could give off intense heat and fire. To its left, almost at the end of the paper, a riveted cast-iron boiler is set on a brick or stone oven used for making steam—perhaps for the recently developed "hot blast" technique for iron fabrication or another function in the forging process—which is carried by a large pipe to an unidentified operation off the paper. At the center, farther back in the print, is a warehouse (a necessary feature of this busy canal country) with a small, square hoist and attached crate jutting from its upper story, serving as a central focus for the entire composition.[132]

But Turner's *Dudley* is more than a visual inventory of early technological development in the English Midlands. Much of its significance lies in its romantic suggestion of power and energy beneath the surface of the observed industry. Turner experiments with generalized forms and broad expanses of dark color to convey the advent of new forces. His mills, furnaces, and machines are basically silhouettes and reflected images suggesting the powerful, novel elements of a community of production that transforms the immediate environment with the encrusted grime of its enterprising activity. In this respect they parallel the steamers in *Staffa* and *Wanderings by the Seine,* while anticipating the hulking ship in *Peace—Burial at Sea.* The nocturnal setting underscores the intense labor of industrial operations: humanity never seems to rest, as workmen are glimpsed at their chores in the artificial light of innumerable fires associated with manufacturing.

There is, moreover, a deeply mysterious quality about this illumination, because its source is never fully delineated. Hidden and enclosed, it represents harnessed energy capable of melting, forging, and moving great pieces of machin-

FIGURE 47. T. Sanders, *A View of Dudley, from Eafey-hill,* from Treadway Russell Nash, *Collections for the History of Worcestershire,* 1781. Engraving, 17.1 × 29.6 cm. The Library of Virginia.

ery. The emphasis here is not on the specific technological operations taking place but rather on a more general sense of the remarkable forces at work. The iron-making at the right seems to be centered in an inferno of such magnitude that the blurred glow it casts lights up the entire right side of the paper, at the same time blinding the eye to the details of the smelting process. The dark building at the left contains its bright energy behind walls and windows, with intense light bursting onto the pool in front and the flames and white-hot gases shooting straight up into the nighttime sky. The square opening at the side of the "haystack" boiler, whose bordered light contrasts with the dark night outside, continues this theme at the left end of the picture.

Completing what one Victorian guidebook later characterized as the "grandeur and strangeness" of Dudley is the backdrop of town and castle.[133] Positioned above the valley of industry, it forms a quiet counterpoint to the activity beneath, its facades caught only in the muted moonlight, most pronounced at the top left, in contrast with the glow of Dudley Port Furnace. Although the two churches stand watch blankly over the scene, the castle seems to echo, in its own peculiar way, the firelit interiors below. Bands of window frames along the wall of the ruined hall are etched vividly by the gentle but all-encompassing

FIGURE 48. David Cox, *Dudley Castle with Lime Kilns and Canal,* 1830s. Charcoal and sepia, 17.78 × 26 cm. Dudley Art Gallery, Dudley.

evening light, an image that evokes the integrated relationship of natural and human sources of illumination in this changing landscape.[134]

Turner was not the only artist drawn to Dudley, but he alone captured its full industrial energy, mystery, and variety. Treadway Nash's *Collections for the History of Worcestershire* (1781) included an engraving of the town, the castle, and a large conical structure that was probably a glass furnace (Fig. 47).[135] Loutherbourg visited the site early in the century but left only a view of the interior of Dudley Castle, published in 1805 (and reprinted in 1824) as a hand-colored aquatint in his *Romantic and Picturesque Scenery of England and Wales,* a work that gave a vibrant depiction of industrial Coalbrookdale. Several engravings of the castle and its environs appeared in Smith's *Dudley Castle,* but only one gave a slight, distant hint of industrial life. In the 1830s Turner's fellow Royal Academician Cox, a native of nearby Birmingham, drew several pictures of canal boats and lime kilns operating beneath the castle, most notably in *Dudley Castle with Lime Kilns and Canal* (Fig. 48), but these light, atmospheric landscapes were far different in mood from Turner's dark, complex vi-

FIGURE 49. Philip James de Loutherbourg, *Coalbrookdale by Night*, 1801.
Oil, 68 × 106.7 cm. Science Museum/Science and Society Picture Library, London.

sion of change and adaptability. Finally, John Martin's 1852 oil *Great Day of His Wrath* (Tate Gallery, London) was said to have been inspired by a nighttime journey through the Black Country; according to his son, the "glow of the furnaces, the red blaze of light, together with the liquid fire, seemed to his mind truly sublime and awful." Martin may also have been motivated by *Dudley*, which he could have seen when he visited the exhibition at the Moon, Boys and Graves Gallery in the summer of 1833.[136]

Turner's *Dudley* continued the tradition in British art, established by the late eighteenth century, that drew inspiration from industrial subject matter.[137] Joseph Wright set the tone in his depiction of Arkwright's textile enterprises. His famous *Arkwright's Cotton Mills, by Night* (c. 1782–83; private collection), "with every window . . . blazing with naked candles, concealing hundreds of inflammable spinners inside,"[138] anticipated the artificial illumination of Turner's Worcestershire buildings, although the latter would be far more intense.

More romantic in conception was Loutherbourg's *Coalbrookdale by Night*, of 1801 (Fig. 49). This "magnificently sublime representation of the furnaces

at Bedlam" effectively conveyed the "hidden . . . sense of mystery" of industrialism by concealing its full operation.[139] Turner knew Loutherbourg, both as a fellow member of the Royal Academy and as a neighbor when both men lived in Hammersmith; he admired his work and, after the Alsatian painter's death, evidently purchased several of his sketches of Shropshire industrial buildings, which are now in the Turner Bequest.[140] Turner employed something of Loutherbourg's lighting in *Dudley*, although with heightened effect. The iron furnaces at the right of Turner's picture are not as generalized as those in *Coalbrookdale*, and they, and their attendant coke fires, cast a golden light bright enough to reveal at least some of the iron-making process, as well as elements of the surrounding area. The mill building on the left in *Dudley*, together with the adjoining boiler—each constructed to confine and direct energy—imply greater human control over the industrial process than that exhibited in Loutherbourg's wild inferno. Absent also from both Wright's and Loutherbourg's works was the fully integrated landscape of modernism and tradition that so interested Turner and his contemporaries.[141]

Dudley shares characteristics of other examples of Turner's urban industrial art, especially in its vivid contrasts of color and its suggestive silhouetting of the essential forms of the mechanized environment. It bespeaks a serious intensity akin to that of the nocturnal coal loading in *Shields* and *Keelmen* or, a decade later, the relentless locomotive in *Rain, Steam, and Speed*. Like *Leeds*, it delineates the features as well as the effects of manufacturing but with closer scrutiny and greater solemnity, and with less emphasis on the airborne discharge that marked such locales. Atmospheric pollution, one of the most noticeable characteristics of urban industrial life, interested Turner considerably. But the smoke and steam of the modern city found its best expression in his paintings of the greatest of early nineteenth-century metropolises, London.

5

Turner's London

as Industrial Metropolis

Britain's populous regional industrial cities paled beside London. Although not given over to any one specific industry, London prospered on a huge variety of small enterprises. In terms of its unprecedented, accelerating concentration of people—it had over one million inhabitants in 1801 and nearly twice as many by 1831—its commercial dominance, its immense and varied collection of manufacturers, and its ever-present pollution, London was the greatest metropolis of the Industrial Revolution.[1]

Turner depicted the modern essence of this city in the painting *The Thames above Waterloo Bridge* (Plate 7). Here London is seen enveloped in an atmosphere of its own making, as a place consumed by mechanization, a human community whose face and accomplishments lie behind a blanket of nearly impenetrable smoke, steam, and dirt. On this opaque canvas Turner examined London's singular makeup as a busy, complex environment gripped by a single-minded commitment to commerce, technology, and industrialism—a vision whose ultimate truth rests on a full acceptance of the city's modern pallor, as perceived by the romantic sensibility, attuned to its apparent and concealed energy.[2] Turner knew this peculiar milieu so well that it affected his other work. One writer said, shortly after his death, that even his Continental subjects had been "invested . . . with London fogs and London sun."[3]

The Thames above Waterloo Bridge is a potent essay on the energy and complexity of modern, polluted urbanism. Smoke and steam obscure most details, and what recognizable objects there are merely serve as markers of the specific geographic context. In the blurred distance, true to the work's title, are the broad arches of the first Waterloo Bridge, while to its right stands the dark vertical shaft of the famous shot tower, a South Bank landmark until its demolition in

the mid-twentieth century. The river's dull, blue-white water leads the viewer's eye toward the bridge, as brown and gray objects—barges, piers, and small rowboats with oars extended—crowd toward midstream, narrowing the perspective. At the left, adjacent to the Westminster bank, lies at least one steamer, with two dark funnel shafts shooting heavy, thick plumes of gray smoke (highlighted with touches of yellow) into the already murky air. Opposite, on the Lambeth side, a nebulous area of factories emits bold patches of gray-white smoke and steam, which race skyward and out to the center of the canvas. There they join the steamboats' engine exhaust, connecting the city's technology in an arched counterpoint to the bridge's elliptical openings below. The monochromatic pallor of the scene is tempered by the dull, golden glow of unpenetrating, reflected sunlight. The resulting view of London, while devoid of much illustrative detail, strongly evokes the new machine-driven dynamism that embodied the early nineteenth-century urban experience.

Dated circa 1830–35 but unexhibited during the artist's lifetime, *The Thames above Waterloo Bridge* has received minimal scholarly attention,[4] despite Turner's acknowledged interest in urban life.[5] One impediment to analysis is the painting's evidently unfinished state, which leaves it open to question whether Turner would have altered it significantly had he decided to show it at the Royal Academy or the British Institution. Yet this caveat has not prevented its exhibition in recent times, along with many other of his admired but also unexhibited canvases, as a worthy specimen of Turner's mature oeuvre.[6]

The Thames above Waterloo Bridge is sufficiently complete to communicate what the standard treatise on Turner's oils terms the "effect of smoke-belching industry" of early nineteenth-century London.[7] Moreover, the blurred panorama evident throughout the canvas is in keeping with Turner's handling of other industrial and technological subjects during the 1830s and early 1840s, most notably *Keelmen, Peace—Burial at Sea,* and *Rain, Steam, and Speed.* Its size is similar to that of other memorable London paintings of the 1830s, *The Burning of the Houses of Lords and Commons* and *The Fighting "Temeraire."* Finally, the picture of London advanced by Turner in *The Thames above Waterloo Bridge* is entirely consistent with the tenor of the times, with the Regency and Victorian London so often evoked in contemporary written descriptions of this quintessential city of the early Industrial Revolution.

Turner was not alone in singling out London's foul atmosphere as a key feature of its modernism. Flora Tristan, the French writer and workers' rights activist, visited London in the 1820s and 1830s and came away with a vivid memory of its choking air: "Above the monster city a dense fog combines with volumes of smoke and soot issuing from thousands of chimneys to wrap Lon-

don in a black cloud which allows only the dimmest light to penetrate and shrouds everything in a funeral veil."[8] Tristan would have realized that this thick atmosphere, especially along the Thames, included discharges from coal-fired dwellings and, of equal if not greater consequence, the soot of countless mills, commercial furnaces, and mechanized river steamers.

Other early nineteenth-century witnesses were similarly aware of this city's peculiar nature. In 1821 a German visitor, Christian Augustus Goede, declared London a melancholy place, where "the streets are gloomy, and black clouds constantly hover over the town, impervious to the cheerful rays of day-light." For the German artist Johann Passavant, a similar feeling took hold as he approached London: "The smiling fruitful country, with its enchanting villas gradually disappears; the atmosphere becomes dense and heavy of respiration." A reviewer for *Blackwood's Magazine* of April 1830 found the situation positively injurious: "Its atmosphere is almost poisonous to infancy, and is trying to the health of those arrived at maturer years." Shelley considered London's opaque grayness the very manifestation of hell in the guise of "a populous and smoky city." Yet the capital's pollution also had its admirers. The painter Haydon, for example, considered its smoke "far from . . . offensive" since it "filled [his] mind with feelings of energy." For him it was a "sublime canopy that shrouds the City of the World," a manifestation of "gloomy grandeur over the vastness of our Babylon." Carlyle wrote in a similar, but less effusive, vein in 1840, when he described a city that was "an infinite potter's furnace, sea of smoke, with steeples, domes, gilt crosses, high black architecture swimming in it, really beautiful to look at from some knoll-top while the sun shines on it."[9]

Commentaries on London's fog-pollution pervade the writings about the city from the first half of the nineteenth century, yet there were few significant parallels in the visual arts aside from *The Thames above Waterloo Bridge*.[10] Historians seeking pictorial evidence of the city's smoke-laden countenance have had to turn, instead, to a different time, to the paintings of the late Victorian and early Edwardian periods, particularly to the splendid Thames-side nocturnes of James A. McNeill Whistler and the evocative impressionist river canvases of Claude Monet. Artists of the earlier part of the nineteenth century tended, with few exceptions, to embrace a "celebratory" attitude toward selected aspects of the urban environment,[11] resulting in paintings and engravings that revealed generally clear vistas, sparkling facades, and informative detail; these works almost uniformly omitted significant reference to recent mechanization and the characteristic industrial and domestic fogs that plagued the metropolis. Such environmental cleansing of visual reality provoked a famous retort from Monet:

"How could the English painters of the nineteenth century have painted bricks that they did not see—that they could not see?"[12]

Turner proved the exception to this tendency. A consummate Londoner, he was born in Covent Garden and died in Chelsea, spent most of his life in the city's various neighborhoods, and participated actively in its cultural and intellectual life. In 1836 he helped evaluate John Martin's scheme for improving the quality of drinking water taken from the Thames.[13] It was fitting that he should do so since, like numerous artists before and since, he found a principal source of artistic inspiration at the banks of this river. Here he painted the London of teeming docks, waiting steamers, embankments crowded with warehouses and factories—scenes with a multitude of smoke-shrouded backgrounds. Vistas with titles such as *Old London Bridge and Vicinity*, *The Custom House*, and *The Tower of London* were as much his essays on economics and society as they were representations of well-known architectural landmarks.

London in Turner's day overwhelmed visitors and residents alike with its enormous size—*Blackwood's Magazine* declared that "amidst such a mass of human beings, individuals are overlooked and lost"[14]—and, even more, with its productive energy. Although it had long been Britain's governmental, financial, and cultural hub, by Turner's time it was also a prime center of the Industrial Revolution. Not only could one find everywhere in its port examples of the latest steam-powered transport, but within its precincts existed countless manufacturing concerns—from brewing to printing, engineering to shipbuilding— employing 15 percent of all the workers in England and Wales, and thriving on the proximity to ready capital and an enormous local market.[15] In the words of one recent historian of the city, the "scale of the larger industrial concerns in London could rival anything in northern towns, where the mills were simply more visible." Goede wrote of one London district, that of Southwark, as resembling "an old manufacturing town; [with] smutty houses of various forms . . . scattered in irregular clusters, and dense volumes of smoke . . . from fire-engines, which put in motion the machinery in the interior of these buildings."[16]

The River Thames formed the matrix of the Regency and Victorian metropolis, "the very spine of London";[17] that spacious artery of business and movement which, while bisecting the city, also linked it to England's interior, facilitated the movement of heavy commodities, and most important, provided access to the rest of the world. Turner, it has been observed, would have learned from eighteenth-century poetry how the Thames could symbolize the "commercial wealth of Britain."[18] From one of the city's bridges, Engels, that perceptive critic of modern capitalism, described the river as a scene of bewildering congestion,

caused partly by "countless ships along both shores, crowding ever closer and closer together, until at last, only a narrow passage remains in the middle." Steam technology added considerably to the confusion. *Punch*, in its first year of publication, observed sarcastically how the Thames's banks "from Vauxhall to London Bridge consist entirely of coal-barges, which leave just room enough in the middle of the stream for pleasure parties to be run down by steam-vessels." A few years earlier, the *Morning Chronicle* had reported the death of two women off Wapping when their small boat was rammed by the Woolwich steamer. The speed capability of these mechanized craft stimulated dangerous races on the crowded river, while also producing "swells" that eroded enough mud from the shoreline to prevent other vessels from resting on the bank.[19]

Since the introduction of the first of these vessels to London in 1814,[20] river steamers had quickly become popular and a source of pride to those who appreciated the benefits of modern machine technology. The travelers in Dickens's *London Sketches* considered steam power a "wonderful thing," and to the author of the 1834 *New Steam-boat Companion* it embodied a worthy testament to "the ingenuity of man," making travel between London's heart and such far-flung places as Gravesend, Nore, Ramsgate, and Margate not only efficient but pleasurable as well. Thames steam traffic rapidly expanded; in 1832 there were forty-two steamboats in active service on the river, and by 1836 an American visitor would remark on the "unnumbered steamers glancing over the crowded thoroughfare . . . [contributing to] a scene of unbounded animation and activity." To the enthusiastic writer for the *Athenaeum* of 1837, it was "a grand sight to contemplate those majestic vessels advancing up the Thames, against both wind and tide as if these obstructions were nothing."[21]

From London Turner often traveled by steamboat to Margate, his favorite seaside resort.[22] Two of his London pictures reveal something of the variety of service offered by early nineteenth-century steam navigation. The 1831 engraving *The Tower of London* (Fig. 50) shows two steamers, the *Lord Melville* and the *Talbot*, both probably packets to the Continent, judging by the traveling coaches positioned on their decks.[23] *Richmond Hill and Bridge*, circa 1831 (Fig. 51), features more open country in London's western environs, where people from the city's crowded lanes could come on a daytrip by steamer, such as the one docked at the left in the watercolor.[24] Turner's most famous Thames steamer, of course, was the tug of *The Fighting "Temeraire."*

The river steamer plays a prominent part in *The Thames above Waterloo Bridge.* Dark smokestacks receive clear articulation in the painting, lunging upward from a confused group of boats, one of which boasts a horizontal line of deck cabin windows. The two slender shafts exude an enormous amount of

heavy, black smoke tinted with puffs of grayish white steam and, for added drama, touches of golden flame from burning cinders—all indicative, perhaps, of a powerful engine surge prior to departure. One poet at the time underscored the excitement of such a quayside scene:

> Lashed into foam by ceaseless strokes
> The river roars, the funnel smokes.[25]

The inclusion of a broad swatch of black color in Turner's atmospheric composition was a simple and direct way to call attention to the presence of steam power, as Turner had often demonstrated elsewhere. Yet the telltale smoke and steam that so readily identify these vessels can also obscure their presence. Given the high volume of Thames traffic at this time, more steamboats and other boats were undoubtedly hidden beneath the colored air throughout Turner's oil, particularly in the area at the left, for according to one observer at the time, "steamboats plying continually to and fro . . . add their quota to the general impurity of the air."[26] Appropriately, many of these vessels were probably built in London, since the city had long been a leader in ship construction. By the early nineteenth century it had also become the center of the marine engine industry, with one of the most celebrated manufacturers, Messrs. Maudslay, Sons and Field, located in Lambeth, the borough at the right in Turner's canvas.[27]

Along the Westminster bank, at the left, and jutting out into the river, a variety of forms indicate the chaotic nature of Thames transportation in the early nineteenth century. In 1838 the *Nautical Magazine* condemned the inadequate "public quays," where as many as a half-dozen steamers would converge at one time. Harold P. Clunn observed that passenger steamboat companies then proliferated to such a marked degree that competition became fierce and landing places sprang up on almost every available riverside site. Eventually this became an unsightly problem: "All along the river the piers were an eyesore, a public nuisance, and an obstruction." Companies "erected long lines of rickety piers made of dirty barges planked over, at any spot that suited their convenience" and engaged in ruthless fare wars and cost-cutting to stay competitive. As a result, there developed a situation "incompatible with reasonable safety and efficiency for those electing to travel to and from the City by water."[28]

The spot Turner depicted at the lower left was an especially busy location, a prime docking area for vessels serving the Westminster area below Trafalgar Square, Covent Garden, and the Strand. Judging by its distance from Waterloo Bridge, the site was Hungerford Dock, now Charing Cross Pier. It served the

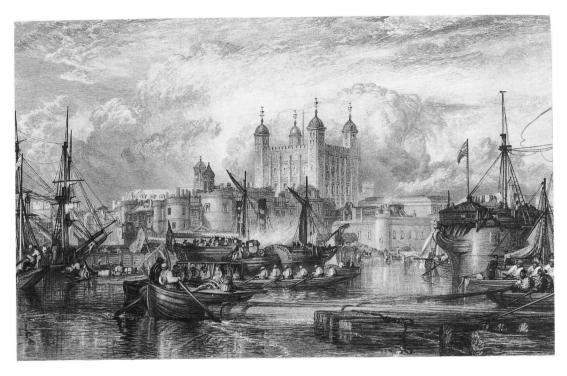

FIGURE 50. W. Miller after J. M. W. Turner, *The Tower of London*, 1831. Engraving, 14.5 × 22.7 cm. © British Museum, London.

very popular market of the same name, built to the design of Charles Fowler and opened in July 1833,[29] between the Strand and the river. The dock of this renowned Westminster enterprise, constructed to bring in steamboat customers, became "the major focus of Thames steam-navigation,"[30] along with adjacent piers downriver on the same bank, such as Waterman's and the Adelphi Wharf. On at least one occasion Turner embarked on a steamer here.[31] In 1834 the Woolwich Steam Packet Company established daily passenger service from Hungerford Dock to Greenwich, Queenhithe, and Strother's Wharf, Woolwich, using craft with such effervescent-sounding names as *Nymph*, *Fairy*, and *Naiad* (Fig. 52). Other points on the river were similarly linked, so that by 1839 the *Quarterly Review* would observe that "steamers are plying in all directions. Almost every five minutes throughout the day, a communication is going on between Hungerford Stairs, London Bridge, Blackfriars Bridge and Waterloo Bridge."[32]

One vestige of the premechanical era appears in Turner's otherwise very modern picture: the waterman's boat, with its extended oars, at the bottom right.

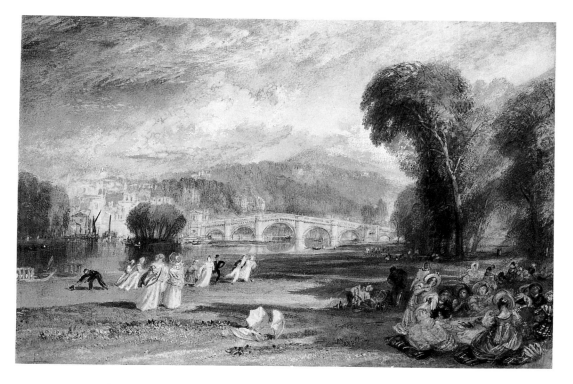

FIGURE 51. J. M. W. Turner, *Richmond Hill and Bridge, Surrey*, c. 1831. Watercolor, 29 × 43 cm. © British Museum, London.

The watermen, having rowed passengers on the Thames for centuries, fought the introduction of mechanized vessels and later caused accidents when they would "lie on their oars and refuse to get out of the way" of approaching steamers.[33] But further progress was soon at hand to threaten these tenacious but obsolete entrepreneurs. The spot from which Turner composed his painting became the site of the Hungerford Suspension Bridge, which provided yet another point of cross-Thames access. Built in part to lure to Hungerford Market "housewives from Southwark and Lambeth," it was designed by Isambard Brunel, commenced in 1841 and completed four years later.[34]

On the south side of the river Turner portrayed an area of off-white smoke and steam rising above an indistinct shoreline. This section of the Borough of Lambeth formed part of an extensive manufacturing zone, benefiting from affordable land and a ready water supply,[35] which continued downriver past Waterloo Bridge to Southwark, Bermondsey, and beyond. The sole identifiable structure in this misty expanse is the tall column of David Riddel Roper's 1826 shot

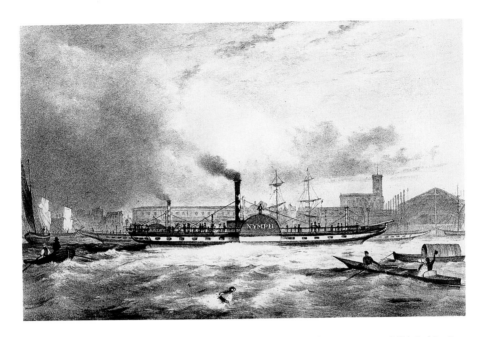

FIGURE 52. C. H. Fairland after W. Ranwell, *"Nymph," "Fairy," and "Naiad,"* 1834. Lithograph, 21 × 30.5 cm. Science Museum/Science and Society Picture Library, London.

tower, "whose lofty shaft, and turreted summit," wrote James Elmes, "smokes aloft in mid air, like a beacon." Elmes's admiring words accompanied a sparkling illustration by Thomas Hosmer Shepherd, published the following year in *Metropolitan Improvements; or London in the Nineteenth Century.* Elmes went on to praise this functional, industrial enterprise as a "beautiful tower, whose majestic and symmetrical proportions give a new and distinguished feature to this portion of the metropolis." At the top of the 186-foot shot tower workers heated molten lead and then dropped it in small amounts through the cooling air to a vat of water, from which the hardened "patent small shot, for the destruction of hares, rabbits, partridges and pheasants," was collected.[36]

Turner presented the tower half-hidden, looming out of the industrial haze (much like the shot tower in *Newcastle*) and acting as a compositional balance to the smaller, yet more dramatic, smoking funnels across the river. To its right a vague area, devoid of specific landmarks, is dominated by the effluent of what one writer of the time called "one continued line of warehouses, wharfs, and manufactories." According to *Leigh's New Picture of London* in 1834, the industrial makeup of this part of London was what "distinguishes it from any

other," a fact confirmed by John Britton's *Original Picture of London,* which listed "iron-foundries, dyers, soap and oil-makers, glass-makers, shot-makers, boat builders" throughout this district. Moreover, in many of these enterprises, Britton noted, "that powerful agent *steam,* performs the work, and steam-engines are daily erecting in others."[37] In 1829 Samuel Leigh had published a large, clearly articulated color print of the area as seen from directly across the river at the Adelphi. It was accompanied by a text that identified specific enterprises to the right of the shot tower, such as Fowler's Ironworks and the College Wharf Saw Mills, while alluding to others with "lofty chimneys belonging to steam engines." Behind and farther from the shore were an additional, unspecified array of vertical shafts, while downriver was more shot- and glass-making, as well as gas and water companies.[38]

One particularly unsavory South Bank industry was glue- and tallow-making, which thrived on the residue of the Smithfield meat market.[39] Hints of this same Lambeth industry appear, incidentally, in the right background of John Constable's 1832 painting *Whitehall Stairs, June 18th, 1817 (The Opening of Waterloo Bridge)* (private collection).[40] Constable's clear panorama reveals, inappropriately for the celebrated 1817 event, the shot tower of a decade later. Included in this painting as well is a second shot tower, opposite Somerset House, and to its right, what was probably the smoking tower of the steam-pumping engines attached to the Lambeth Waterworks.[41] At the extreme right of Constable's canvas is a flame-topped iron foundry. Unlike Turner, however, Constable made these industrial elements entirely subordinate to his clear, broad conception of ceremonial London.

If Turner's painting could be dated at or after 1836, another major Lambeth manufacturing concern would be hidden by the steam and smoke rising from the river's south bank. That year the Lion Brewery was built by James Goding on what is now the site of the Royal Festival Hall.[42] It soon became popular with artists, such as Thomas Shotter Boys, who featured its five-story facade, opposite the shot tower, in his 1842 lithograph of Westminster seen from Waterloo Bridge (Fig. 53).[43] Its opening was celebrated by a sculls competition on the river that attracted the attention of Dickens.[44] London boasted some of the country's largest malt beverage concerns, in part to satisfy the huge demands in and around the metropolis, because transportation of beer and ale was slow and cumbersome. Most famous was the plant of Barclay and Perkins downriver at Bankside, the largest brewery in the world at this time and a popular stop on the itinerary of visitors to London.[45] The more recent Lion Brewery could have greatly contributed to the area's murky environment, since steam was a crucial

FIGURE 53. Thomas Shotter Boys, *London as It Is: Westminster, from Waterloo Bridge*, 1842. Lithograph, 17.7 × 45.6 cm. © 1995 The Cleveland Museum of Art, Gift of Mrs. Ralph Perkins in memory of Coburn Haskell, 46.17.

element in the brewing process, driving pumps, cooling elements, and the all-important mashing and milling machinery: "Everywhere that steam can be used, manpower is excluded," wrote Tristan of this increasingly automated industry.[46]

Turner placed a further indication of modern London, caught in a burst of diffused sunshine, at the center of his hazy view of transportation and industry: Waterloo Bridge, called by the Italian sculptor Antonio Canova the "finest in Europe." The Prince Regent presided at its festive opening in 1817. Designed by John Rennie, it ran "perfectly level" over nine great elliptical arches, each spanning 120 feet, and was faced with coupled Doric columns, many of which are visible in Turner's painting.[47] The bridge, which stimulated development of the Lambeth area,[48] quickly became a focal point for the city. Writers at the time urged London visitors to stand on the bridge to experience the daily transformation of the modern, industrial city. Charles Mackay, the future editor of the *Illustrated London News* and author of a two-volume description of the Thames published in 1840, observed that in the clear, early morning air one could see London's numerous architectural landmarks from the bridge, as well as, in the far distance to the southwest, the bucolic "hills of Surrey crowned with verdure." But with the "haze of noon" the scene changed to coincide with Turner's painting: "After a time, the manufactories and gas-works, belching out volumes of smoke, will darken all the atmosphere; . . . all these mingling together will form that dense cloud . . . which habitually hangs over London and excludes its inhabitants from the fair share of sunshine to which all men are entitled."[49]

In Turner's painting the bridge is not only a central compositional element,

but it also forms an arcaded link between the two clouded riverbanks. And just as activity on both sides of the bridge is concealed, so too on the bridge itself all identifiable human presence is absent, although Waterloo Bridge was a stage for part of the unseen drama of this huge urban center. Mackay records that the noble structure had achieved a certain notoriety as London's "Bridge of Sighs." Because a small toll made its roadway a relatively private place, it became popular for illicit rendezvous, many of which, inevitably, resulted in suicide jumps into the river.[50] Thomas Hood used the bridge as the setting for just such a tragedy in his 1844 poem *The Bridge of Sighs*.[51]

Turner may have had this association in mind, as well as a parallel to the Bridge of Sighs in Venice, a subject that also attracted his interest during this period. In 1833 he exhibited *Bridge of Sighs, Ducal Palace and Custom-House, Venice: Canaletti painting*, followed in 1840 by *Venice, the Bridge of Sighs* (both Tate Gallery, London); *Keelmen*, furthermore, contrasted with another Venetian scene (see Chapter 4). To *Venice, the Bridge of Sighs* he attached lines from Byron that demonstrate, in the opinion of two recent critics, "that Turner saw even the beauties of Venice as a sham, concealing the grim realities on which her departed glories had depended."[52] The London depicted in *The Thames above Waterloo Bridge*, with its smoking steamers and industries and its half-obscured stone viaduct, may have represented the modern manifestation of these same feelings. Here the individual and collective existence of millions lies hidden beneath the manufactured clouds of their relentless labor.

The Thames above Waterloo Bridge continued Turner's interest in depicting the effects of modern, concentrated aerial pollution, a preoccupation since *Leeds*. His attention to the variety of color in this city's atmosphere—the whites and grays of Lambeth, the chalky streaks of brightness over the bridge, the dark gray spotted with yellow above the steamers—speaks to an awareness of the workings of natural light in such a setting, a subject that also interested some of his contemporaries. Ruskin analyzed the colors of smoke rising over a town in *Modern Painters* but later, in *Fors Clavigera*, complained of the pernicious modern, light-obscuring sky, which he dismissed as a "mere dome of ashes." James D. Forbes of Edinburgh University probed such phenomena with greater objectivity, explaining the colors associated with steam condensation in an essay published in 1839, prompted by observing steam vented from a Greenwich locomotive. He described the range of color produced by steam seen at various distances; closely observed, it was "deep orange red," whereas farther away a "steam cloud is absolutely opaque to the direct solar rays, the shadow it throws being as black as that of a dense body; and when the thickness is very small it is translucent, but *absolutely* colorless, just like thin clouds passing over the sun."[53]

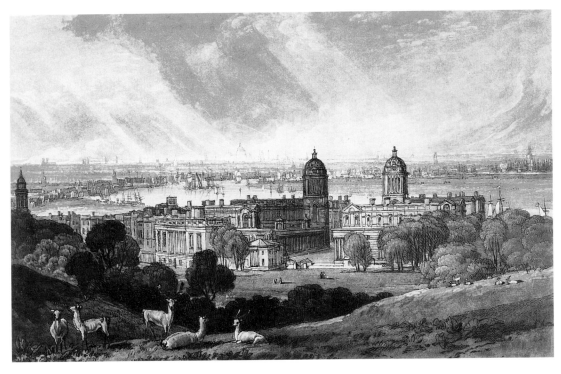

FIGURE 54. J. M. W. Turner, *London from Greenwich,* 1811. Etching, with mezzotint by
Charles Turner, 20.9×29.1 cm. © 1996 The Cleveland Museum of Art, Gift of Miss Katherine
Bullard in memory of Francis Bullard, 19.143.

Turner's painting reflects a similar interest in such impressions, while prob-
ing for deeper analysis and understanding. The verses of "The Extended Town"
(contained in his *Greenwich Sketchbook*) underline the physical as well as hu-
man dimensions of urban-industrial growth, to "the high raised smoke no pro-
totype of Rest."[54] Even London's distinguished religious monuments were ob-
scured in the choking, multicolored air of the new nineteenth-century world:

> While scarce seen thy numerous spires
> In honor reard & as the smoke aspires[55]

The immense capital's historic and architectural beauties, overtaken by the
effluent of change, figured prominently in the 1809 painting *London* (Tate
Gallery, London). This oil, engraved two years later for inclusion in Turner's
Liber Studiorum (Fig. 54), pictured the city from the far-removed heights of

Greenwich Park, a pastoral setting where herds of deer rest as if on the sheltered estate of some wealthy aristocrat. Below, the noble baroque monuments of Britain's past stand as testaments to a former prominence. Regency London, by contrast, exists upriver in the far background, in a cloudy area crowded with river traffic—a scene coinciding almost exactly with the comments of visitors approaching from the southeast. Goede would liken such distant ships to "a stately forest advancing with a slow motion" on the Thames, and Passavant would remark on first glimpsing "the grand dome of St. Paul's; the lower portion . . . being entirely lost in the atmosphere of the surrounding smoky metropolis."[56] In a poem attached to the painting, Turner brought this aspect of the city to the fore, articulating a view of London that also called attention to the human drama, what Brian Lukacher has termed "the churning life that is embroiled within the city's atmosphere spreading across the horizon":

> Where burthen'd Thames reflects the crowded sail,
> Commercial care and busy toil prevail,
> Whose murky veil, aspiring to the skies,
> Obscures thy beauty, and thy form denies,
> Save where thy spires pierce the doubtful air,
> As gleams of hope amidst a world of care.[57]

By 1825 Turner would present London smoke at Greenwich itself, placing several steamers on the river opposite the hospital in the watercolor *View of London from Greenwich* (private collection).[58] In the 1830s, the time assigned to *The Thames above Waterloo Bridge*, Turner produced a variety of works on the industrial nature of Britain's cities and towns to which, as we have seen, that canvas can be linked. Already in 1816 *Leeds* had pictured a community of distant smoke viewed from sunlit environs. But Turner's London essay places the observer in the midst of a far more enveloping haze. Compositionally, its central, lighted focus anticipates the Tyneside vista of *Keelmen*. Closest to the painting's smoky opaqueness, however, was *Study of an Industrial Town at Sunset* (c. 1830; Fig. 55), a depiction of what was probably a provincial manufacturing center. This watercolor stressed the all-consuming aerial effects of industrialism in its blurred panorama, which included a prominent factory chimney at the left spewing a plume of thick smoke, similar to the steamer discharge at the edge of *The Thames above Waterloo Bridge* but less pronounced.

At the same time, the oil painting portrayed London's "busy toil" and the "murky veil" at close hand, in a way that evoked the steam-powered source of so much of the city's dirty atmosphere. Beneath this manufactured screen, largely

FIGURE 55. J. M. W. Turner, *Study of an Industrial Town at Sunset*, c. 1830. Watercolor, 24.4 × 48.3 cm. © Tate Gallery, London, TB CCLXIII-128.

hidden from full view, worked the engine fires responsible for this modern vision. Here the regulated coal burning (something Turner would soon investigate in *Keelmen*) resembled another type of combustion that interested the painter at this time, the disastrous conflagration he immortalized in two paintings shown at the Royal Academy of 1835, both bearing the title *The Burning of the Houses of Lords and Commons* (Cleveland Museum of Art and Philadelphia Museum of Art). Turner captured the intensity of this phenomenon in a blurred mass of color capable of lighting up the entire night sky.[59] The Cleveland version in particular matches the loose handling evident in *Thames*, appropriately conveying the observer's confusion when confronting the smoke and fire of this city (Fig. 56). The 1836 watercolor *Fire at Fenning's Wharf, on the Thames at Bermondsey* (Fig. 57) conjures a similar feeling before unmanageable forces.[60] Yet the latter is a smoldering landscape resulting not from some

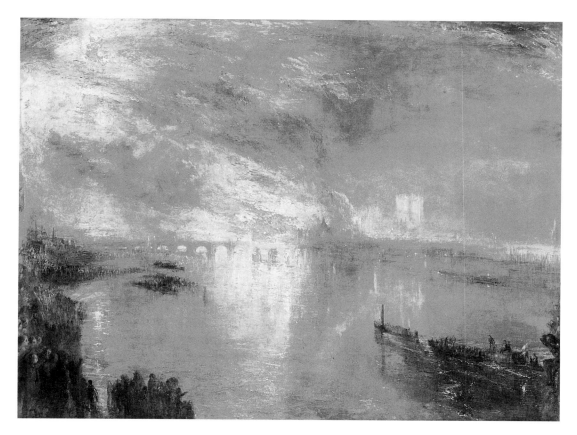

FIGURE 56. J. M. W. Turner, *The Burning of the Houses of Lords and Commons, October 16, 1834*, 1835. Oil, 92.7 × 123.2 cm. © 1995 The Cleveland Museum of Art, Bequest of John L. Severance, 42.647.

violent disaster but rather from the powerful, yet contained, fires of human ingenuity.

Thames stands as a wholly contemporary picture, devoid of historic or religious distractions. As such it is a fully realized document of the new London, the metropolis of steamboats, factories, and multitudes. This was the type of modern environment that so displeased the social critic Peter Gaskell. In his 1836 *Artisans and Machinery* he blamed modern technology for an explosion in urban growth: "One principal effect of the steam engine has been, to crowd workmen together" into settings of societal decline, where time-honored family roles disappeared, work lost its individual meaning, drunkenness increased, and overall physical well-being suffered. Charles Turner Thackrah, like Gaskell a physi-

FIGURE 57. J. M. W. Turner, *Fire at Fenning's Wharf, on the Thames at Bermondsey*, 1836. Watercolor, 29 × 43.6 cm. Whitworth Art Gallery, The University of Manchester.

cian, warned of the health dangers of urban industrial life. Studying the condition of urban workers, he noted in 1832 the large number of deaths resulting "from the injurious effects of manufactories, the crowded state of population, and the consequent bad habits of life!"[61]

One specific disease, endemic to the early nineteenth-century urban experience, became notorious. Cholera appeared in London in early 1832. Merchant ships from India may have brought it up the Thames, as could have colliers from Tyneside, where there had been outbreaks earlier. It reached epidemic proportions that year. Although it is now known to spread through contaminated water, at the time many believed it came from fetid air.[62] The presumption and the reality both can be implied in Turner's *Thames*, where putrid atmosphere hangs heavily over the sewage-choked river, the source of much of the city's drinking water.

Turner's painting came from a decade that also witnessed a more positive, but highly disruptive, London connection with the Industrial Revolution: the

railroad. The first line, the London and Greenwich, opened in 1836. It would not be long before tracks would drive into the heart of the city, huge terminals would be constructed, and masses of people would move between the city center and the ever-expanding suburbs.[63] Soon two stations would mark both ends of the expanse depicted in *The Thames above Waterloo Bridge*—Charing Cross at the left and Waterloo in the right background. One notable early railway serving London was the Great Western. This line was to be the subject of one of Turner's most memorable paintings of the Industrial Revolution.

6 *Rain, Steam,*

and Speed

The Railroad and the Victorian Consciousness

Turner's uncompromisingly modern view of busy Thames-side London leads logically to his seminal industrial painting, *Rain, Steam, and Speed — The Great Western Railway*, of 1844 (Plate 8). This daring portrayal of a railway train cutting across the golden English countryside affirmed the railroad's central place in early nineteenth-century life, its relationship to the human and natural environments, and Turner's acute understanding of its powerful mechanical character.

Turner painted *Rain, Steam, and Speed* with the freedom and richness characteristic of his mature style, features also evident in the six other paintings he had on display in the 1844 Royal Academy exhibition. Regarding one of this group, *Ostend*, the critic of the *Art-Union* confessed annoyance with the artist's penchant for haze and indistinctness: "Turner has long forsaken the world of forms."[1] In *Rain, Steam, and Speed*, blurred sections, often intense in color, alternate with identifiable subjects to produce a sense of the artist's fervent emotional involvement, grounded firmly in his own time.

The precise location can be established as the Maidenhead crossing of the Thames, looking east toward Taplow.[2] The bottom portion of the painting exposes a landscape of golden browns punctuated by touches of white, while the top half is tinged by the blue of the sky, a color echoed slightly on the meandering river to the left. This sky is stained by arched swirls of gold and white, which straighten around the advancing train, becoming vertical lines above and behind its carriages and parallel diagonals at and before the locomotive. Perhaps a summer shower is just ending, one too brief to have driven away the plowman on the extreme right or the group of people on the riverbank at the lower left, whose raised arms might allude to a passage in a popular 1839 railway guide describing the "banks [of the Thames] waving with the groves of Clief-

den, Taplow, and so many poet-hallowed scenes."[3] It is one of those transitory moments of natural variety and brilliance, always appealing to Turner's eye, in which the bright rays of the sun are just emerging through the moisture-soaked atmosphere, turned white by their energy.

Out of this complex background comes the railway train, a conspicuous study of human precision, caught for but an instant, like the fleeting weather conditions. Carried across the river on the arches of a majestic stone bridge, the train advances along dark parallel iron rails, which, because of their mechanical exactness and the way the bottom of the canvas is cropped, suggest a road of infinite length. These precise lines are echoed by the equally straight walls of the viaduct, which, together with the long rectangle of the train carriages, draw the eye back into the misty, limitless distance. Defining the rail line at two points on the canvas concentrates attention on its identifiable iron and machine elements, as well as the speed suggested in the painting's title.

The soft golds, blues, and whites of nature stand in stark contrast to the blacks and grays of industrial technology, which makes the latter all that more startling to the onlooker. Dark coloration could imply a threatening quality in industrial objects,[4] considerably enhancing their prominence, as it did for the critic of the *Morning Post:* "Nothing can be more vigorous and fine than the manner in which the delicate hues of this picture are focused by the dark monster which is advancing along the line. . . . The eye is fastened upon the coming train by its colour . . . the eye returns to the dark engine." Late eighteenth-century theory taught the association of black with those things "which minister to the convenience of life."[5] The locomotive in *Rain, Steam, and Speed*—and to some extent the carriages it pulls—speaks to such utilitarianism. Its blackness shines with a factory-made, precision smoothness (familiar in early Turner steam paintings), which reflects perpendicular lines of sunlight. Black also indicates the secondary effects of technological power, in the stains in the immediate vicinity of the track left by machine-burned coke fuel. The long stone bridge, already stained by the residue of the countless locomotives passing over it, presents a further contrast to the bright, undefiled preindustrial road bridge in the left distance.

Rain, Steam, and Speed, a large canvas occupying "the place of honour upon the sight line" of the wall of the exhibition's East Room, thus became, along with the singular evocation of the words of its title, an important and provocative essay on technology, worthy of its characterization as "the very apotheosis of the Romantic view of industry."[6] Turner's fascination with mechanized power here emerged with uncommon force, as did his interest in contrasts, which were only enhanced by the coincidental placing of this painting opposite another artist's conventionally bucolic effort bearing the gentle label *A Rapid*

Stream.[7] The opposition of industrial and pastoral in *Rain, Steam, and Speed* conferred a distinctive vitality,[8] as did the collusion of human and natural dynamics as competing energy systems, each endowed with peculiar qualities of power and mystery.

Turner's choice of a railroad subject not only fit the mood of the times but also completed his artistic program of utilizing modern technology to reaffirm fundamental truths on the human condition. At the same time it forced him to find ways to realize, with paint, the essentials of mechanized energy. Once again this artist succeeded in astounding the art world with a picture of striking singularity, in terms of both subject and execution. Although Turner was not the first artist to depict a railroad, his resolution to embrace this theme so boldly and publicly was virtually unprecedented.[9]

Railroads struck many as the outstanding achievement of the industrial era. Consider the words of one rail traveler in 1838, who wondered whether there was anything "whose influence is . . . more wide, more direct, more permanent than that of the railway." Emerson found in the locomotive's sound the very essence of the new age, in its whistle "the voice of the civility of the Nineteenth Century saying 'Here I Am.'" Brewster declared that railways embodied one of "the most striking instances of the triumph of the scientific arts," while the civil engineer and writer Francis Whishaw went so far as to assert that they represented "one of the greatest blessings ever conferred on the human race."[10]

By the time of Turner's *Rain, Steam, and Speed*, railways had become the most prominent manifestation of industrialism. A reviewer for the *Athenaeum* in 1841, noting that the current "Age of Iron" had generated a surfeit of books— "our table trembles beneath a burden of this new and voluminous literature"— traced the cause to the all-pervasive railway: "It is hardly to be conceived that there is a department of life or of literature not already permeated by the genius of iron, or a recluse so antiquated as not to experience a deep and soul-stirring interest in the practice and theory, . . . of railway bars and locomotive engines." This reviewer summed up the railroad's impact in one phrase, describing contemporary Britain as so crisscrossed with tracks that it had become "an 'iron-bound' rock of ocean." Some years earlier the *Art-Union*, a journal accustomed to addressing more aesthetic issues, felt moved to predict that railways would provide opportunities for "the greatest works of international improvement." Even the nation's most conservative elements found it expedient to welcome their arrival, as witnessed by the participation, at the opening of the Liverpool to Manchester line, of that consummate Tory politician, the Duke of Wellington.[11]

Turner's painting appeared at the moment when railroads seemed omni-

present, although in fact they had been operating for scarcely two decades. Although locomotives had pulled coal over short distances since early in the century, the first "purpose-built" railway, in 1825, ran only from Stockton to Darlington, followed five years later by the more ambitious and efficient Manchester to Liverpool route.[12] Lines cut through countryside and city with equal abandon, tunnels and viaducts eliminated formidable natural impediments, and provincial stations and metropolitan terminals became the new transportation centers. In contrast to regionalized manufacturing districts and water-dependent steamers, locomotives knew few bounds, and consequently their influence was widespread. They brought mechanization, with all its novelty and drama, its noise, smoke, and speed, to areas of the country previously untouched by industrialism, to the hills, valleys, and villages of Britain's secluded and remote regions.[13] This beneficial technology also facilitated contact and intercourse throughout the kingdom. Because of such improved communication, in the opinion of the *Athenaeum*, "dissension, discord, division, dismemberment, must become less and less possible."[14]

At the same time, the success of the railways was in itself a catalyst for economic and technological advancement.[15] Machine manufacturing, rail-making, civil engineering, and a host of other industries and activities grew with the railroads. Investment banking had to meet unprecedented demands for capital: by 1844 it was reckoned that for each year since 1832 five million pounds had been spent on railway construction.[16] Development followed the boom-and-bust cycle typical of most early industrialization. The years 1836–37 saw a "mania" of speculation and building, followed by a downturn in late 1842 and early 1843, and then in 1845 renewed activity, what John Stuart Mill called "a perfect frenzy."[17] In the years before midcentury, as one historian has aptly commented, "the railroad was a favorite emblem of progress."[18]

Turner's inclusion of the corporate identification "Great Western Railway" in the title of his painting confirmed his familiarity with what was arguably the most famous railroad of the 1840s.[19] Primarily the work of Brunel, the designer of such mammoth undertakings as the *Great Britain* and *Great Eastern* steamships and a specialist in the building of bridges and tunnels, the Great Western line from London to Bristol epitomized one of the herculean accomplishments of industrial technology at the time. Whishaw called the Great Western "by far the most gigantic work of the kind, not only in Great Britain, not only in Europe, but . . . in the whole world."[20] Under Brunel's single-minded direction, the world's first express service operated on its controversial broad-gauge tracks through the lengthy tunnel cut at Box and over the splendid viaduct erected at Maidenhead.[21] One German visitor of the early 1840s could scarcely

hide his admiration for the "most perfect and splendid railroad in Great Britain," with its "road and carriages . . . of astonishing dimensions" and its "gigantic locomotives." Innovation and expansion seemed to stimulate financial success. In the summer of 1844 *Herpath's Journal and Railway Magazine* reported that the Great Western company had voted to raise its dividend from 2½ to 3⅓ percent.[22]

The Great Western's place in the technological development of industrial Britain during the 1830s and 1840s amply justified its choice as a subject for art, as various popular prints attest. The line had been portrayed in a series of lithographs by W. W. Young entitled *Illustrations of the Great Western and Bristol & Exeter Railways*, appearing first in 1835 and reprinted in 1840. In 1846 John Cooke Bourne brought out his famous *History and Description of the Great Western Railway*.[23] Turner must have been aware of such images when he decided to acknowledge the Great Western's fame in a far more impressive way, in a large canvas displayed at London's premier annual fine arts event.

The locomotive, a somber, relatively small object approaching from the middle distance, is the most readily identifiable object in Turner's painting. Probably one of the Firefly class models, named for the 1840 prototype then in wide use (Fig. 58), this engine, with drive wheels seven feet in diameter, weighed only twenty-four tons.[24] What transforms the image of a diminutive machine into a thing of startling energy and immediacy is the patch of gold paint placed squarely on its black front. Too big, too low, and too intense for a headlight (which at that time would have lacked the power to illuminate the tracks usefully for any distance),[25] it likewise could not have been a direct portrayal of the hot firebox, since that would not have been fully visible from the front. This departure from conventional realism confused the reviewer for the *Morning Chronicle*, who queried "how engine fires blaze where no one ever saw them blaze." Yet this writer should have known of a popular 1840s habit of rendering locomotives as fire-breathing monsters. Scarcely a year after the exhibition of *Rain, Steam, and Speed*, George Cruikshank published two illustrations in association with *Punch* showing the front of locomotives as hot, smoking orifices pouring forth chaos and destruction.[26]

In an oncoming train some fires could seem visible from the front, with light emanating from behind and at the sides, the result of combustion as fresh fuel is shoveled into the open firebox. Turner accurately portrayed this by placing several daubs of crimson paint just to the bottom left of the locomotive. At night or during dark weather, however, it could appear as if most of the locomotive was aglow. "A train was coming in their direction, . . . the locomotive, lit by crimson flame," recalled Lady Simon of an incident she believed was represented

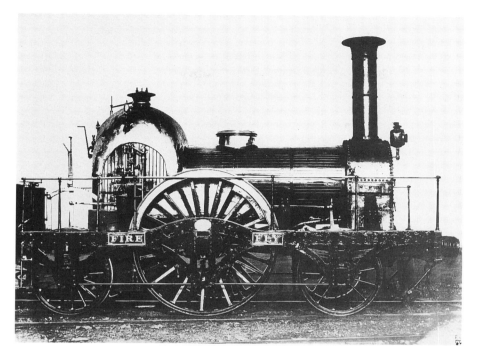

FIGURE 58. Great Western Railway locomotive *Firefly*, 1840. Photograph. Science Museum/Science and Society Picture Library, London.

in the painting. Another observer recalled a train "leaping forward like some black monster, upon its iron path, by the light of the fire and smoke which it vomits forth."[27] While Turner presented a locomotive fully glowing with heat, reminiscent of the emotional responses of contemporary witnesses, he also enlarged upon verifiable fact to reveal the temper of steam locomotion.

Blazing industry, already the subject of *Dudley*, appeared with more studied effect in *The Hero of a Hundred Fights* (Fig. 59), a later painting of the process of metal casting viewed close up, as a blurred vision of intense heat rendered on canvas with bright pigment. The fires associated with such processes could be highly symbolic of "the energy necessary to make nature's raw material useful."[28] Turner conveys this symbolism in *Rain, Steam, and Speed*, where fire reaps rapid motion from coke and water. Turner's choice of color communicates his unique ability to enter "into the boiler, the furnace, the firebox. He sees matter transformed by fire."[29] This combustion is larger than life, glowing over much of the locomotive's front and augmented by the contrasting background of black metal.

FIGURE 59. J. M. W. Turner, *The Hero of a Hundred Fights*, c. 1800–1810; reworked 1847. Oil, 91 × 121 cm. © Tate Gallery, London.

The locomotive's small, gleaming visage is pictured beside bursts of sunlight—one at a golden area above the center riverbank and another pouring through the arches of the viaduct—as if challenging nature's radiance with "the man-made and secondary sun."[30] Natural sunlight could transform the landscape, but Turner imagines human-generated fires producing exceptional feats of movement, stoked hot enough to symbolically transform black iron to crimson and white. For further emphasis, Turner bracketed this central section in an arched design, just as in earlier works he "employed a round arch enframing a burst of light to allude to a spiritual presence."[31] Here the bright area implies the engine's dangerously intense energy, contained by a horseshoe shape of black iron, itself a small counterpoint to the sunlit brick arch below. In *Staffa* and *Peace—Burial at Sea*, Turner had underscored the peculiar inner potency of machines by painting modest touches of light color in the midst of dark superstructures

and below masses of extruded black smoke. But on Brunel's railway the fire of interior dynamism had to be enlarged and exaggerated, in part to compensate for the diminished external effects, since coke, less polluting than coal, was burned during this period.[32]

One further indication of technological energy is the spherical gray area immediately behind the locomotive's chimney. It represents the metal casing over the firebox, in which water was heated and the pipe connecting the steam cylinders ended.[33] This "steam dome" of a "haystack boiler" was a conspicuous feature of locomotives of the period, necessary to prevent impure steam from entering the machine's cylinders.[34] Here it is loosely painted, giving the impression of blurred movement, as if it were bulging and ready to explode from the pressure of the pent-up steam beneath.[35] This feature, combined with the locomotive's bright, frontal luminescence, completes the overall sensation of a machine of enormous concentrated power, one that can be seen, felt, and, given the proper leap of imagination, heard by viewers of the painting as it seems to roar onward. Describing an advancing train in 1839, Francis B. Head used words that *Rain, Steam, and Speed* could well be seen to embody:

> The immense weight . . . to be transported at such a pace to such a distance, when compared with the slight, neat outline of the engine, the circumference of whose black funnel-pipe would not twice go round the neck of the antelope, and whose bright copper boiler would not twice equal the girth or barrel of a race-horse, induces the stranger to apprehend for a moment that the approaching power must prove totally inadequate to its task.[36]

The contemporary critical response to *Rain, Steam, and Speed* confirms that the art establishment gathered at the Royal Academy was prepared to receive such a novel subject. Positive reactions generally dominated in the press, although not everyone admitted to a full understanding of the painting. The *Times* saw it as a continuation of the artist's "wonted peculiarities" and "eccentric style," yet confessed that in this painting, "the Great Western in very sudden perspective, and the dark atmosphere, the bright sparkling fire of the engine, and the dusky smoke, form a very striking combination." The *Morning Chronicle* declared *Rain, Steam, and Speed* "perhaps the most insane and the most magnificent of all [Turner's] prodigious compositions." For the *Illustrated London News* it was a "picture of singular power," to the *Critic* a "composition . . . [of] striking merits." *John Bull* found it "a most extraordinary picture," and to Thackeray, writing for *Fraser's Magazine,* it was the embodiment of something remarkably new: "The world has never seen any thing like this picture," de-

clared the novelist. The writer for the *Morning Post* understood the method and value of Turner's idiosyncratic approach in this work: "Mad it may be, but this is the kind of madness which can only spring out of consummate knowledge."[37]

Nor did *Rain, Steam, and Speed* lose its notoriety after 1844. Cox quite likely intended his watercolors *Sun, Wind, and Rain* and *Night Train* (1845 and c. 1849, respectively; Birmingham Libraries and Museum, Birmingham) as references to Turner's oil. One of Turner's most talented contemporaries, Cox did not share his enthusiasm for industrial forms; consequently, these two watercolors treat the railway as a minute object on the distant horizon.[38] Around the same time, the author George Augustus Sala "borrowed" a version of Turner's title for his comic travel book *Hail Rain, Steam, and Speed*. This was no empty honor, for Sala had been deeply impressed by "Turner's extraordinary picture of a train on the Great Western Railway rushing along a viaduct in the midst of a blinding storm of rain."[39]

On the other hand, Turner's great champion Ruskin felt little affection for *Rain, Steam, and Speed,* and in a famous remark he declared that Turner painted it "to show . . . what he could do even with an ugly subject."[40] Nevertheless, Ruskin shared something of his contemporaries' ambivalence toward the new machine-driven reality. Although he would spend much of his later career condemning facets of the Industrial Revolution, earlier, in the first volume of *Modern Painters*, he admitted contemporary technology as a stimulus for renewed creativity in British art, writing that if "we are now to do anything great, good, awful, religious, it must be got out of our own little island, and out of . . . railroads and all."[41]

Modern writers have accepted the painting's central place in Turner's oeuvre, as well as in the art of the early nineteenth century, but some disagree over the artist's attitude toward the railroad. John Gage, in his extended discussion of the work, finds Turner celebrating the Great Western and the affirmation of progress it embodied, a view challenged by John McCoubrey, who sees *Rain, Steam, and Speed* as Turner's protest against the machine's despoliation of the environment, in this case a lovely section of Thames landscape long dear to the painter.[42]

Historians of technology and culture have approached the work in a more straightforward manner, seeing it essentially as a key early document on the rise of steam industrialism. Over sixty years ago one writer suggested that Turner stood out from other Victorians in his ability to foresee the enduring impact of the early railways. Around the same time, Nikolaus Pevsner pointed to *Rain, Steam, and Speed* as a clear indication of Turner's "delight" in mechanization, while by 1947 Francis D. Klingender would declare it "one of the great tributes

of the Victorian age to steam." The American writer Lewis Mumford linked the painter with Tennyson, Thoreau, and Emerson as someone who "saluted with admiration the locomotive, that symbol of the new order in Western society." Turner, according to Mumford, along with the others in this illustrious group, was "conscious of the fact that new instruments were changing the dimensions and to some extent therefore the very qualities of experience." As a piece of cultural evidence, *Rain, Steam, and Speed* occupied a unique place for this critic of modern culture, as "perhaps the first lyric expression of the steam engine," a point echoed most recently by Julie Wosk, who termed it "an iconic statement of the nineteenth century's sense of technological imperative."[43]

All these commentaries fix on the novelty of the painting's central image while neglecting its emotional impact, its ability to communicate the dangerous, fiery energy of technological power with "expression." At the time of its first showing, *Rain, Steam, and Speed* seemed to attract as much attention for its affective qualities as for its subject matter. One such quality was the sense of determined movement it communicated. With its blurred detail and atmospheric effects, the canvas presented a marvelous and unprecedented realization of mechanized power. The *Critic* attributed this side of Turner's success to his "*characteristic* extravagances." This journal went on to say that "it is difficult to conceive the *idea* of speed more ably conveyed than it is here." The normally cautious *John Bull* was equally forceful in praising the manner in which Turner got his message across: "[The painting] is remarkably spirited, and conveys admirably to the mind all the ideas suggested by the title. The clouds are driving, the rain is pelting, the engine is snorting, puffing and the whole scene excites the sort of agitated feeling which the occurrence represented would create."[44]

The words "agitated feeling" underscore the painting's romanticism, a quality which, understandably, was not lost on other observers, who seemed to see movement everywhere; "whirlwinds, cataracts, rainbows . . . spattered over the incomprehensible canvas," wrote the critic of the *Morning Chronicle*. For this writer, Turner had succeeded in evoking the actual presence of rail power, indeed to the point of making the critic feign alarm at the lifelike image of a "train . . . bearing down on the spectator at the rate of fifty miles an hour." Such was the power of the illusion that Thackeray jokingly warned his readers "to make haste to see [Turner's locomotive], lest it should dash out of the picture and away up Charing Cross through the opposite wall." The reviewer for the *Critic* took this immediacy even further: "One is absolutely almost afraid to stand before the advancing train," so realistic did it appear.[45]

Indeed, part of the effect would have been auditory. Paintings, of course, are silent, but the loud noises known to emanate from such a hissing, clanging ma-

chine would have added to the artist's inspiration, complementing the doctrine he may have gleaned from earlier theorists that linked sounds to "ideas of great power or might."[46] To those who studied the canvas during the early railroad age, sound could hardly be absent from their assessment. As Philip Gilbert Hamerton wrote sometime later, Turner's intent was "to give the idea of 'Rain, Steam, and Speed,' much more than the portrait of a steam-engine or a view of the Great Western Railway."[47] To many who saw the painting in 1844, he succeeded in this very well.

Rain, Steam, and Speed communicated many of the sensations associated with early railroads but conspicuously absent in the rather static and matter-of-fact railway art of the time. A case in point is the 1831 series by Thomas Talbot Bury, *Views of the Liverpool and Manchester Railway*—colored aquatints described as "careful, clear and sunny," in which "everything is bright and spotless."[48] Perhaps the most famous railway views came from Bourne, who published his lithographs of the London and Birmingham Railway in 1838, with views of the Great Western appearing eight years later. These drawings were likewise light and airy, with so little of the disruption and soot of technology as to make one reviewer at the time wonder if the artist had not made the new railways more attractive than they actually were—a supposition that Bourne's rendition of the Maidenhead Bridge confirms (Fig. 60).[49] Some painters interested in a more restrained modernism opted for removing trains from center stage and making them incidental elements in broad, panoramic landscapes. In Thomas Cole's 1843 canvas *River in the Catskills*, for example, a meandering locomotive is nearly hidden from view by surrounding foliage and rocks.[50] It fell to Turner to evoke the unique power and novelty of the railroad, both in paint and in words, in the aptly titled *Rain, Steam, and Speed*.

The Great Western trains pressed over environmental obstacles; they employed an army of highly skilled specialists and demanded rigid rules and schedules of operation.[51] The loose handling of paint conveys the excitement mixed with terror that characterized the early railroad age. At that time people could still be startled by the spectacle of this technology, capable of being left "gaping with wonder" before what Gage has termed its romantic horror.[52] In Turner's hands the locomotive and cars became one splendid, subjective study in mechanical force. From its shiny smokestack—successor to the tug's funnel in *The Fighting "Temeraire,"*[53] if not to the steamers of the Seine series—smoke spews into the air, only to be left behind by the train's tireless advance. Below this chimney, the iron casing of the prodigious machine curves down to meet the seven-foot rails of the mighty broad-gauge line. One might well feel insignificant beside such extraordinary machines, which, once set in motion, proceed

FIGURE 60. John Cooke Bourne, *The Maidenhead Bridge*, 1846. Lithograph, 29 × 43 cm. Science Museum/Science and Society Picture Library, London.

with relentless, careless momentum. Dickens's often-quoted description of a rail journey from Leamington to Birmingham in the 1846 *Domby and Son* evokes a train that has become "the triumphant Monster, Death," possessed of a power "defiant of all paths and walls, piercing through the heart of every obstacle," and—as if echoing the reactions to *Rain, Steam, and Speed*—"it shrieks and cries as it comes tearing on resistless to the goal."[54]

The potency of Turner's startling picture owes something to his romantic use of pictorial elements associated with the previous century's philosophy of the sublime, especially in its emphasis on powerful, large objects that were often dark or obscure and conveyed a feeling of terror. These qualities were present in trains, as were those "sublimities" of the 1840s noted by Ruskin, the "blackness, fire, and fury of the engine itself, . . . the length of the line, . . . the height of the embankments."[55] Yet in *Rain, Steam, and Speed*, as elsewhere in his art, Turner went beyond this theory, stressing imagination over observation.[56] For him, arresting incidents or objects were to be analyzed, probed, and finally exaggerated through the lens of human understanding. *Rain, Steam, and Speed*'s opaque atmospherics, the backward streaks alongside the speeding train, and most telling, the frontal luminescence all testify to the artist's need to convey and amplify features that give the scene its special, dazzling power. The romantic

artist, more than his sublime predecessors, delved inward, into his own responses or the motive underpinnings of the subject, to suggest, without slavish regard to constraints of naturalistic convention, what he saw and felt to be the source, the essence, of the reality he chose to depict.

Turner's success in capturing the element of alarm in *Rain, Steam, and Speed* benefited from the popular Victorian view of railroads as more than an occasional physical hazard to passengers, operators, and bystanders. This menace predictably engendered fear, but also a certain fascination. Explosions, collisions, derailments, many the result of movement at unprecedented speeds, all contributed to the romantic effect. Almost from the dawn of the railway age injury and death had figured in this form of progress. The famous 1830 accident at the opening of the Liverpool and Manchester Railway, at which the statesman William Huskisson was hit by a train and died, was one of the earliest railroad tragedies. The uncertainties of the new transport as late as 1842 prompted the journalist and clergyman Sydney Smith to plea for unlocked carriages on the Great Western (carriages were locked to prevent occupants from opening doors while the train was moving), so that passengers could escape during a mishap, instead of, as he gently put it, sitting quietly while the machine and its appendages "are pounding you into a jam, or burning you into a cinder, or crumbling you into a human powder."[57]

Violent injuries and deaths involving locomotives occupied a salient place in the early Victorian consciousness, occurrences of which Turner was certainly aware. Indeed, there seemed to be an inordinate preoccupation with the bodily harm performed by these erratic machines. The *Annual Register*, a chronicle of significant events published each year since the mid-eighteenth century, reveled in presenting sensational descriptions of such unhappy events in the decade before Turner's painting. For November 1838, for example, it reported how an engine at Whiston "exploded, with a noise resembling the firing of cannon." The engineer and fireman "had been blown into the fields on either side of the road . . . both men dreadfully scalded." That summer, on the London and Birmingham Railroad, an injured attendant had been unable to receive immediate attention because "the train, owing to the velocity with which it was going, went on near a mile before it could be stopped."[58] In 1840 the newspaper *John Bull*, which would later acknowledge Turner's success with *Rain, Steam, and Speed*, editorialized sarcastically on the railway menace:

> It is gratifying to know that coffins and stretchers are always ready at the different stations, and a new regulation is in course of completion, by which every passenger on all the lines . . . will be supplied with a label, to be suspended around

his neck, so that when the crash comes, his bones, head, etc., may all be care-fully collected, and sent home to his expectant relations and friends, according to the address on the ticket.[59]

The Great Western figured in one of the most dramatic incidents of the era when, in late 1841, the Bristol train crashed at Sonning, just outside Reading. Eight people were killed, and the opponents of railways had another case with which to bolster their arguments.[60]

That same year a fatal incident on the Great Western testified to another of the railroad's pernicious qualities, one present in Turner's painting: its perilously mesmerizing attraction to bystanders. Near Maidenhead a sawyer and his brother ventured onto the line "to see the Great Western train pass by." Then, according to the report, they "fell asleep on the embankment till aroused by the approach of the train, when the sawyer, instead of moving off the line, went further on it, so that his head was caught by one of the carriage steps; and be-ing thrown under the train, he was almost instantly killed." Commenting in 1850 on this peculiar, and often deadly, attraction of speeding locomotives, Diony-sius Lardner wrote in his *Railway Economy:* "Persons on or near railways ap-pear to be seized with a delirium or fascination which determines their will by an irresistible impulse to throw themselves under an approaching train."[61]

To many train passengers, mechanized movement could be an invigorating experience despite the hazards. Consider Fanny Kemble's 1830 excursion by rail: "You can't imagine how strange it seemed to be journeying on thus, with-out any visible cause of progress other than the magical machine, with its fly-ing white breath and rhythmical, unvarying pace." Riding in an open carriage, she marveled at the sensation of speed (at that time, thirty-five miles an hour): "I stood up, and with my bonnet off 'drank the air before me.' The wind, which was strong, or perhaps the force of our own thrusting against it, absolutely weighed my eyelids down." A writer for the *Quarterly Review* would allude to a similar feeling nine years later, remarking that a train passenger "can scarcely conceive the sensation he experiences" traversing the greatest distances with such new energy.[62]

Carlyle, the skeptical critic of many aspects of the new industrial age, nev-ertheless responded effusively to rail travel. In September 1839 he wrote of a night excursion: "The whirl through the confused darkness, on those steam wings, was one of the strangest things I have experienced—hissing and dashing on, one knew not whither." On a journey from Leeds in April 1844 he likened the locomotive to a "Steam-horse; entirely a wondrous business!" The tech-nology defied rational comprehension as he and his wife sped along, helpless,

toward Manchester, "as driven by the devil,—the *Steam*-Devil," or as Jane Welsh Carlyle put it, "like one shot out of a cannon."[63] Surely Turner—who only two years before *Rain, Steam, and Speed* claimed he had been strapped voluntarily to the mast of a steamship paddling furiously in a snowstorm (see p. 82 above), and who reportedly delighted in moving trains (in Lady Simon's account, discussed below)—was attuned to these experiences. For Turner as artist and as traveler, the actual episode of movement along the rails, now more than ever, became a matter for serious reflection.

Speed, with all its consequences and rewards, is an essential element in Turner's painting. One of the principal benefits of modern technology that Turner had so far not recognized in his work, it is accented in the title as well as in the representation of the train's progress. Recent writers have seen in the speeding train crossing the languid river—the highway of the past—a nostalgic comment on the accelerated pace of modern life.[64] With steam-powered locomotion on land reaching record speeds, the champions of the Industrial Revolution had another achievement to celebrate. For some, particularly in America during this time, velocity proclaimed the mechanized conquest of nature, the phenomenon of "nature conceived as space," or simply "another example of the human attempt to defeat time."[65] More and more it was the quickness of movement that counted. Writing in 1830, during the formative days of rail, the civil engineer George Buchanan remarked that one train on the Liverpool and Manchester line moved "at the rate of twenty and even thirty miles an hour," with an ease and grace of motion, according to one witness, "more resembling . . . the flight of a winged animal." Eleven years later a reviewer for the *Athenaeum* would praise the railway locomotive as "the Vulcanian Pegasus" capable of attaining a speed of fifty miles an hour![66]

Fifty miles an hour was a convenient, round number that resonated with Victorian viewers, both at the exhibition and in subsequent reviews of Turner's painting. On the Great Western, built on a broad gauge to facilitate such high speeds, one engine actually achieved this rate, as an average, over a distance of slightly more than thirty miles in 1840.[67] In February 1844, when the Great Western was opened to Exeter, the train that made the inaugural journey to London averaged 41½ mph.[68] Testifying before the Select Committee on Railways a year later, George Stephenson, while recommending moderate rates of no more than 40 mph, did agree that 50 mph could be attained with safety "on a level railway."[69] This statement, coming from one of the great engineers of the age, may have stuck in people's minds, to be resurrected in the reviews of *Rain, Steam, and Speed*. The fastest trains were those assigned to passenger service, like the one Turner portrayed (as indicated by the curved coaches behind the engine and

tender); its specific, functional construction would have permitted it "to draw light loads at great speed."[70]

Speed produced a new reality, which Turner rendered in smudges and smears of vigorously applied paint. The traditional landscape became a series of quickly perceived or blurred images to the train rider,[71] while the moving locomotive had a similar effect on the stationary observer as it darted in and out of sight. In both cases images became ever more transitory, defying thorough examination. As a writer styled "Phoenix" noted in 1838, "you pass through the country without much opportunity of contemplating its beauties."[72] Modern critics have argued that the train introduced "a sense of space which few people had experienced before," because "the succession and superimposition of views, the unfolding of landscape in flickering surfaces as one was carried swiftly past it . . . compressed more motifs into the same time." This rapidly changing panorama allowed "less time in which to dwell on any one thing." The torpid sequence of impressions noticed by steamboat travelers now became a heightened shrinkage of space, creating "the ability to perceive the discrete, as it rolls past the window, indiscriminately."[73]

One guide to the Great Western, from 1839, pointed out how the very construction of the line altered expectations for sightseers: "A great part of the road is sunk too low to afford a view of the country, but the beautiful scenes which present themselves at different openings, more than repay the temporary privation."[74] Speed now left passengers with a quick, furtive collection of outward impressions, at once exhilarating and unsettling. Already in 1830 an American visitor recalled a ride on a British railway in terms that capture the mood of Turner's painting of fourteen years later:

> While the passing objects appeared to whirl by with dizzy swiftness, occasionally, carriages from the other direction shot by us with their sparkling furnaces, leaving a train of smoke and fire behind them. We had scarce time to take note of their presence before they had passed us with the *whir* and speed of a rocket; *a mist of wagons and races*, visible for a moment, then gone![75]

Turner's canvas called to mind just such excitement. In one case it evidently awakened a specific memory: Lady Simon, the wife of the surgeon Sir John Simon, claimed to have been present at the incident that inspired Turner's painting. While the veracity of her claim has justly been questioned,[76] her testimony nonetheless shows how Turner's painting spoke to contemporary views of speed and technological energy. Simon, according to one version of the story, witnessed the scene from a horse-drawn coach taking her to the station: "A train was com-

ing in their direction, over one of Brunel's bridges, and the effect of the loco-motive, lit by crimson flame, and seen through the driving rain and whirling tempest, gave a peculiar impression of power, speed and stress." Simon was summoned by a fellow passenger, an "old gentleman" she suggested was Turner, who, "craning his neck out" the window, directed her attention to the "curious effect of light." A second version of the story placed her in a first-class railway compartment, looking out the carriage window into the inclement weather as the train was leaving Bristol station. There she perceived "such a sight, such a chaos of elemental and artificial lights and noises, I never saw or heard, or expect to see or hear."[77] In both accounts Lady Simon remembered the incident on the train after the mind-jolting experience of seeing *Rain, Steam, and Speed* at the Royal Academy.

In this work Turner portrayed high-speed mechanized movement as a moment frozen on canvas. As an early twentieth-century critic put it, "Turner was not painting the fact of an engine; but the effect of an engine rushing through rain and mist."[78] The painting's opaqueness, its essential indistinctness, tempered in places to reveal key elements (such as the central locomotive and its attached carriages), contributed to its success as a vision of racing machinery. Such painterly elements, so often denounced by the period's critics, here struck a responsive chord—hence the *Morning Chronicle*'s attention to the "wonderful effects" the artist employed to convey the presence of the train and Thackeray's feigned alarm.[79] Evidently they were prepared to accept Turner's loose handling, his "effects," because this technique succeeded in creating the illusion of what speed seemed like to them.

Turner used a number of devices to achieve this all-important illusion, from the daubs of grayish white steam or smoke placed on a plane behind the smokestack to the faint dots of white paint that run parallel to the top of the carriages. These connote the force of the great machine pushing through the moisture-laden atmosphere, as if cutting a path in its own straight image. Alison had written earlier that "rapid motion, in a straight line, is simply expressive of great power."[80] Indeed, other straight lines accentuate this feeling: parallel black lines mark the width of the viaduct's parapet, and thin streaks of brown tinged with black before the locomotive, which represent the rails, carry the viewer's eye to the right, anticipating the train's deliberate path to an unseen area. By having the train emerge from an enveloping storm at the center of the canvas, Turner heightened the viewer's surprise in confronting the momentarily visible machine.

Through its title and its content, *Rain, Steam, and Speed* stressed the interaction of nature and mechanized movement, by now a familiar Turnerian theme. As in *Staffa* and *Snow Storm*, recent human invention confronts turbulent

weather. One modern writer alluded to how the "forms of the locomotive and the smoke merge into the storm, thus equating the steam with the violent forces of nature."[81] These forces act in opposition as the locomotive rushes into the sunlight, liberating its carriages from the freely painted, enveloping atmospheric grip—nature as vague, ill-defined, and ultimately incomprehensible energy, in contrast to the discernible machine created by human intellect. Yet here the threat to mechanized power is minimal, unlike in many of Turner's steamboat paintings.[82] To be sure, the weather might diminish visibility and so lead to an accident, but this eventuality appears unlikely as the train moves toward a clearer, sunlit area. Scientific enterprise, as embodied in this machine, is more confident, less obviously endangered by the capriciousness of nature. It is relentless, too, in fulfilling the primary functions of early rail technology: limiting "the resistance caused by friction" and "leveling the irregularities of the terrain" with smooth approaches, viaducts, and tunnels.[83]

But the painting is not entirely a celebration of the machine over nature. While free of the threat of avalanche or gale, the speeding locomotive, with its passenger carriages, challenges the fundamental laws of physics as it drives heedlessly out of the obscure background, over a seemingly feeble bridge, toward the unknown at the right. In some ways it is emblematic of the impetuosity that characterized the line and its engineer. Brunel was famous for conceiving grand projects and taking considerable risks, which resulted in a mixture of failure and success. The audacious broad-gauge plan proved a costly mistake, because it inhibited integration with previously laid narrow-gauge lines serving other regions of the country.[84]

The Maidenhead Bridge, which carries the train over the Thames, was another story. This "magnificent viaduct of the Great Western Railway," completed in 1838 and later illustrated by Bourne in his sparkling manner (see Fig. 60), appears opposite the sloping, aging stone road bridge of 1772 in Turner's painting.[85] Brunel used two 128-foot arches for the new bridge, at the time "the largest which have ever been constructed in brick,"[86] so as not to impede navigation below; skeptics erroneously predicted that the bridge would not remain standing for long. In accenting one of these bold arches with streams of radiating sunlight, Turner gave the bridge a vague and rather insubstantial look, which perhaps reflects still-lingering doubts about its structural integrity. As one of the artist's early twentieth-century biographers was prompted to object, "One cannot help thinking that Brunel built a rather more solid fabric than is here suggested."[87] Such an implied danger only heightened the excitement of a scene devoted to a risky, accident-prone new technology.

The new viaduct, here seen as an appendage of the threatening locomotive,

FIGURE 61. John Martin, *The Bridge over Chaos*, from John Milton, *Paradise Lost*, 1827. Mezzotint and etching, 19.1 × 27.2 cm. Yale Center of British Art, Paul Mellon Collection.

may have a sinister quality as well, if, as seems likely, Turner was acknowledging a visual construct that his friend and fellow painter John Martin had established. The latter's *Bridge over Chaos* (Fig. 61), an illustration for an 1827 edition of Milton's *Paradise Lost*, presented an arcaded viaduct to complement the verse lines "a ridge of pendent rock / Over the vexed abyss, following the track / Of Satan" (10.313–15). Turner surely knew this Martin work, in either its original version or the 1838 reprint, as well as Milton's poem, which he himself illustrated for publication in 1835.[88] Turner may have found the satanic parallel ("the track / Of Satan") appropriate to the popular demonic image of the railroad current during these years. Possibly he derived the likeness of the Maidenhead Bridge from Martin's hellish bridge, as a friendly challenge to a fellow painter who, although he had trained as a civil engineer and had traveled in a locomotive during the speed trials on the Great Western in 1841, avoided de-

picting industrial subjects.[89] Like the structure painted by Turner, Martin's *Bridge over Chaos* rests on arches created with technological precision and crowned with a smooth, level surface. The dramatic lighting Martin used to envelop the top left of the bridge as it extends into the unknown and to highlight the figures in the right foreground is also echoed by Turner, whose glowing engine bursts forth from the bright mist at the center of his painting like a demon hurtling both from and toward the unknown.

This association is not to imply that Turner condemned technology in *Rain, Steam, and Speed*. While the painting bears witness to the railroad's relentless intrusion into bucolic England, a symbol of the unstoppable modern "world of power and complexity," it gives no hint of the technophobia voiced by Ruskin ("iron roads are tearing up the surface of Europe") or Wordsworth ("the molestation of cheap trains pouring out their hundreds [of visitors]").[90] Instead of expressing "resentment of the despoliation of a valley," as some have argued,[91] the peripatetic Turner would probably have agreed with the Tory politician J. W. Croker, who, in a letter of 1844 to a constituent who had complained of how a new rail line was about to damage a picturesque area, declared that "a train, enlivens *en passant* the uniform features of nature. . . . A railroad runs through the beautiful valley of the Derwent, and I think that triumph of art sets off, as well as renders more accessible, the natural beauties of the scene."[92]

Not only did Turner devote much of his career to accommodating the Industrial Revolution, but he also recognized the value of new inventions, particularly railroads, in quickening the pace of travel. A letter of 1840, for example, spoke enthusiastically of the soon-to-be-completed rail line to Brighton and the advantages it would afford when engines christened "Rapid Dart or Quicksilver" would convey their passengers to London.[93] Turner's attitude fits with the enthusiastic descriptions of railway progress published in the learned magazines of the day. The *Quarterly Review* gave considerable space to the new developments, as did the *Edinburgh Review*. Pieces like the 1839 discussion of railways in Ireland spoke directly to the merit of steam locomotion on land, while essays on science frequently lauded the advantages of the new machines. One of the *Edinburgh*'s regular (anonymous) contributors in this area was David Brewster, who, in reviewing several books on James Watt in 1840, praised locomotive power, which "outstrips the antelope in its speed, and . . . propels, with almost equal velocity, *a hundred loaded wagons*, or carries along with it the whole rank and file of a regiment."[94]

Finally, in *Rain, Steam, and Speed* there emerges something of the British patriot. Like Carlyle, Turner questioned aspects of industrial development but took

pride in his nation's technological accomplishments, already the focus of his factory-town and steamboat pictures.[95] The railroad was a particularly apt symbol of national achievement, for not only did Britain embrace it eagerly, but the locomotive—unlike the steamboat, which was credited to the American Robert Fulton—was a uniquely native invention. For the engineer Stephenson it was "not the invention of one man, but of a nation of mechanical engineers!"[96] This is the spirit that informs *Rain, Steam, and Speed*.

Conclusion

When the Crystal Palace opened, in May of 1851, the Great Western provided transportation for many of the more than six million visitors. Its London terminal, very close to what would in a few years become Brunel's Paddington Station, stood just across Hyde Park from the mammoth glass enclosure. All of Britain's railroads played an essential part in the success of the exhibition, providing what the *Westminster Review* termed "that especial portion of utility without which this huge compendium of human civilization" would scarcely have been possible. Trains brought building materials and displays to the site and conveyed numerous dignitaries to this most spectacular of attractions, this unprecedented assemblage "of the Works of Industry of All Nations." Inside the Crystal Palace the Great Western Railway Company attracted special attention with the display of its novel system for laying iron rails and, most remarkable, its sparkling new locomotive. Christened Lord of the Isles, it weighed more than fifty tons (when loaded with coke and water) and rested on drive wheels of over eight feet in diameter. It won high praise from the reviewer as "a specimen of very beautiful workmanship, . . . said [to] . . . take one thousand passengers at great speed."[1]

Turner had watched as the great enclosure rose opposite Princess Gate, reporting details of its construction in some of his very last letters. Late in December 1850 he criticized the pace, although completion was but a few weeks away: "The Crystal Palace is proceeding slowly I think considering the time, but suppose the Glass work is partially in store, for the vast Conservatory all looks confusion worse confounded."[2] His correspondent was Francis Hawksworth Fawkes, son of his long-deceased friend and patron Walter Ramsden Fawkes. Turner's reference to the glass work may have triggered the memory

of his own unexecuted design, over three decades earlier, for a far smaller glazed "conservatory" at the Fawkeses' Yorkshire estate, for which he produced the watercolor *Conservatory, with memorial window, Farnley* (c. 1818; private collection).

Throughout these winter months of 1850–51, the elderly artist probably made a number of trips to the exhibition site, situated conveniently between his Queen Anne Street gallery and his residence with Mrs. Booth in Chelsea. His letter to Fawkes reporting further progress of 31 January 1851 displays a keen familiarity with the building, no doubt born of personal observation. "The Crystal Palace has assumed its wonted shape and size. It is situated close to the Barracks at Knights Bridge, between the two roads at Kensington and not far from the Serpentine: it looks very well in front because the transept takes a centre like a dome, but sideways ribs of Glass frame work only Towering over the Galleries like a Giant."[3]

Much about this amazingly modern edifice could have impressed Turner, the perceptive chronicler of the Industrial Revolution, the romantic witness to the grandiose achievements of recent technology. The building's colossal, 1,848-foot length; its precision prefabrication; its "giantlike" galleries housing over 7,300 exhibitors; its displays of locomotives, farm machinery, and the great hydraulic press used to raise the Britannia Bridge;[4] all would have engaged his thoughts and stimulated his emotions in his final days.

Turner died in December 1851, only a few months after the Great Exhibition closed. He had lived to see the popular celebration that culminated a century of extraordinary improvement and change, a period of the Industrial Revolution distinguished by separate but interrelated upheavals in textile manufacture, iron casting, steam-generated power, and urban growth. As a lifelong resident of London, Turner had contact with more aspects of the Industrial Revolution than he would have had he lived almost anywhere else. He must have breathed the foul air of the city's industrial and domestic fires, been jostled on its teeming streets and lanes, confronted towering buildings dedicated to commerce, traveled the Thames on steamers, and witnessed the construction of proliferating rail lines and their mammoth terminals. Finally, he may have watched the assembly and dismantling of the Crystal Palace, one of the most ingenious structures of this industrial age.

Turner's steamers and mills legitimized the technological and economic achievements of this era as subjects of art. Until the early decades of the nineteenth century, images of smoking industry had been largely the purview of popular illustrators whose cheap prints adorned countless shop windows or provincial artists who catered to the utilitarian tastes of a local clientele. While some

fellow academicians inserted steam-driven objects into their works, none did it on the scale of Turner or with the confidence he demonstrated. In his hands, machines and workshops, heretofore simple curiosities, became objects of sophisticated admiration, intelligent metaphors for human aspiration and weakness. To communicate the essential qualities of machine technology, Turner sharpened his technique and focused his vision. Just as he had developed new ways to approximate the transcendent power of nature, he now adopted intense chromatic effects and loose textures to convey the motive force of machines.

Turner accorded machine technology a key place in his artistic program. Elizabeth Helsinger has pointed to several of the contemporary references in the *England and Wales* series as Turner's way of attacking the "European tradition of historical landscape painting."[5] But his industrial subjects make a far stronger case for this challenge. Elegant watercolors destined for the collections of connoisseurs, subtle engravings prepared for expensive publications, and large, elaborate oils executed for display at the most prestigious fine art exhibitions proclaimed the value of engine and factory and proved them worthy of serious artistic consideration. During the last decades of his life Turner went even further, making steam-driven technology the central focus of some of his supreme achievements as a painter. In canvases bearing such avowedly contemporary titles as *Keelmen heaving in Coals by Night, Snow Storm—Steam-Boat off a Harbour's Mouth,* and *Rain, Steam, and Speed—The Great Western Railway,* Turner elevated everyday industry to the level of high art.

A skilled colorist and draftsman, a master of line and light, he knew how to accent industrial subjects, how to render them special, even beautiful—to pursue Shelley's dictum of adding "beauty to that which is most deformed."[6] Thus the tug in *The Fighting "Temeraire"* is not some paltry worker, accidentally encountered, but rather a colorful, vital object meriting considered notice. Turner could convert the meanest industrial setting into a classical vision of timeless serenity. *Keelmen* advances less the image of dirty coal-loading at grim Tyneside than that of a grand nocturne, in which the lunar light softens and universalizes the harsh world of manufacturing and commerce.

And yet the arts establishment, unlike the philosophers, writers, and politicians of the era, only slowly admitted the validity of such an undertaking. Turner's steam paintings hastened this recognition. They attracted considerable critical attention which, though at times dismissive and sarcastic, for the most part came to accept the depiction of this salient feature of modernism. What difficulty Turner had with the critics usually stemmed from his romantic freedom of expression and what was perceived as technical and stylistic excess, not his choice of subject matter.

This romantic sensibility lay at the core of Turner's industrial art. For him objective reality was a stimulus for intuitive involvement, imaginative perception, and emotional reaction. When drawing steam engines and furnace fires, he delved beneath the surface to extract visual confirmation of the energy he sensed in the thing observed. At the same time he communicated the excitement of encountering novel industrial activity. Another aspect of Turner's romanticism was his fascination with humanity's vulnerability before nature. For this acknowledged master of marine and landscape painting, nature consistently impressed with its variety, capriciousness, and might, evoking the most profound human responses. He felt especially drawn to those things in nature that arrested attention, those special times when the earth seemed most radiant, alive, or threatening. Golden sunsets, black thunderclouds, swift-flowing streams, and churning oceans became favorite subjects.

Against this highly charged conception of the world, Turner considered the implications of machine technology, asking if steam power could mitigate nature's power. While intrigued by the spectacle of industrial prowess and alive to the benefits machines promised, Turner nonetheless departed from the effusive confidence of his age to argue the limitations of these recent examples of human enterprise. Repeatedly he depicted the contest between energetic steam power and superior environmental forces. For him, nature would always remain omnipotent.

In spite of Turner's inventive themes and techniques, his industrial art can also be characterized as an exercise in caution. His paintings on steam subjects were relatively few, and although they include highly significant efforts, they were never the dominant feature of his work. Paintings such as *The Fighting "Temeraire"* and *Rain, Steam, and Speed,* which stand out as testaments to the artist's provocative spirit, appeared before the public in conjunction with Venetian, classical, or marine works conceived, although not necessarily executed, in the established manner. That Turner presented two conspicuous steamers at the 1842 Royal Academy exhibition was an exceptional acknowledgment of industrial technology. His engraved work displays a comparable prudence in the ratio of industrial to traditional subjects.

The dates of Turner's steam paintings reveal a similar conservatism. Steamboats first achieved prominence in his work around 1832, twenty years after the sailing of the *Comet* on the Clyde. *Rain, Steam, and Speed* came before the public almost fifteen years after the opening of the Liverpool and Manchester rail line. Clearly Turner knew that time had to pass, the public had to have sufficient experience with the new technology, and popular images and the efforts

of rival artists had to develop an audience for steam power before it could fit in with the serious art he espoused.

Turner's industrial works also coincided with the prevailing political and intellectual climate of the first half of the nineteenth century. By then industrialism, and the changes it had brought, was no longer exclusively the concern of "Philosophic Radicals."[7] Instead it was seen to advance the interests of all sections of the community, including Conservatives. Industrial developments stimulated wide interest and acceptability, not only in a progressive journal like the *Edinburgh Review* but also in the more conservative *Quarterly Review,* which praised Turner's Seine steamers on one notable occasion and often lauded the nation's technological accomplishments. The old Tory world of paternalistic responsibility, rural custom, and timeless virtue had given way to a new attitude that favored industry-driven change. Even the Conservative party of Sir Robert Peel, prime minister in the early 1840s, welcomed the Industrial Revolution and much of what it stood for.[8]

Pride in the nation's technological accomplishments also contributed to the acceptance of industry. Many of Turner's steam paintings identified industry with national greatness.[9] Like the English ironmaster's wife who, when traveling in Mainz, delighted in the knowledge that the German railroads used iron manufactured by her husband's firm,[10] Turner gloried in the sources of Britain's leadership. From the energetic developments at Leeds to the great advance of Brunel's railroad, Turner vigorously pressed his view of the new realities of national technological advancement into galleries and exhibition rooms.

Britain's ability to adapt technology to its traditional ways of living made it wealthy and powerful. The locomotive in *Rain, Steam, and Speed* drives through the landscape with determined precision, but it does not destroy or entirely displace the old England evoked by the distant plowman. Tradition and technology coexist in the new environment, something the English soon learned to accept. Turner's attack on the canon of landscape painting became all the more chauvinistic when the subject was steam. Steamers off the coast confirmed Britain's up-to-date embrace of mechanized transport, and steam tugs showed the country's ability to accept innovation. Steamboats on the Seine, whether English or not, reflected an English approach to transport in books designed to appeal to English travelers, while the railroad, in all its enormity of cost and scale, proclaimed Britain's unchallenged commercial and technical leadership.

Turner confronted the Industrial Revolution directly and with focused intensity. In *Snow Storm* the steamer is central. Likewise, *Rain, Steam, and Speed* featured the advent of the new locomotion in both its content and its title. Else-

where Turner recorded, with similar candor and boldness, the triumph of industry. The 1816 watercolor *Leeds* left little doubt that the old Yorkshire city of defined residential and ecclesiastical districts was fast becoming an unwieldy sprawl of multistory factories, seen to pollute with incessant abandon. The highly popular *Fighting "Temeraire"* brought the viewer into contact with transition more closely observed. Turner's paintings assert his full engagement with the subject, with no desire to establish distance from industrialism in all its vigor. By placing industry in conventional settings, juxtaposed with accepted icons of beauty and admiration, Turner confirmed an ongoing alteration of modern life. Industrialism has arrived, his work announces; it is growing in prominence, and there is no use looking back.

Turner's message of the limitations of steam, suggested in technology's vulnerability to nature, did not, however, indicate a larger desire to condemn the Industrial Revolution as a whole. Attempts to find a note of censorship in his views of labor are equally misguided. John Barrell has argued for a positive reading of Turner's depiction of rural workers—"men with interests of their own at heart"—in two paintings from early in the nineteenth century.[11] I concur with this view, insofar as Turner was largely sympathetic to the new economic and social developments, painting them affirmatively, if not with affection. But industrial laborers, when they appear at all in his work, function merely as incidental or implied elements of a wider vision, in which anonymous humanity is subject to cosmic constraints. Turner limited his role as critic to a cautionary note on human aspiration, without expressing any explicit social concern.

As historical evidence, Turner's machine studies greatly enhance our understanding of the Industrial Revolution. They speak eloquently and imaginatively of a time of transition, conveying the outward countenance, as well as the inner energy, of early mechanization as perceived by a sensitive, acute observer, one whose insights often amplify the words of contemporary thinkers. Turner's art explores novelty and obsolescence, a power both wonderful and frightening, and the insurmountable checks on human invention. His steam paintings advance, most of all, a penetrating understanding of the Industrial Revolution, valuable for its own time and for future generations.

Notes

INTRODUCTION

1. Gage, *Turner: "A Wonderful Range of Mind,"* 21. See Wilton, *Turner in His Time,* 246–47, for a list of items in Turner's library at the time of his death.
2. Chumbley and Warrell demonstrate how Turner used Sir Joshua Reynolds's doctrine of the superiority of history painting, with its claims to moral truth, to raise the status of landscape painting (*Turner and the Human Figure,* 7).

CHAPTER 1

1. The eminent art historian Kenneth Clark once remarked that Turner could have earned renown as "the great poet of Romantic Industrialism" had he devoted more attention to the theme of machine technology, particularly late in his career (*Romantic Rebellion,* 259). In fact that renown is merited, but Clark seriously underrated Turner's achievement.
2. J. C. D. Clark, *English Society, 1688–1832* (New York, 1985), 65–67. See Musson, *Growth of British Industry,* 61, 63, 68, and 140–41, for a similar view of industrial development.
3. McCord, *British History,* 83.
4. Ibid., 78, 216; Gildea, *Barricades,* 8; Landes, *Unbound Prometheus,* 122.
5. Macaulay, "Francis Bacon," in *Essays,* 2:375–76; Charles Babbage, *On the Economy of Machinery and Manufactures* (1835), in *The Works of Charles Babbage,* ed. Martin Campbell-Kelly, 11 vols. (New York, 1989), 8:4.
6. Ure, *Philosophy,* 33, 7.
7. Disraeli, *Coningsby* (1844), in *Works,* 12:212, 216, 206.
8. David Roberts, "Tory Paternalism and Social Reform in Early Victorian England," in *The Victorian Revolution: Government and Society in Victoria's Britain,* ed. Peter Stansky (New York, 1973), 156.

9. Ure, *Philosophy*, 18.

10. [Head], "Railroads," 3. For identification of the author of this essay and other unsigned essays published in nineteenth-century learned journals, see Houghton, *Wellesley Index*.

11. Mary Somerville, *Physical Geography* (Philadelphia, 1848), 374.

12. *Mechanics' Magazine* 1, no. 3 (March 1833): 118–19.

13. Emerson, *English Traits*, 47–48; Daunton, *Progress and Poverty*, 564.

14. Everett, *Tory View*, 2–4; Wosk, *Breaking Frame*, 34.

15. Sussman, *Victorians and the Machine*, 28.

16. Carlyle, "Signs of the Times" (1829), in *Works*, 27:59, 74.

17. Stephen Daniels, "Landscaping for a Manufacturer: Humphrey Repton's Commission for Benjamin Gott at Armley in 1809–10," *Journal of Historical Geography* 7 (1981): 380.

18. Uvedale Price, *Essays on the Picturesque*, 3 vols. (London, 1810), 1:198.

19. Bermingham, *Landscape and Ideology*, 81; Stanley Robinson, *Inquiry into the Picturesque* (Chicago, 1991), 128.

20. Everett, *Tory View*, 8. This observation appears in the author's summary of the work of John Barrell.

21. Emerson, *English Traits*, 19.

22. Townshend made these comments under the pseudonym of Timothy Crusty, "Complaint of an Antediluvian on the Decay of the Picturesque," *Blackwood's Magazine* 27 (February 1830): 265, 266.

23. Barrell, *Darkside*, 8–9.

24. Esther Houghton, assisted by Mary Wallace, "The *Edinburgh Review*," and Esther Houghton, assisted by Priscilla Ross and Mary Wallace, "The *Quarterly Review*," in Houghton, *Wellesley Index*, 1:417, 697, and 699.

25. Nikolaus Pevsner, *The Englishness of English Art* (New York, 1978), 47–48.

26. Landes, *Unbound Prometheus*, 123.

27. Klingender, *Art and the Industrial Revolution*, chapters 3–5 passim.

28. Quoted in Hemingway, *Landscape Imagery*, 127.

29. Nina Althanassoglou-Kallmyer, "Romanticism: Breaking the Canon," *Art Journal* 52, no. 2 (summer 1993): 20.

30. Jennings, *Pandemonium*, 85–86.

31. Martha Somerville, *Personal Recollections, from Early Life to Old Age, of Mary Somerville* (Boston, Mass., 1874), 104.

32. Disraeli, *Coningsby*, in *Works*, 12:205.

33. Arnold Toynbee, *Hellenism: The History of a Civilization* (New York, 1959), 10; L. C. B. Seaman, *Victorian England: Aspects of English and European History* (London, 1973), 29.

34. Carlyle, "Signs of the Times," in *Works*, 27:60; Tarnas, *Passion*, 367, 372.

35. Cole, "Essay," 1–3. For a discussion of Cole's "ambivalence about the prospect of development," see Daniels, *Fields of Vision*, 157.

36. Louis Legrand Noble, *The Life and Works of Thomas Cole*, ed. Elliot S. Vesell (1853; reprint, Cambridge, Mass., 1964), 81.

37. Cyrus Redding, *Past Celebrities Whom I Have Known*, 2 vols. (London, 1866), 1:59.

38. Quoted in Lindsay, *Sunset Ship*, 64.

39. *Athenaeum*, 16 June 1832, 388.

40. Clark, *Romantic Rebellion*, 234; Wilton, *Turner in His Time*, 6.

41. Clark, *Romantic Rebellion*, 226.

42. Quoted in Butlin and Joll, *Paintings*, 78.

43. Jennings, *Pandemonium*, 64; Bermingham, *Landscape and Ideology*, 80.

44. Lister, *British Romantic Art*, 136. See Woodring, *Nature into Art*, 124, for the observation that for Turner "the sublimity of steam remained subordinate to the majestic power of nature."

45. Haydon, *Diary*, 4:517; Head, *A Home Tour in the Manufacturing Districts*, 131–32.

46. Cole, "Essay," 8; Burke, *Sublime*, 39.

47. See Wilton, *Turner and the Sublime*; and Finley, "Genesis" and "Turner and the Steam Revolution."

48. Most late eighteenth- and early nineteenth-century British writers on aesthetics had something to say about the sublime, usually to correct Burke's analysis or to add to it, often at length. Archibald Alison and Dugald Stewart gave it substantial coverage in their learned treatises (1790 and 1810); William Wordsworth discussed it in an essay (c. 1812).

49. Ruskin, *Works*, 3:128.

50. Sussman, *Victorians and the Machine*, 29.

51. Baudelaire, "What Is Romanticism?" trans. J. Maynes, in Eitner, *Neoclassicism and Romanticism*, 2:156–57.

52. Charles Rosen, *The Romantic Generation* (Cambridge, Mass., 1995), 39–40. See also Tarnas, *Passion*, 371, for the romantic program of bringing "forth unborn realities."

53. Schlegel, *Course of Lectures on Dramatic Art and Literature*, trans. John Black; revised A. J. W. Morrison (1846; reprint, New York, 1965), 27; Schelling, "On the Relationship of the Creative Arts to Nature" (1807), trans. J. Elliot Cabot, in Eitner, *Neoclassicism and Romanticism*, 47.

54. Hegel, *Lectures on Aesthetics*, in *The Philosophy of Hegel*, ed. Carl J. Friedrich, trans. B. Bosanquet and William Bryant (New York, 1954), 354, 356, and 382.

55. Jack Kaminsky, *Hegel on Art* (New York, 1962), 105.

56. Heine, *The Romantic School*, in *Heinrich Heine: Selected Works*, ed. and trans. Helen M. Mustard (New York, 1973), 139. For a recent discussion of the romantic artist's need to "explore the mysteries of interiority," see Tarnas, *Passion*, 368, 373.

57. Carlyle, "The State of German Literature" (1827), in *Works*, 26:66.

58. William Vaughan, *German Romanticism and English Art* (New Haven, 1979), 65, 82.

59. Gage, *Colour*, 173–88; William Vaughan, review of *Turner in Germany* (London, 1995), by Cecilia Powell, in *Turner Society News*, 71 (December 1995): 5; Butlin and Wilton, *Turner*, 190.

60. Tarnas, *Passion*, 369.

61. Stewart, *Philosophical Essays*, 253, 329.

62. Ruskin, *Works*, 4:284 and 253. See also Elizabeth K. Helsinger, *Ruskin and the Art of the Beholder* (Cambridge, Mass., 1982), 31, for Ruskin's understanding of "changing patterns of light as the visible manifestations of a great inner energy."

63. Joshua Reynolds, *Fifteen Discourses* (1769–91; reprint, New York, 1928), 209.

64. Jerrold Ziff, "J. M. W. Turner on Poetry and Painting," *Studies in Romanticism* 3, no. 4 (summer 1964): 199.

65. Shanes, *Turner's Human Landscape*, 273.

66. Lindsay, *Sunset Ship*, 126.

67. Shelley, *Defence*, 116, 137, 117.

68. Ibid., 137, 134, 136.

69. See Butlin and Joll, *Paintings*, 253, for lines of Turner's that echo Shelley's *Prometheus Unbound*.

70. The phrase is from Turner's obituary in the *Times*, 23 December 1851, 8. See ibid., 250–53; Gage, *Turner: "A Wonderful Range of Mind,"* 186; Shanes, *Turner's Human Landscape*, 52.

71. Shanes, *Turner's Human Landscape*, 47–76 passim.

72. Alison, *Principles of Taste*, 19; Stewart, *Philosophical Essays*, 323 and 329.

73. Wilton, *Turner and the Sublime*, 99.

74. *Morning Chronicle*, 7 May 1832, 4.

75. Bryson, "Enhancement," 62.

76. Macaulay, "Moore's Life of Byron" (1831), in *Essays*, 2:628.

77. Jonathan Wordsworth, Michael C. Jaye, and Robert Woof, *William Wordsworth and the Age of English Romanticism* (New Brunswick, N.J., 1987), 29. This quote comes from an analysis of the art of William Blake, but it could apply as well to that of Turner.

78. Woodring, *Nature into Art*, vi–vii. See also William Desmond, *Art and the Absolute: A Study of Hegel's Aesthetics* (Albany, N.Y., 1986), 117; and on Turner specifically, Pierre Courthion, *Romanticism* (Cleveland, 1961), 48–49, and Bryson, "Enhancement," 63.

79. Wilton, *Turner and the Sublime*, 99.

1. Lindsay, *Turner*, 255.

2. *Encyclopaedia Britannica*, 7th ed., s.v. "steam navigation," 686; "Steam Navigation to India," *Nautical Magazine*, September 1839, 632.

3. *Nautical Magazine*, October 1832, 447. The December issue reported the successful prosecution of the steamboat *Glasgow* for "too rapid a speed on the river Thames" (605). For an account of the *Cricket* incident, see Clunn, *Face of London*, 129–30.

4. [Head], "Railroads," 6; Musson, *Growth of British Industry*, 119, notes that in 1850, 3.4 million tons of British shipping were sail-driven, while only 168,000 tons operated under steam.

5. See the advertisement for this work in *Athenaeum*, 2 July 1842, 600.

6. This piece was the work of one H. G. Dixon. A critic commented that it "*paddles* well enough for the instruction of the remarkable youth of both sexes." *Athenaeum*, 11 September 1830, 573.

7. For good contemporary accounts of the early history of steamboat development, see "Report" (1822) and Rennie, "Retrospect" (1847). For a modern overview of steam transport, see T. K. Derry and Trevor I. Williams, *A Short History of Technology* (Oxford, 1960), 328.

8. Spratt, *Handbook*, 92, 122–23; Henry Fry, *The History of North Atlantic Steam Navigation* (1895; reprint, London, 1969), 28.

9. Robertson Buchanan, "On Steam-Boats," *Philosophical Magazine* 45 (January 1815): 181–82. For the opposition of traditional carriers to Bell's innovation, see Bennet Woodcroft, *Sketch of the Origin and Progress of Steam Navigation* (London, 1848), 86.

10. Russell, *Guide*, 85 and 90. See also Thomas Sutton, *The Daniells: Artists and Travellers* (London, 1954), 128, which calls this work "the first pictorial record of the appearance of a steam-boat." Richard Ayton provided the text for the first two volumes.

11. Daniell, *Voyage* (1818), 3:17–18.

12. Finberg, *Life of Turner*, 138. Finberg notes that Turner voted for Daniell's election as a Royal Academy Associate in 1807.

13. Luke Herrmann, "Turner and the Sea," *Turner Studies* 1, no. 1 (summer 1981): 4.

14. Finley, *Turner and George the Fourth*, 8, 16. For tonnage and a description of the *James Watt*, see Spratt, *Handbook*, 74. George IV, who also used a steamer for his celebrated trip to Ireland in 1821, contributed to the popularity of early steamboats.

15. A steamer, perhaps the *James Watt*, appears at the left of Turner's sketch of Leith Roads (TB CC-35). This drawing is reproduced in "*King's Visit to Edinburgh* Sketchbook," in Finley, *Turner and George the Fourth*, n.p.

16. For the critical reception of this work in early 1823, see the *Literary Chronicle*, 4 January 1823, 15, and the *London Magazine*, February 1823, 219. None of these reviews, however, made specific mention of the steamboat in the watercolor.

17. See Nathaniel S. Wheaton, *A Journal of a Residence during Several Months in London* (Hartford, Conn., 1830), 333, for a less than enthusiastic description of embarkation on a Channel steamer, in this case out of Southampton: "At last we shoved off about noon, having a motley deck cargo of horses, carriages, dogs, and their appendages of gentlemen travellers, and leaving at least a thousand spectators on the pier and bridge gazing after us. What ennui must possess these hunters after amusement, to take so much interest in the departure of a steam-boat!" Wheaton's experiences were in 1823–24.

18. Starke, *Information*, 326; Douglas A. Allan and Charles Carter, *Handbook and Guide to the Shipping Gallery in the Public Museum, Liverpool* (Liverpool, 1932), 46.

19. Experts had told a parliamentary committee earlier that year that "a vessel, in case the engine cannot be used, may be sufficiently well managed with the sails, as to carry her safely into port" ("Report," 116).

20. See Shanes, *Rivers*, 33–34, for a good discussion of the wind-blown sailboats in the drawing.

21. George Dodd, *An Historical and Explanatory Dissertation on Steam-Engines and Steam-Packets* (London, 1818), xiii; John Ross, *A Treatise on Navigation by Steam* (London, 1828), 97.

22. "Report," 258; Clammer, *Paddle Steamers*, 89; Bernard Cox, *Paddle Steamers* (Pool, 1979), 46. Shanes, *Rivers*, 33, incorrectly identifies the *Majestic* as the first steamer to cross the Channel in 1816.

23. See Clammer, *Paddle Steamers*, 89, for the 1821 date. However, the *Rob Roy* may have arrived at Dover in 1819. See Rennie, "Retrospect," 22.

24. Ibid.; "Report," 115, 262. For a list of French steamers operating out of Dover, see Grasemann and McLachlan, *Packet Boats*, 148.

25. Finberg, *Inventory*, 1:503; Finberg, *Life of Turner*, 260.

26. For the transfer of navy boats to the post office, see Grasemann and McLachlan, *Packet Boats*, 19, and "Report," 115. Marestier, *Mémoire*, 178 and 181, and Grasemann and McLachlan, *Packet Boats*, 150, list the steamboats at Dover during this period. See also the *Times*, 23 November 1823, 2, for an account of the *Dasher*, "post office packet (steam), belonging to Dover."

27. Lyles and Perkins, *Colour into Line*, 7 and 52.

28. Shanes, *Rivers*, 7. See also Wilton, *Turner in His Time*, 102. For the relationship between Turner and Daniell, see Finberg, *Life of Turner*, 110, 138, and 140.

29. For the circumstances surrounding the engraving of *Dover Castle*, see Herrmann, *Turner Prints*, 237–38.

30. *Examiner*, 5 January 1823, 18. See also the reviews in the *London Magazine* and the *Literary Chronicle*, cited above.

31. Shanes, *Rivers*, 35.

32. *Athenaeum*, 26 July 1856, 923. *Harbours* contained a text by Ruskin. For *Dover*, he had nothing to say about the steamer, prompting a rebuke from the *Athenaeum*'s critic: "For mechanical progress Mr. Ruskin has no great respect. He is pugnacious, and opposed to what we call Civilization. Progress in the modern sense seems to him to walk crab-like."

33. Morse, *Samuel F. B. Morse: His Letters and Journals*, ed. Edward Lind Morse, 2 vols. in 1 (1914; reprint, New York, 1972), 1:314. Morse based this observation on a December 1829 crossing from Dover to Calais.

34. Egerton, *Temeraire*, 57.

35. Shanes, *Rivers*, 16.

36. This book has been issued in a facsimile edition. See *Turner's "Ideas of Folkestone" Sketchbook* (London, 1990). The scenes that include steamers are TB CCCLVI-3, 4, 19, and 23.

37. Wilton, *Turner: His Art and Life*, 409, points particularly to the precedent of the *Rivers of England*.

38. Finberg, *Life of Turner*, 341–42. For Turner's visits to France during the late 1820s and early 1830s, see Alfrey, "French Rivers," 192.

39. Schama, *Landscape*, 364.

40. Hawes, "*Temeraire*," 47. Ruskin acknowledged the presence of these Seine steamers only in discussions of particular facets of Turner's technique (*Modern Painters*, in *Works*, 3:315, 401, 549). Hamerton, in a more interpretative vein, suggested that depictions of Seine shipping in general (presumably including steamboats) embodied the artist's concern not with "the rivers themselves" but with "the human works which are connected with them" (*Life of Turner*, 239), a point echoed by Rawlinson, *Engraved Work*, 1:lvi–lvii. Nicholas Alfrey has recognized the steamer not only as "a symbol of modern life, a reminder that the river [Seine] is a heavily used commercial waterway," but also as an indication of "the processes of change, the old displaced by the new" (Guillaud, *Turner en France*, 436).

The following discussion of Turner's Seine drawings is a revised and expanded version of my article "Turner and Steamboats."

41. Helsinger, "Turner and the Representation of England," 104 and 106.

42. *Examiner*, 22 December 1833, 806; Herrmann, *Turner Prints*, 167, 175–76.

43. Jack Simmons, introduction, in Murray, *Switzerland*, 10; Thornbury, *Life and Correspondence*, 109n.

44. The quote is from the unsigned "Jorgenson's *Travels*," *Edinburgh Review*, 28 (August 1817), 371. For Turner's ownership of the Starke guide, see Wilton, *Turner in His Time*, 247.

45. Sauvan, *Picturesque Tour*, preface.

46. Ibid., 175.

47. *Art-Union*, November 1839, 171–72.

48. *Heath's Picturesque Annual for 1832: Travelling Sketches in the North of Italy, the Tyrol, and on the Rhine* (London, 1832), iii.

49. *Athenaeum*, 29 January 1831, 76.

50. Alfrey, "French Rivers," 192–93. Rawlinson, in *Engraved Work*, 1:xlvi, noted that between 1826 and 1828 Turner provided numerous designs for annuals.

51. [George Croly], "Steam Carriages," *Blackwood's Magazine* 23 (January 1828), 95; [William Erskine], "Captain Head's *Steam Navigation to India*," *Edinburgh Review* 57 (July 1833): 313.

52. F. T. O'Brien, *Early Solent Steamers* (Glasgow, 1973), 97; Galignani, *Guide*, xiii.

53. Hemingway, *Landscape Imagery*, 194.

54. Galignani, *Guide*, xvi–xvii. For a description of the diligence, see J. G. Links, *The Ruskins in Normandy: A Tour in 1848 with Murray's Hand-book* (London, 1968), 29–30.

55. For assessments of economic development in France, see R. M. Hartwell, "Economic Change in England and Europe, 1780–1830," in *The New Cambridge Modern History*, ed. C. W. Crawley, vol. 9, *War and Peace in the Age of Upheaval, 1793–1830* (Cambridge, 1963), 56; Dunham, *Industrial Revolution in France*, 420–33; Shepard Bancroft Clough, *France: A History of National Economics, 1789–1939* (New York, 1939), 97, 115. Comparative developments in England and France are examined in N. F. R. Crafts, "Industrial Revolution in England and France: Some Thoughts on the Question, 'Why was England First?'" *Economic History Review* 30 (1977): 429–41. For a recent appraisal of the transportation system in France, see Pamela Pilbeam, "The Economic Crisis of 1827–32 and the 1830 Revolution in Provincial France," *Historical Journal* 32, no. 2 (1989): 328–29. On French engineering, see Milton Kerker, "Sadi Carnot and the Steam Engine Engineers," *Isis* 51, part 3, no. 165 (September 1960): 259.

56. The American visitor's account is Humphrey, *Great Britain*, 1:287. See W. O. Henderson, *Britain and Industrial Europe, 1750–1870*, 2d ed. (London, 1965), 75, on the Industrial Revolution in France; the comments of the English traveler are from Hardy, *Tour*, 6.

57. Dunham, *Industrial Revolution in France*, 38, 369–71; Price, *Economic Modernization*, 13.

58. Marestier, *Mémoire*, 177; Félix Rivet, "American Technique and Steam Navigation on the Saône and the Rhône, 1827–1850," trans. David S. Landes, *Journal of Economic History* 16 (1956): 24; Sauvan, *Picturesque Tour*, 175.

59. Price, *Economic Modernization*, 17. For a modern assessment of British expertise see Landes, *Unbound Prometheus*, 148.

60. Galignani, *Guide*, xiii, xxxvii, and xxxix; Morlent, *Voyage historique*, vii.

61. Wilton, *Turner in His Time*. For the dates of Turner's visits to France, see Alfrey, "French Rivers," 192.

62. Morlent, *Voyage historique*, 9–10, 20, 80, and 114.

63. Auguste Pugin and Charles Heath, *Paris and Its Environs*, 2 vols. (London, 1831), 1: opposite p. 136.

64. Leitch Ritchie, *Heath's Picturesque Annual for 1833: Travelling Sketches on the Rhine, and in Belgium and Holland* (London, 1833), 254.

65. Leitch Ritchie, *Heath's Picturesque Annual for 1834: Travelling Sketches on the Sea-Coasts of France* (London, 1834), 83.

66. Ritchie, *Turner's Annual Tour: Embouchure to Rouen*, n.p. In the second volume, *Rouen to the Source* (London, 1835), 1, Ritchie declared that the steamboat should be used in conjunction with a walking tour of the Seine region.

67. Alaric A. Watts, "Biographical Sketch," in Ritchie, *Liber Fluviorum*, xxxv. Ritchie probably did not accompany Turner on the French journeys. See Jan Piggott, *Turner's Vignettes*, 50.

68. *Athenaeum*, 14 December 1833, 842; Piggott, *Turner's Vignettes*, 51.

69. "Hydrography," *Nautical Magazine*, August 1832, 282. The La Hève lights rose to a height of 446 feet above the water and were 206 feet apart.

70. *Arnold's Magazine* 3, no. 3 (1832): 268. This comment was made about the watercolor version exhibited at the Moon, Boys and Graves gallery.

71. James Fenimore Cooper, *Gleanings in Europe: France* (Albany, N.Y., 1983), 46.

72. Robert Bell, *Wayside Pictures Through France, Holland, Belgium and up the Rhine* (London, 1858), 7.

73. Ritchie, *Liber Fluviorum*, 88; in *The Keepsake*, see Ritchie, "Havre," 117, for his identification of the subject as "the quay where the steam-boat adventurers land."

74. Egerton, *Temeraire*, 61–62. See also Nicholas Alfrey's discussion of this work in Guillaud, *Turner en France*, 396–97.

75. *Examiner*, 22 December 1833, 806; *Gentleman's Magazine*, December 1833, 530. In his descriptive comments accompanying Turner's print of the town for *The Keepsake*, Ritchie stated the opposite view: "Havre is one of the most agreeable of English haunts in France. The new streets are clean, and even handsome; and the Place, in which there is an elegant theater, gives an imposing air to the town" ("Havre," 117).

76. The conditions at Quilleboeuf are noted in Ritchie, *Turner's Annual Tour: Embouchure to Rouen*, 95, and Sauvan, *Picturesque Tour*, 165. Turner's note is in Butlin and Joll, *Paintings*, 203.

77. Dunham, *Industrial Revolution in France*, 43.

78. Lyles and Perkins, *Colour into Line*, 11–12, 39.

79. John Murray, *Handbook for Travellers in France* (London, 1843), 53; Ritchie, *Turner's Annual Tour: Embouchure to Rouen*, 182.

80. Just what was taking place in this scene has long been a matter of dispute. Rawlinson, *Engraved Work,* 2:269, observed that the sailing ship was in tow, without citing any evidence for this view. More recently, Hawes, "*Temeraire,*" 34, argued that the steamer was not offering assistance: "the [sailing] ship is ready to journey under her own power; the tug poses no threat, going about its business independently." Yet the dangers on the river already alluded to make this unlikely, as I made clear in "Turner and Steamboats," 40.

81. Ritchie, *Turner's Annual Tour: Embouchure to Rouen,* 182; *Athenaeum,* 14 December 1833, 859; *Arnold's Magazine* 3, no. 3 (1832): 269.

82. Sauvan, *Picturesque Tour,* 160.

83. See my "Humanity and Nature," 458, for a discussion of the smoke in this work as an expression of technological power. Nicholas Alfrey sees the steamer juxtaposed with the funeral in the foreground, "establishing within the same frame both death and the continuity of everyday life" (Guillaud, *Turner en France,* 421).

84. James Fenimore Cooper, *The Letters of James Fenimore Cooper,* ed. James Franklin Beard, 6 vols. (Cambridge, 1960), 1:46; Humphrey, *Great Britain,* 1:292.

85. See Nicholas Alfrey's comments in Guillaud, *Turner en France,* 395.

86. Ritchie, *Turner's Annual Tour: Embouchure to Rouen,* 99. See Ann Lyles, *Turner: The Fifth Decade* (London, 1992), 18, for the suggestion that this steamer is pictured carrying tourists.

87. Ruskin cited this work as an example of the different appearance of steam and smoke. See Ruskin, *Works,* 3:407.

88. The words are those of the American author Washington Irving, who visited Jumièges in September 1823. See the record of this trip in Washington Irving, *The Complete Works of Washington Irving: Journals and Notebooks,* ed. Walter A. Reichart, 30 vols. (Madison, Wisc., 1970), 3:223.

89. Ruskin, *Works,* 3:548; *Spectator,* 6 December 1834, 1168.

90. Ritchie, *Liber Fluviorum,* 312.

91. *Athenaeum,* 24 November 1834, 882.

92. For Smith's work and interests, see George S. Merriam, *The Story of William and Lucy Smith* (Boston, Mass., 1889), 56–57.

93. [William Henry Smith], "Campbell's *Poetical Works,*" *Quarterly Review* 57 (December 1836): 360–61.

94. Finberg, *Life of Turner,* 341–42.

95. Tim Hilton, *John Ruskin: The Early Years* (New Haven, Conn., 1985), 25.

96. *Nautical Magazine,* December 1832, 601.

97. Frederick Knight Hunt, *The Rhine: Its Scenery and Historical and Legendary Associations* (London, [1840]), 1; John Murray, *Handbook for Travellers on the Continent* (London, 1836), 229.

98. Cecilia Powell, *Turner's Rivers of Europe: The Rhine, Meuse and Mosel* (London, 1991), 186.

99. W. A. B. Coolidge, *Swiss Travel and Swiss Guide-Books* (London, 1889), 111.

100.	Henry E. Dwight, *Travels in the North of Germany, in the Years 1825 and 1826* (New York, 1829), 13.

101.	John Russell and Andrew Wilton, *Turner in Switzerland* (Zurich, 1976), 102; Susan Phelps Gordon and Anthony Lacy Gully, eds., "Introduction," in *John Ruskin and the Victorian Eye* (New York, 1993), 17.

102.	Malcolm Cormack, *J. M. W. Turner, R.A. 1775–1851: A Catalogue of Drawings and Watercolours in the Fitzwilliam Museum, Cambridge* (Cambridge, 1975), 70. See also Jane Munro, *British Landscape Watercolors, 1750–1850* (New York, 1994), 86. For another watercolor of a steamer at Lucerne, see Finberg, *Inventory,* 2:1195, TB CCCLXIV-272.

103.	Murray, *Switzerland,* 51.

104.	Shanes, *Turner's Human Landscape,* 106–7.

105.	*Spectator,* 16 May 1840, 476.

106.	[Head], "Railroads," 3–4.

107.	Ruskin, *Works,* 35:576.

108.	Hawes, "*Temeraire,*" 23; Finberg, *Life of Turner,* 372–73; Walker, *Turner,* 130; Ruskin, *Works,* 13:170–72; Butlin and Joll, *Paintings,* 231.

109.	Clammer, *Paddle Steamers,* 9.

110.	Eugenia Janis, *The Photography of Gustave Le Gray* (Chicago, 1987), 83. Janis has adopted this title for Le Gray's calotype instead of the former *Seascape at Cette.*

111.	*Times,* 13 September 1838, 6; Shanes, *Turner's Human Landscape,* 41; Egerton, *Temeraire,* 42–43.

112.	*Art-Union,* May 1839, 69; Hawes, "*Temeraire,*" 28, characterized it as "the mundane but efficient Victorian tug."

113.	*Spectator,* 11 May 1839, 447; *Fraser's Magazine,* June 1839, 744.

114.	The earliest steamers were notorious for their fiery smokestacks and "some of those in the Thames were threatened with indictments as nuisances, on account of the coal, sparks, and cinders, ejected from their chimneys." See "Steam Navigation in the Port of London," 362. Clammer, *Paddle Steamers,* 9–10, points out that early tugs were almost all fitted with simple "Grasshopper" engines that used a great supply of coal. Egerton inexplicably sees the tug "moving sedately"; see *Temeraire,* 84.

115.	The quote is from Thornbury, *Life and Correspondence,* 461. On the effects of sunlight on steam, see Forbes, "Color of Steam," 121–22. Daniels, *Fields of Vision,* 132, observes that Turner presented a rising sun to indicate that the tug was assuming the sun's power.

116.	Thornbury, *Life and Correspondence,* 460.

117.	Egerton, *Temeraire,* 75–78.

118.	*Times,* 13 September 1838, 6; G. R. Porter, *The Progress of the Nation, in Its Various Social and Economical Relations, from the Beginning of the Nineteenth Century to the Present Time* (London, 1838), quoted in *Athenaeum,* 28 April 1838, 301.

119. *Times,* 12 October 1838, 7. *Nautical Magazine,* which concerned itself with a host of maritime issues, failed to make mention of the end of the *Temeraire* in its 1838 issues.

120. *Athenaeum,* 11 May 1839, 357. Finley, in *Turner and George the Fourth,* 64, sees the conflict of two eras in the following light: "The steam tug becomes the symbol of the corrupting materialism of this new industrial age, while its correlative and contrast, the wraith-like *Temeraire,* is made the representative of those spiritual and heroic values of the past which he [Turner] cherished and had pictorially enshrined, but of which this new age was contemptuous." See also Richard L. Stein, *Victoria's Year: English Literature and Culture, 1837–1838* (New York, 1987), 264, for the less censorious interpretation: "The juxtaposition of these ships, like the reciprocities in nature, represents history as an endless succession of achievements and replacements, deaths and births."

121. [Head], "Railroads," 5; "Steam to India," *Tait's Edinburgh Magazine,* May 1839, 293.

122. Rolt, *Victorian Engineering,* 80, 85; Lubbock, "Mercantile Marine," 1:398.

123. Samuel Seward, "Memoir on the Practicability of Shortening the Duration of Voyages, by the Adaption of Auxiliary Steam Power to Sailing Vessels," *Transactions of the Institute of Civil Engineers* 3 (1842): 385–86, 390. Rolt, *Victorian Engineering,* 96, notes that for much of the early nineteenth century, ocean steamers "all carried sail for three reasons, first to steady the ship in rough weather, secondly as an insurance in the event of serious engine failure and thirdly to take advantage of a fair wind to economize fuel."

124. Rolt, ibid.

125. Boyd Cable, *A Hundred-Year History of the Peninsular and Oriental Steam Navigation Company* (London, 1937), 68, 243; Geoffrey Body, *British Paddle Steamers* (Newton Abbot, 1971), 81; Cunningham, *Wilkie,* 3:469.

126. Spratt, *Handbook,* 13.

127. Cunningham, *Wilkie,* 3:474; Wallace, "Circular, Octagonal, and Square Paintings," 112.

128. Finberg, *Life of Turner,* 390.

129. Wallace, "Circular, Octagonal, and Square Paintings," 112 and 117, nn. 30 and 31.

130. See discussions of this painting's relationship to its companion, *War: The Exile and the Rock Limpet* (Tate Gallery, London), in Wallace, "Circular, Octagonal, and Square Paintings," 12, and John McCoubrey, "War and Peace in 1842: Turner, Haydon and Wilkie," *Turner Studies* 4, no. 2 (winter 1984), passim; the latter gives a full examination of the pair of paintings and the artistic atmosphere at the time of their conception and exhibition. Most recently, Wilton, *Turner in His Time,* 230, has seen in the pairing "the peaceful trade of artist, as represented by Turner's long-standing colleague and rival Wilkie, and the warlike one of soldier and tyrant as exemplified in the career of Napoleon."

131. *Art-Union,* June 1842, 124.

132. Thornbury, *Life and Correspondence,* 579. The burial had heroic dimensions, especially when considered with reference to the painting's companion, *War,* depicting Bonaparte in exile. With the Napoleonic era in mind, Turner could have been drawing a parallel between Wilkie and Nelson, both of whom died on board ship. Furthermore, according to the painter Haydon, Wilkie was "lowered to his last refuge from Worldly anxiety down into the Depths of Trafalgar Bay," the scene of Nelson's death (Haydon, *Diary* 5:176).

133. See Shanes, *Turner's Human Landscape,* 102, for the mistaken assertion that Turner was depicting a ship converted from sail to steam. As noted previously, the *Oriental* was built as a steamer and incorporated from the beginning elements of earlier ship design.

134. Charles Dickens, *American Notes and Pictures from Italy* (1842; reprint, New York, 1987), 11; James Gordon Bennett in New York's *Morning Herald,* quoted in Rolt, *Brunel,* 258; Jacob Abbot, *A Summer in Scotland,* quoted in Lockwood, *Passionate Pilgrims,* 166.

135. Walker, *Turner,* 2.

136. *Times,* 6 May 1842, supplement.

137. Gage, *Colour,* 186.

138. Turner's comment is in Butlin and Joll, *Paintings,* 248. I am grateful to Andrew Wilton for the observation on Turner's use of black.

139. Lubbock, "Mercantile Marine," 398. Lubbock described the typical steamer as "always dirty. Her ill-consumed smoke poured down on her decks in a black pall which spread its soot and smuts everywhere and drove a keen mate to distraction."

140. *Morning Chronicle,* 11 June 1841, 6.

141. On indications of mechanical energy here and in similar Turner paintings, see Paulson, *Literary Landscape,* 96–97.

142. The statistic is from the *British Almanac,* 194; Spratt, *Handbook,* 18. When the *Great Western* docked in New York after its maiden voyage, its engineer was scalded to death while "blowing down" the ship's boilers. See Rolt, *Brunel,* 259.

CHAPTER 3

1. Alexander Pope, *The Poems of Alexander Pope,* vol. 9, *The Odyssey of Homer,* ed. Maynard Mack (New Haven, Conn., 1967), 330.

2. Gage, *Colour,* 128–29.

3. Elements of this chapter enlarge on points I examined in "Humanity and Nature."

4. *British Almanac,* 194; "Chronicle," in *Annual Register for the Year 1831* (London, 1832), 129–37.

5. Butlin and Joll, *Paintings,* 206.

6. Two of these depictions were oils—*Dunstanborough Castle* (c. 1798) and *Dunstanborough Castle, N.E. coast of Northumberland: Sunrise after a Squally Night* (1801)—and two watercolors—*Dunstanborough Castle* (c. 1801–2) and *Dunstanborough Castle, Northumberland* (c. 1828).

7. Evelyn Joll, "Turner at Dunstanborough, 1797–1834," *Turner Studies* 8, no. 3 (winter 1988): 3–7, especially p. 6.

8. Wilton, *Turner in His Time,* 205.

9. Finley, *Landscapes of Memory,* 142; Butlin and Joll, *Paintings,* 206.

10. Lumsden, *Steam-Boat Companion,* 5, 13.

11. See T. S. R. Boase, "Shipwrecks in English Romantic Painting," *Journal of the Warburg and Courtauld Institutes* 22 (1959): 343. J. W. Carmichael, a contemporary of Turner's, depicted the event as the ship lay on its side, with the famous Victorian heroine and her father rushing to the rescue (reproduced in W. A. Montgomery and M. Scott, *Grace Darling* [Seahouses, England, 1981], 18).

12. Peter Bicknell and Helen Guiterman, "The Turner Collector: Elhanan Bicknell," *Turner Studies* 7, no. 1 (summer 1987): 34.

13. *Arnold's Magazine* 4, no. 8 (1834): 136; *Literary Gazette,* 13 February 1836, 105; *Examiner,* 3 April 1836, 213.

14. Paulson, *Literary Landscape,* 97.

15. Butlin and Joll, *Paintings,* 198. Turner exhibited his Scott illustrations two months before *Staffa* was presented at the Royal Academy. See Wilton, *Turner in His Time,* 204.

16. Gage, *Correspondence,* 144. Steamboat service in Scotland, and particularly to Staffa and Iona, was an important factor in Wordsworth's 1829 plans for a future visit. See Alan G. Hill, *The Letters of William and Dorothy Wordsworth,* 2d ed., part 2, *The Later Years, 1829–1834* (Oxford, 1979), 79, 82.

17. Lumsden, *Steam-Boat Companion,* 2.

18. The itinerary is from Butlin and Joll, *Paintings,* 198. For a more recent and precise itinerary, see David Wallace-Hadrill and Janet Carolan, "Turner in Argyll in 1831: Inveraray to Oban," *Turner Studies* 11, no. 1 (summer 1991): 20. Lumsden, *Steam-Boat Companion,* 143, names the castle as one of the sites on this route.

19. Finley, *Landscapes of Memory,* 204.

20. J. G. Lockhart, *Memorials of the Life of Sir Walter Scott,* 10 vols. (Edinburgh, 1882), 3:276.

21. William Wordsworth, *The Poetical Works of William Wordsworth,* ed. Thomas Hutchinson (Oxford, 1923), 463, 473–74. Wordsworth probably traveled on a steamboat. See the poem *On the Firth of Clyde: In a Steamboat* (471–72).

22. Daniell, *Voyage,* 37; Lumsden, *Steam-Boat Companion,* 172; Ruskin, *Works,* 13:445.

23. Daniell, *Voyage,* 41 and 46; Wilfred Blunt, *On Wings of Song: A Biography of Felix Mendelssohn* (New York, 1974), 107; James Boswell, *The Journal of a Tour to the Hebrides with Samuel Johnson* (1785; reprint, New York, 1968), 230; Lumsden, *Steam-Boat Companion,* 172–73.

24. Gage, *Correspondence,* 209–10. Despite the dangers alluded to in this letter, as well as the ominous sky pictured in the painting, Hawes sees the steamer "advancing toward us confidently" (*"Temeraire,"* 33).

25. For possible discrepancies in Turner's memory of his treacherous trip, see Lumsden, *Steam-Boat Companion,* 165–66, 277.

26. Head, *A Home Tour through Various Parts of the United Kingdom,* London, 1837, 101.

27. Paulson, *Literary Landscape,* 79; Serres, "Turner Translates Carnot," 59.

28. *Morning Herald,* 7 May 1832, 3.

29. John Gage, "The Distinctness of Turner," *Journal of the Royal Society of Arts* 123 (July 1975): 454, and idem, *Turner: "A Wonderful Range of Mind,"* 203.

30. *Literary Guardian,* 12 May 1832, 94; *Examiner,* 1 July 1832, 421.

31. *Examiner,* 1 July 1832, 421; Hawes, *"Temeraire,"* 33.

32. A steamboat may have traveled on the lake as early as 1835, according to W. A. B. Coolidge, *Swiss Travel and Swiss Guide-Books* (London, 1889), 112. The date given by G. W. Hinton, R. Plummer, and J. Jobe is 1836, in *The Illustrated History of Paddle Steamers* (Lausanne, 1977), 110.

33. Murray, *Switzerland,* 52. Seventy-five years later, the winds on the lake were still considered dangerous "even for steamers" (Karl Baedeker, *Switzerland* [Leipzig, 1913], 118–19).

34. Turner visited Venice in 1833 and 1840. The watermark on the paper is 1834, which indicates a date of 1834 or immediately thereafter for this work. See National Gallery of Scotland, *The Vaughan Bequest of Turner Watercolours* (Edinburgh, 1980), 34. Wilton, in his authoritative catalogue of Turner's watercolors, has assigned the 1840 date (*Turner: His Life and Art,* 464–65).

35. The date, title, and setting of this watercolor have been the subject of some disagreement. In a 1977 exhibition it was labeled *A Paddle-Steamer in a Storm,* c. 1830?, "possibly off the coast of Britain." See Christopher White, *English Landscape, 1630–1860* (New Haven, Conn., 1977), 81. Wilton places it on Lake Lucerne and has assigned it the title and approximate date used here (*Turner: His Art and Life,* 478, no. 1484). Egerton, *Temeraire,* 65, accepts the earlier dating and links it to *Staffa.*

36. Butlin and Joll, *Paintings,* 238–39.

37. Ibid.

38. *Morning Chronicle,* 8 May 1840, 3; *Spectator,* 6 February 1841, 139; *Athenaeum,* 6 February 1841, 118; *Morning Post,* 5 May 1840, 5.

39. John Dixon Hunt, "Wondrous, Deep and Dark: Turner and the Sublime," *Georgia Review* 30 (1976): 142.

40. Lynn R. Matteson, "The Poetics and Politics of Alpine Passage: Turner's *Snow Storm: Hannibal and his Army Crossing the Alps*," *Art Bulletin* 62, no. 3 (September 1980): 385. Wilton has pointed to an earlier vortex arrangement in *Bonneville* (1802); see Ronald Paulson, "Turner's Graffiti: The Sun and Its Glosses," in *Images of Romanticism*, ed. Karl Kroeber and William Walling (New Haven, Conn., 1978), 183–84, n. 34. See also Paulson's discussion of the vortex in *Literary Landscape*, 98–99.

41. Elizabeth Chambers Patterson, *Mary Somerville and the Cultivation of Science, 1815–1840* (Boston, 1983), 126.

42. Rhodes W. Fairbridge, *The Encyclopedia of Atmospheric Sciences and Astrogeology* (New York, 1967), 586–87.

43. For example, see a review of Redfield's "Remarks relating to the Tornado which visited New Brunswick in the State of New Jersey, June 19, 1835, with a Plan and Schedule of the Prostrations observed on a Section of its Track," *Philosophical Magazine and Journal of Science* 18 (January 1841): 20.

44. [Brewster], "Storms," 406–8, 432.

45. See, for example, [Basil Hall], "On the Law of Storms," *Foreign Quarterly Review* 23 (April–July 1839): 19: "Our chief anxiety, . . . has been . . . to direct the attention of practical men to the most effectual method of meeting gales of wind with advantage to their voyage and safety to their ships, than to indulge in speculation on the abstract principle of storms."

46. Finley, *Landscapes of Memory,* 178, notes Turner's acquaintance with Brewster. On scientific discourse in London, see J. N. Hays, "The London Lecturing Empire, 1800–1850," in *Metropolis and Province,* 107–10. Turner's interest in the weather is discussed superficially in the dated article by L. C. W. Bonacina, "Turner's Portrayal of Weather," *Quarterly Journal of the Royal Meteorological Society* 64 (1938): 601–11. Surprisingly, it says nothing of the vortex.

47. On Turner's membership in the Athenaeum Club, see Gage, *Turner: "A Wonderful Range of Mind,"* 228, and Jack Morell and Arnold Thackeray, *Gentlemen of Science* (Oxford, 1981), 18. On his acquaintance with Faraday, see Joseph Agassi, *Faraday as a Natural Philosopher* (Chicago, 1971), 138, and Fever, *Martin,* 126.

48. *Gentleman's Magazine,* 3 May 1834, 540, quoted in Roy M. MacLeod, "Whigs and Savants: Reflections on the Reform Movement in the Royal Society, 1830–48," in Inkster and Morrell, *Metropolis and Province,* 67. For Turner's attendance at the Royal Society's gatherings, see Gage, *Turner: "A Wonderful Range of Mind,"* 226–29.

49. Altick, *Shows of London,* 377.

50. See Read, "'A name that makes it looked after,'" 316, for the theory that Turner knew William Whewell's *History of the Inductive Sciences* (1837) and its discussion of vortices.

51. Berger, *About Looking,* 146.

52. [Brewster], "Storms," 406–7.

53. See Butlin and Wilton, *Turner,* 170, for the relationship of this vortex to that of *Snow Storm—Steam-Boat off a Harbour's Mouth.*

54. Gage, *Turner: "A Wonderful Range of Mind,"* 68; Brian Lukacher, "Turner's Ghost in the Machine: Technology, Textuality, and the 1842 *Snowstorm,"* *Word and Image* 6, no. 2 (April–June 1990): 129, for the quotation; Wilton, "Turner and the Sense of Place," 29. For the technology and nature conflict, see my "Humanity and Nature," 472–73, and Read, "'A name that makes it looked after,'" 317.

55. Wilton, "Turner and the Sense of Place," 30.

56. Pieter van der Merwe, *The Spectacular Career of Clarkson Stanfield, 1793–1867* (Newcastle, 1979), 87 and 90; Altick, *Shows of London,* 216.

57. Berger, *About Looking,* 143.

58. Finley, "Genesis," 165.

59. [Brewster], "Storms," 407; James B. Twitchell, *Romantic Horizons: Aspects of the Sublime in English Poetry and Painting, 1770–1850* (Columbia, Mo., 1983), 107.

60. Paulson, *Literary Landscape,* 96, notes the "vortex generated by the sun."

61. Butlin and Joll, *Paintings,* 247; *Athenaeum,* 14 May 1842, 433; *Literary Chronicle,* 14 May 1842, 331; *Morning Post,* 11 June 1842, 5; [John Eagles], "Exhibitions—Royal Academy," *Blackwood's Magazine* 52 (July 1842): 30; *Art-Union,* June 1842, 123.

62. Ruskin, *Works,* 13:162. It has been suggested recently that Turner may not even have been on this boat that night. See Jerrold Ziff's review of *The Paintings of J. M. W. Turner,* by Martin Butlin and Evelyn Joll, *Art Bulletin* 16, no. 1 (March 1980): 170.

63. Cosmo Mockhouse, *The Turner Gallery* (New York, 1878), part 13.

64. Hill, *Thames,* 156.

65. Murray, "Art, Technology, and the Holy," 84.

66. W. J. T. Mitchell, "Metamorphoses of the Vortex: Hogarth, Turner, and Blake," in *Articulate Images: The Sister Arts from Hogarth to Tennyson,* ed. Richard Wendorf (Minneapolis, 1983), 139.

CHAPTER 4

1. Lindsay, *Sunset Ship,* 99.

2. For a similar view of the subject of this poem, see Daniels, *Fields of Vision,* 123.

3. Louis Hawes, *Presences of Nature: British Landscape, 1780–1830* (New Haven, Conn., 1982), 196.

4. Ruskin, *Works,* 13:254; Rawlinson, *Engraved Work,* 2:407. This trip is noted in Hill, *In Turner's Footsteps,* 104. For Turner's visits to the area, see the chronology in Wilton, *Turner in His Time,* 124–26.

5. Nigel Yates, "The Religious Life of Victorian Leeds," in *A History of Modern Leeds,* ed. Derek Fraser (Manchester, 1980), 252. I am indebted to Professor Maurice Beresford, University of Leeds, for identifying the Wesleyan Chapel and several other buildings in Turner's watercolor.

6. Louis Simond, *An American in Regency England: The Journal of a Tour in 1810–1811,* ed. Christopher Hibbert (London, 1968), 112.

7. Singleton, *Industrial Revolution in Yorkshire,* 82; Spencer Walpole, *A History of England,* 6 vols. (London, 1913), 1:94.

8. *Nicholson's Guides to the Waterways: North West* (London, n.d.), 123.

9. Aikin, *Description,* 577; Ryley, *Leeds Guide,* 104–5; Thomas Allen, *New and Complete History of the County of York,* 6 vols. (London, 1828), 2:467; Page, *York,* 400.

10. On Burley, see Crump, "History of Gott's Mills," 269–70.

11. Griscom, *Europe,* 287; Ballard, *England,* 69.

12. E. A. Wrigley, *Continuity, Chance and Change: The Character of the Industrial Revolution in England* (New York, 1988), 15–16; Lees, *Cities Perceived,* 9–10, 16.

13. Edward Baines, *The Social, Educational, and Religious State of the Manufacturing Districts* (2d ed., 1843; reprint, New York, 1969), 53, 58, 54.

14. Lees, *Cities Perceived,* 45.

15. Robert Vaughan, *The Age of Great Cities; or, Modern Society Viewed in Its Relation to Intelligence, Morals, and Religion* (1843; reprint, Shannon, Ireland, 1971), 91, 90.

16. Jennifer Tann, "Building for Industry," in *The Archeology of the Industrial Revolution* (Rutherford, N.J., 1973), ed. Brian Bracegirdle, 174.

17. "A Day at a Leeds Flax-Mill," *Penny Magazine* 12 (December 1843): 503.

18. Tann, *Evolution,* 149.

19. Hill, *In Turner's Footsteps,* 104.

20. For discussions of these and other figures, see Daniels, "Implications of Industry," 11 and 13; Rawlinson, *Engraved Work,* 2:404. On the expanding industrial landscape represented here, see Arscott, Pollock and Wolff, "Partial View," 226.

21. Tann, *Evolution,* 143. Daniels, "Implications of Industry," 12, and more recently in *Fields of Vision,* incorrectly identifies the Benyon and Bage Mill as Marshall's, which in fact was to the left in Turner's watercolor. Fowler's map (see next note) confirms Beresford's reading of the painting, which I have followed.

22. Charles Fowler, *Plan of the Town of Leeds with the Recent Improvements* (Leeds, 1821), was based on an 1815 *Plan of Leeds and Its Environs.* See Kenneth J. Bonser and Harold Nichols, "Printed Maps and Plans of Leeds, 1711–1900," *Publications of the Thoresby Society* 47 (1958): 12.

23. W. G. Rimmer, *Marshalls of Leeds: Flax Spinners, 1788–1886* (Cambridge, 1960), 58–59.

24. Bears, *Armley Mills,* 6, 65, 88.

25. Connell and Ward, "Industrial Development," 148; Singleton, *Industrial Revolution in Yorkshire,* 33; Griscom, *Europe,* 288. When J. C. Fischer visited from Germany in 1814, he was astonished by the size of Marshall's and its up-to-date steam engine, hydraulic press, carding machine, and gas-generating plant. See Henderson, *Fischer,* 59.

26. Connell and Ward, "Industrial Development," 151–53; Samuel Smiles, *Industrial Biography: Iron Workers and Tool Makers* (1863; reprint, 1968), 261–62. Ryley, *Leeds Guide,* 104, mentions foundries in the neighborhood of Meadow Lane for the manufacture of steam engines and machines.

27. Page, *York,* 400.

28. Ryley, *Leeds Guide,* 103; Baines, *Directory,* 30; Bears, *Armley Mills,* 5; Crump, "History of Gott's Mills," 260.

29. Aikin, *Description,* 577; the identifications are from Beresford.

30. Baines, *Directory,* 40.

31. Edward Daynes, *A Picturesque Tour in Yorkshire and Derbyshire* (London, 1824), 44; Griscom, *Europe,* 287; Thackrah, *Effects,* 72.

32. Maurice W. Beresford, "Prosperity Street and Others: An Essay in Visible Urban History," in *Leeds and Its Region,* ed. Maurice W. Beresford and G. R. J. Jones (Leeds, 1967), 191.

33. Daniels, "Implications of Industry," 12; Maxine Berg, *The Machinery Question and the Making of Political Economy, 1815–1848* (New York, 1980), 30.

34. Singleton, *Industrial Revolution in Yorkshire,* 146–48.

35. Ballard, *England,* 69.

36. McCord, *British History,* 80; Musson, *Growth of British Industry,* 87. For the extent of the use of power in wool production at this time, see Crump, "History of Gott's Mills," 4 and 26; and Connell and Ward, "Industrial Development," 197.

37. Rawlinson, *Engraved Work,* 1:41–43; Herrmann, *Turner Prints,* 76.

38. Daniels, "Implications of Industry," 12; Hubert R. Rigg, *Turner and Dr. Whitaker* (Burnley, 1982), 10.

39. Oulton, *Guide,* 2:127. Harewood, however, seems to have abandoned his patronage of Turner about a decade prior to *Leeds.* See David Hill, *Turner in Yorkshire* (York, 1980), 19–20.

40. On Fawkes's support of abolition, see Lindsay, *Turner,* 112; on Cowper, see Maurice Beresford, "The Face of Leeds, 1780–1914," in *A History of Modern Leeds,* ed. Derek Fraser (Manchester, 1980), 100.

41. Rawlinson, *Engraved Work,* 1:lxii; Russell, *Guide,* 104; Lyles and Perkins, *Colour into Line,* 23.

42. For a discussion of these works, see Arscott, Pollock, and Wolff, "Partial View," 220–28.

43. Joseph Priestley, *Historical Account of the Navigable Rivers, Canals, and Railways of Great Britain* (1831; reprint, Newton Abbot, 1969), 387–88, 393.

44. Shanes, *Rivers*, 32. For additional discussion of this work, see Daniels, "Implications of Industry," 15–16.

45. The quote is from Hoole, *River Scenery*, 15. I am indebted to Peter C. D. Bears for identifying specific elements in this work.

46. D. J. Rowe, "The North-East," in *Regions and Communities*, vol. 1, *The Cambridge Social History of Britain: 1750–1950*, ed. F. M. L. Thompson (New York, 1990), 419–20; Paul Mantoux, *Industrial Revolution in the Eighteenth Century* (London, 1952), 289.

47. Barthélemy Faujas de Saint-Fond, *Travels in England and Scotland*, 2 vols. (London, 1799), 1:136; Oulton, *Guide*, 2:317. On iron-making, see Atkinson, *Coalfield*, 71.

48. Eric T. Svedenstiera, *Svedenstiera's Tour in Great Britain 1802–1803* (Newton Abbot, 1973), 104; Hoole, *River Scenery*, 4.

49. Hoole, *River Scenery*, 5.

50. Mitchell, *Abstract*, 24 and 26.

51. For Turner's influence on Carmichael, see Greg, *Carmichael*, introduction.

52. Smiles, *Lives*, 23.

53. Shanes, *Rivers*, 30.

54. *Athenaeum*, 11 August 1838, 537; *Parliamentary Gazetteer*, s.v. "Newcastle," 9:483; Mackenzie, *Newcastle-upon-Tyne*, 715.

55. See the map by Thomas Oliver, *Plan of the Town and County of Newcastle*, c. 1828–30, for the location of these and other Newcastle industries.

56. Head, *A Home Tour in the Manufacturing Districts*, 348.

57. Mackenzie, *Newcastle-upon-Tyne*, 162; "Newcastle upon Tyne," 313.

58. W. H. Bartlett and William Beattie, *Finden's Views of the Ports, Harbours and Watering Places of Great Britain*, 2 vols. (London, 1842), 1:42; McCord, *North-East England*, 114.

59. Smiles, *Lives*, 27–28; Thomas H. Hair, *Sketches of the Coal Mines in Northumberland and Durham* (London, 1839), 8. See "Newcastle upon Tyne," 313, for an additional description that reveals how little the keel had changed between 1807 and the 1830s and 1840s.

60. Daniell, *Voyage* (1822), 4:57.

61. Chumbley and Warrell, *Turner and the Human Figure*, 47.

62. Robert Salmon's *Low Lighthouse, North Shields* (1828; Yale Center for British Art, New Haven, Conn.) offers a clear, close view of this structure. See also Carmichael's watercolor *North Shields* (1866), reproduced in Greg, *Carmichael*, no. 115. Turner's "Little Liber" comprised twelve mezzotints engraved in the mid-1820s, including *Shields Lighthouse*. See Lyles and Perkins, *Colour into Line*, 58–60.

63. *Parliamentary Gazetteer*, s.v. "Shields," 10:108.

64. Oulton, *Guide*, 2:572.

65. McCord, *North-East England*, 36; Daunton, *Progress and Poverty*, 219–20.

66. Head, *A Home Tour in the Manufacturing Districts,* 334.

67. Chumbley and Warrell, *Turner and the Human Figure,* 47.

68. Head, *A Home Tour in the Manufacturing Districts,* 334. See also Shanes, *Rivers,* 30.

69. James Guthrie, *The River Tyne and Its History and Resources* (London, 1880), 22.

70. Shanes, *Rivers,* 30.

71. Atkinson, *Coalfield,* 57; Raumer, *England in 1835,* 3:153. This volume was translated from the German by H. E. Lloyd, who wrote the text for Turner's *Picturesque Views in England and Wales.* His knowledge of the Newcastle region, gleaned from working on the Raumer translation, could have stimulated Turner's continued interest in Tyneside.

72. Lumsden, *Steam-Boat Companion,* 12.

73. Julian Treuherz, "The Turner Collector: Henry McConnel, Cotton Spinner," *Turner Studies* 6, no. 2 (winter 1986): 38–39.

74. Butlin and Joll, *Paintings,* 210.

75. Raumer, *England in 1835,* 3:152; Daniell, *Voyage,* 58.

76. Oulton, *Guide,* 2:572; *Parliamentary Gazetteer,* s.v. "Shields," 10:108.

77. McCord, *North-East England,* 43.

78. On salt-making in Shields, see Atkinson, *Coalfield,* 70. This industry was in decline, however, by the 1820s. Daniel Defoe wrote a century earlier, "It is a prodigious quantity of coals which those [Shields] salt works consume; and the fires make such a smoke, that we saw it ascend in clouds over the hills, four miles before we came to Durham, which is at least sixteen miles from the place" (*A Tour through the Whole Islands of Great Britain,* 1724–26, ed. and abridged by Pat Rogers [New York, 1971], 536). On the glass industry in Shields, see John Butt and Ian Donnachie, *Industrial Archaeology in the British Isles* (New York, 1979), 151.

79. Roger Dodsworth, *Glass and Glassmaking* (Aylesbury, 1982), 13; Rees, *Manufacturing Industry,* s.v. "Glass-house Furnace," 3:92.

80. *Spectator,* 9 May 1835, 447.

81. Ronald Paulson, *Breaking and Remaking: Aesthetic Practice in England, 1700–1820* (New Brunswick, N.J., 1989), 317, identifies Turner's penchant for "the Claude landscape structure of the open central perspective to the horizon." This is clearly evident in *Keelmen.*

82. *Morning Chronicle,* 6 May 1835, 3; *Spectator,* 9 May 1835, 447; *Morning Post,* 5 May 1835, 5; *Leigh Hunt's London Journal,* 27 May 1835, 127; *New Monthly Magazine,* 2d part (1835), 245.

83. See Shanes, *Picturesque Views,* 43, for the dating of circa 1830–31 for the watercolor; Wilton, *Turner: His Art and Life,* 400, gives circa 1832. The justification for the earlier date rests in part on the belief that Turner's sketches of the Dudley area were from 1829–30. See Finberg, *Inventory,* 2:739–40. Added evidence for a circa-1832 date can be found in a notice in the *Tatler,* 31 March 1832, 311,

which refers to an "Artists and Amateurs Conversazione" on 24 March of that year at which "a drawing by Turner viewing the town of Dudley" was exhibited.

This section is a revised version of my article "Turner's *Dudley:* Continuity, Change and Adaptability in the Industrial Black Country." *Turner Studies* 8, no. 1 (summer 1988): 32–40.

84. Herrmann, *Turner Prints,* 128–29; Lyles and Perkins, *Colour into Line,* 36; Lukacher, "Nature Historicized," 132.

85. Helsinger, "Turner and the Representation of England," 106. Inexplicably, Helsinger does not discuss *Dudley* in this article.

86. The term is Helsinger's, ibid., 119.

87. *Tatler,* 31 March 1832, 311; *Spectator,* 16 April 1836, 374; Ruskin, *Works,* 13:435; Rawlinson, *Engraved Work,* 1:158.

88. For example, Shanes, *Picturesque Views,* 43; Gordon N. Ray, *The Illustrator and the Book in England from 1790–1914* (New York, 1976), 16.

89. Wilton, *Turner and the Sublime,* 97 and 169.

90. Barrie Trinder, Introduction to S. Smith, *Iron Bridge,* 8; Mitchell, *Abstract,* 24.

91. Birt and McDougall, *Black Country Bygones,* 3.

92. John Byng, fifth Viscount Torrington, *The Torrington Diaries,* ed. C. Bruyn Andrews, 4 vols. (London, 1936), 3:146; Breckinridge, *Memoranda of Foreign Travel,* 1:45. Breckinridge visited the Black Country in 1837–38.

93. *Parliamentary Gazetteer,* s.v. "Dudley," 4:622; Birt and McDougall, *Black Country Bygones,* 3–8.

94. T. E. Lones, "The South Staffordshire and North Worcestershire Mining District and Its Relics of Mining Appliances," *Transactions of the Newcomen Society* 11 (1930–31): 43; W. G. Hoskins, *The Making of the English Landscape* (New York, 1977), 211–12.

95. Dud Dudley, *Metallum Martis; or Iron Made with Pit-Coale, Sea-Coale, etc.* (1665; reprint, London, 1851), 9.

96. Birt and McDougall, *Black Country Bygones,* 8 and 13; G. R. Porter, *The Progress of the Nation,* ed. F. W. Hirst (1836; reprint, London, 1912), 241, 238.

97. Burritt, *Walks,* 143.

98. [J. R. McCulloch], "Philosophy of Manufactures," *Edinburgh Review* 61 (July 1835): 456. For a good discussion of Dudley's claims, see T. E. Lones, "A Precis of *Metallum Martis* and an Analysis of Dud Dudley's Alleged Invention," *Transactions of the Newcomen Society* 20 (1939–40): 17–28, especially p. 28.

99. R. A. Mott, "The Newcomen Engine in the Eighteenth Century," *Transactions of the Newcomen Society* 35 (1962–63): 70.

100. W. H. Smith, *Dudley Castle,* 5; Barrie Trinder, *The Making of the Industrial Landscape* (London, 1982), 102; Trevor Raybould, "Aristocratic Landowners and the Industrial Revolution: The Black Country Experience, c. 1760–1840," *Midland History* 9 (1984): 67.

101. J. Ian Langford, *The Dudley Canal Tunnel* (Dudley, 1973), 1; William A. S. Sarjeant, "The Dudley Canal Tunnel and Mines, Worcestershire," *Mercian Geologist* 1 (1964): 61.

102. S. D. Chapman and J. D. Chambers, *The Beginnings of Industrial Britain* (London, 1970), 77.

103. Robert Southey, *Letters from England* (1807; reprint, London, 1951), 203.

104. Charles Dickens, *The Old Curiosity Shop*, ed. Angus Esson (New York, 1985), 423–24.

105. Henderson, *Fischer*, 69; L. D. Ettinger, "A German Architect's Visit to England in 1826," *Architectural Review* 97 (May 1945): 133. See also Karl Friedrich Schinkel, *"The English Journey": Journal of a Visit to France and Britain in 1826*, ed. David Bindman and Gottfried Riemann (New Haven, Conn., 1993), 128–30.

106. Hall, "Joshua Field's Diary," 28; James Hall Nasmyth, *James Nasmyth, Engineer: An Autobiography*, ed. Samuel Smiles (London, 1885), 159–60.

107. Zachariah Allen, *The Practical Tourist; or Sketches of the State of the Useful Arts, and of Society, Scenery, etc. in Great-Britain, France and Holland*, 2 vols. (1832; reprint, New York, 1972), 1:67–68.

108. Booker, *Dudley Castle*, 13.

109. Ibid., 13–14.

110. Carlyle and Carlyle, *Collected Letters*, 3:126–27.

111. W. H. Smith, *Dudley Castle*, 1; Burritt, *Walks*, 144.

112. J. M. W. Turner and H. E. Lloyd, *Picturesque Views in England and Wales*, 2 vols. (London, 1838), 2:n.p. (opposite *Dudley*).

113. "Chronicle," in *Annual Register for the Year 1826* (London, 1827), 115; Chandler and Hannah, *Dudley*, 95–96; Hobsbawm, *Industry and Empire*, 54. Hobsbawm noted that in Dudley a person born in the 1840s had a life expectancy of just over eighteen years.

114. Nikolaus Pevsner, *The Buildings of England: Staffordshire* (Harmondsworth, 1974), 120–21.

115. See "Dudley and Vicinity," from *One-Inch Map of the Ordnance Survey (Old Series)*, LXII-S.W. (London, 1834).

116. Just how mundane the view from the castle was, by comparison, can be seen in T. Creswick's *View of Dudley*, published in W. H. Smith, *Birmingham*, opposite p. 44. Of necessity, the emphasis is on the town buildings, especially the two churches. Only two smokestacks provide evidence of industrialism. The castle is suggested merely by a ruined arched gateway and some masonry in the foreground.

117. Lukacher, "Nature Historicized," 134. For photographs of the two prominent churches pictured in Turner's view, which still mark the horizon, see Chandler and Hannah, *Dudley*, illustrations 53 and 54.

118. Rees, *Manufacturing Industry*, s.v. "Canals," 1:349, 362.

119. Booker mentioned a Castle Mill Pool as being in the area, and this could

have been connected to the canal near Dudley Port (*Dudley Castle,* 11). See Birt and McDougall, *Black Country Canals,* 10–11, and Gale, *Black Country Iron Industry,* 35, for information on canal basins.

120. *Parliamentary Gazetteer,* s.v. "Dudley," 4:622; Burritt, *Walks,* 156, remarked how, for an anvil block, "a ball of iron wire as large as a bushel basket is welded in a solid mass."

121. Hall, "Joshua Field's Diary," 36.

122. W. H. Smith, *Birmingham,* 52–55. Smith's book provides one of the best contemporary descriptions of Black Country iron-making.

123. Rees, *Manufacturing Industry,* s.v. "Foundery," 3:4.

124. See *Interior of a tilt forge with figures* (TB XLII, 60–61), examined in Richard Seddon, "Turner's Tilt Forge," *Turner Society News* 56 (November 1990): 8–10. The *Interior of an Iron Foundry* is discussed, with reference to Joseph Wright's *Iron Forge* (1777), in Judy Egerton, *Wright of Derby* (London, 1990), 98. See also Michel Serres's interpretation of this work in "Turner Translates Carnot," 56, 60–61.

125. Chandler and Hannah, *Dudley,* 91; Peter Mathias, *The First Industrial Nation: An Economic History of Britain, 1700–1914* (New York, 1969), 125–26; Hobsbawm, *Industry and Empire,* 53–54.

126. Birt and McDougall, *Black Country Bygones,* 10–11; T. J. Raybould, *The Economic Emergence of the Black Country: A Study of the Dudley Estate* (Newton Abbot, 1973), 172. For the lime kilns near Dudley Castle, see Booker, *Dudley Castle,* 7.

127. Andrew Wilton, *Turner in Wales* (Llandudno, 1984), 47.

128. Birt and McDougall, *Black Country Bygones,* 3; *Parliamentary Gazetteer,* s.v. "Dudley," 4:622.

129. M. W. Greenslade and J. G. Jenkins, eds., *The Victoria History of the County of Stafford,* vol. 2, The Victoria History of the Counties of England (London, 1967), 270; Chandler and Hannah, *Dudley,* 93–94.

130. J. W. Willis-Bund and William Page, eds., *The Victoria History of the County of Worcester,* vol. 2, The Victoria History of the Counties of England (London, 1906), 270; Gale, *Black Country Iron Industry,* 69. See also Breckinridge, *Memoranda of Foreign Travel,* 1: 45, for the observation that "to each chimney is attached a flue, through which issues the blaze from the smelting furnaces."

131. Charles Fogg, *Chains and Chainmaking* (Aylesbury, 1981), 6. See also Birt and McDougall, *Black Country Canals,* 9, for an illustration of the Parkes's chainworks not far from Dudley, which bears some similarity to the prominent building in Turner's painting.

132. H. R. Schubert, "Extraction and Production of Metals: Iron and Steel," in *The History of Technology,* ed. Charles Singer et al., 7 vols. (Oxford, 1958), 4:109; Birt and McDougall, *Black Country Canals,* 8–9.

133. John Murray, *Handbook for Travellers in Gloucestershire, Worcestershire, and Herefordshire* (London, 1867), 113.

134. Turner also organized this work according to a number of diagonal relationships. For example, the castle's keep balances the similarly shaped waterside factory; the two church towers relate to the vertical elements at Dudley Port Furnace.

135. Treadway Russell Nash, *Collections for the History of Worcestershire*, 2 vols. (London, 1781), 1: opposite p. 358.

136. James Balston, *John Martin 1789–1854: His Life and Works* (London, 1947), 236; Shanes, *Picturesque Views*, 13 and 157.

137. The classic examination of this theme is Klingender, *Art and the Industrial Revolution*. Other useful discussions appear in two exhibition catalogues: Arthur Elton, *Art and the Industrial Revolution* (Manchester, 1968); and S. Smith, *Iron Bridge*.

138. Benedict Nicolson, *Joseph Wright of Derby: Painter of Light*, 2 vols. (London, 1968), 1:166.

139. S. Smith, *Iron Bridge*, 46; Sussman, *Victorians and the Machine*, 30. The best recent discussion of this painting is Daniels, "Loutherbourg's Chemical Theatre," 195–230.

140. John Burnet, *Turner and His Work* (London, 1852), 28; Thornbury, *Life and Correspondence*, 157–62; Butlin and Joll, *Paintings*, 21.

141. The type of scene Turner painted, however, was not unique in earlier European art. For instance, *Landscape with a Forge* (c. 1535), by the Flemish artist Henri Met de Bles, juxtaposes a hilltop castle with surrounding ironworking operations; see the exhibition catalogue *Liechtenstein: The Princely Collections* (New York, 1985), 279.

CHAPTER 5

1. Sheppard, *London*, 18; Roy Porter, *London: A Social History* (Cambridge, Mass., 1995), 186–88; McCord, *British History*, 80.

2. For one aspect of Turner's views of London, see Shanes, "London Series," 36–41.

3. *Athenaeum*, 24 January 1857, 109.

4. Butlin and Joll, *Paintings*, 306, assign the date for "stylistic reasons." Theirs is the only full-fledged discussion of this painting. A 1988 exhibition of Monet's London paintings failed to note the obvious parallels with Turner's *Thames above Waterloo Bridge*, although the catalogue credits the older painter as "one source of inspiration for Monet's later attempt to make pictures which take on a modern urban subject." See Grace Seiberling, *Monet in London* (Seattle and London, 1988), 42. Recently Schama has attempted to distance Turner from London's smoke and steam, writing that the artist "took pains to preserve and embellish its [London's] ancient myths rather than confront their modern corruption" (*Landscape*, 359).

5. Johnson, "Victorian Artists," 465; Vaughan, "London Topographers," 69.

6. It was shown in Italy in 1948, in Rotterdam in 1955, in Edinburgh in 1968, and at the Royal Academy's Turner retrospective in 1974–75 (Butlin and Joll, *Paintings,* 306). The painting has also been on view at the Tate Gallery. Notable examples of Turner's unexhibited works that have achieved recognition in their own right are *Interior at Petworth,* c. 1837, and *Norham Castle, Sunrise,* circa 1840–50 (both Tate Gallery).

7. Ibid., 306.

8. Tristan, *London Journal,* 22. For a modern examination of this atmospheric problem, see Carlos Flick, "The Movement for Smoke Abatement in Nineteenth-Century Britain," *Technology and Culture* 21, no. 1 (1980): 29–50. Flick notes that the problem was not new; complaints about "smoke nuisance" had been recorded as far back as the reign of Edward I. With the advent of modern industry, however, the situation deteriorated to such a degree that a House of Commons select committee was appointed, in 1819–20, to investigate (29–30).

9. Goede, *Foreigner's Opinion,* 1:16–17; Passavant, *Tour,* 13; [Forsyth], "Mourn, Ancient Caledonia!" 636 (this article, protesting plans to locate Scottish administrative buildings in London, was critical of the city "already overgrown" [635]); Shelley, *Peter Bell the Third,* in *The Complete Poetical Works of Percy Bysshe Shelley,* ed. Thomas Hutchinson (New York, 1933), 350; Alexander P. D. Penrose, ed., *The Autobiography and Memoirs of Benjamin Robert Haydon* (New York, 1925), 37; James Anthony Froude, *Thomas Carlyle: A History of His Life in London, 1834–1881,* 2 vols. (New York, 1910), 1:161.

10. Johnson, "Victorian Artists," 1:449, remarks that this smoking urban context "had strangely little impact on the imagination of English artists of the age."

11. Vaughan, "London Topographers," 449. An important exception to the "celebratory" view came from the hand of the French artist Gustave Doré, who probed much that was unsightly in the city's life in the 1872 *London: A Pilgrimage.*

12. William Seitz, *Claude Monet: Seasons and Moments* (Garden City, N.Y., 1960), 36.

13. Fever, *Martin,* 126.

14. [Forsyth], "Mourn, Ancient Caledonia!" 635.

15. L. C. B. Seaman, *Life in Victorian London* (London, 1973), 11; Musson, *Growth of British Industry,* 71.

16. Martin Daunton, "London and the World," in *London: World City, 1800–1840,* ed. Celina Fox (New Haven, Conn., 1992), 36; Goede, *Foreigner's Opinion,* 25.

17. Aldon D. Bell, *London in the Age of Dickens* (Oklahoma City, 1967), 10.

18. Hemingway, *Landscape Imagery,* 225. He quotes several lines from James Thomson's *The Seasons* that are apt:

> Then commerce brought into the public walk
> The busy Merchant; the big warehouse built;

Raised the strong crane; choked up the loaded street
With foreign plenty; and thy stream, O Thames,
Large, gentle, deep, majestic, king of floods!
Chose for his grand resort . . .

Hemingway discounts the idea that Turner was interested in the industrial nature of London: "He was never to make the commercial heart of London the subject of [a major oil]" (237).

19. Frederick Engels, *The Condition of the Working-Class in England* (1844; English ed., Moscow, 1973), 63; *Punch,* July–December 1841, 178; *Morning Chronicle,* 3 September 1838, 4; Broodbank, *Port of London,* 1:164.

20. "Steam Navigation in the Port of London," 84–85. The first steamer on the Thames was the *Margery,* brought from Scotland. By 1815 she was joined by two more vessels, the *Regent* and the *Thames.* Regular service began that year. See Sheppard, *London,* 122.

21. Charles Dickens, *Sketches by Boz* (1833–36; reprint, New York, 1987), 72; William Smith, *A New Steam-boat Companion* (London, 1834), 2–5; "English Steamboats," *Journal of the Franklin Institute* 9, no. 5 (1832), 350 (on steam traffic); [Alexander Slidell Mackenzie], *The American in England,* 2 vols. (Paris, 1836), 2:156; and "Notes of a Traveller on the Thames in 1814 and 1837," *Athenaeum,* 21 October 1837, 787.

22. Finberg, *Life of Turner,* 370–71.

23. Shanes, "London Series," 41. For steamboat activity to the Continent at this point on the river, see Galignani, *Guide,* xii–xiii; John Weale, ed., *Bohn's Pictorial Handbook of London* (London, 1854), 342.

24. See also N. Whittock, *The Modern Picture of London* (London, c. 1836), for a depiction of Richmond Bridge with a steamer in the foreground (opposite p. 554).

25. Henry Luttrell, "Steamer to Margate," from *Letters to Julia,* early 1820s, quoted in Jeremy Warburg, *The Industrial Muse* (London, 1958), 15.

26. Mackay, *Thames,* 1:38.

27. Rolt, *Victorian Engineering,* 78–80. See McCord, *British History,* 80, for a discussion of London's leadership in the machine tool industry and other advanced technologies and the role played by engineers like Maudslay.

28. *Nautical Magazine,* January 1838, 44; Clunn, *Face of London,* 120.

29. One indication of the market's fame in the 1830s was its inclusion, as the sole example of notable English architecture, in C. L. F. Forster's *Bauzeitung* (see reference in [W. H. Leeds], "Architecture at Home and Abroad," *Foreign Quarterly Review* 24 [October 1839–January 1840]: 291); Gater, *Strand,* 44–45.

30. Timbs, *Curiosities,* 63. Timbs began his study in 1828.

31. See map by B. R. Davis, *London* (London, 1843); and Turner's letter to David Roberts from 1847 in John Gage, "Further Correspondence of J. M. W. Turner," *Turner Studies* 6, no. 1 (summer 1986): 8.

32. See Spratt, *Handbook*, 93, for the 1834 schedule; the quote is from [Head], "Railroads," 5.

33. "Steam Navigation in the Port of London," 85; Broodbank, *Port of London*, 1:165.

34. Gater, *Strand*, 45–50; Rolt, *Brunel*, 408. If Turner's painting could be assigned a date of c. 1845, the artist could have surveyed the busy river and Waterloo Bridge from the center of this new structure, as can be done today from the present Charing Cross footbridge, which occupies the same site.

35. L. D. Schwarz, *London in the Age of Industrialisation: Entrepreneurs, Labour Force and Living Conditions, 1700–1850* (Cambridge, 1992), 32.

36. Elmes and Shepherd, *Metropolitan Improvements*, 155. The engraving appears opposite p. 288. See also Roberts and Godfrey, *South Bank and Vauxhall*, 47; and Neil Cossons, *The BP Book of Industrial Archeology* (London, 1975), 212–13.

37. N. Whittock, *The Modern Picture of London* (London, 1836?), 29; [Samuel Leigh], *Leigh's New Picture of London* (London, 1834), 26; John Britton, ed., *The Original Picture of London* (London, 1832?), 387.

38. [Samuel Leigh], "View from the Adelphi," in *The Panorama of the Thames from London to Richmond*, accompanied by a separate text, *Descriptions of the Most Remarkable Places Between London and Richmond* (London, 1829), 5; Howard Roberts and Walter H. Godfrey, eds., *Bankside*, Survey of London, vol. 22 (London, 1950), 59, 80, 114.

39. Daunton, *Progress and Poverty*, 209.

40. For a discussion of this work, see Leslie Parris, Ian Fleming-Williams, and Conal Shields, *Constable Paintings, Watercolors and Drawings* (London, 1976), 112–13; and Graham Reynolds, *The Later Paintings and Drawings of John Constable*, text vol. (New Haven, Conn., 1984), 233–35.

41. Roberts and Godfrey, *South Bank and Vauxhall*, 51, and plates 6b for the "Shot Tower east of Waterloo Bridge" and 39b for the waterworks.

42. See Hermione Hobhouse, *Lost London* (New York, 1971), 159, for a photograph of the brewery shortly before demolition. Cherry and Pevsner, *London 2*, 345, mistakenly date the brewery at 1826–27, but prints of the area from that time show no such structure.

43. Thomas Shotter Boys, *London as It Is* (London, 1842), no pagination. See Vaughan, "London Topographers," 60–61, for a discussion of the work as an example of the "beneficial activity" of urban industrialism. For a detailed description of the brewery, see Roberts and Godfrey, *South Bank and Vauxhall*, 51–54.

44. *Pilgrim Edition of the Letters of Charles Dickens*, ed. Madeline House and Graham Story, 7 vols. (Oxford, 1969), 1:185.

45. Timbs, *Curiosities*, 27; Tristan, *London Journal*, 72, 79.

46. John Butt and Ian Donnachie, *Industrial Archaeology in the British Isles* (London, 1979), 63; Tristan, *London Journal*, 72.

47. Clunn, *Face of London*, 125; Cherry and Pevsner, *London 2*, 712–13; Old Humphrey, *Old Humphrey's Walks in London*, 3d ed. (New York, 1844), 284.

48. Sheppard, *London*, 107; J. E. Martin, *Greater London: An Industrial Geography* (Chicago, 1966), 1.

49. Mackay, *Thames*, 1:37–38.

50. The toll was a penny for pedestrians and three pence for carriages—so modest that by 1826 the bridge's owners could net only about fifty pounds a day (Mackay, *Thames*, 1:34–36). See also Hermann Ludwig Heinrich Puckler-Muskau, *Tour in Germany, Holland and England in the Years 1826, 1827, and 1828*, 4 vols. (London, 1832), 3:47.

51. *Selected Poems of Thomas Hood*, ed. John Clubbe (Cambridge, Mass., 1970), 28. The poem describes the case of Mary Furley, a woman who jumped with one of her children into the Regent's Canal. She survived, but the child died. For his poem Hood moved the incident to "the grander Thames and Waterloo Bridge, the traditional jumping-off place of suicides" (28).

52. Butlin and Joll, *Paintings*, 235. See also Max F. Schulz, "Turner's Fabled Atlantis: Venice, Carthage, and London as Paradisal Cityscape," *Studies in Romanticism* 19, no. 3 (fall 1980): 395–417.

53. Ruskin, *Works*, 7:162; 28:464; Forbes, "Colour of Steam," 121–22.

54. Turner, "The Extended Town," in Lindsay, *Sunset Ship*, 99.

55. Turner, "Hail Silver Thames," in ibid., 99.

56. Goede, *Foreigner's Opinion*, 15–16; Passavant, *Tour*, 12.

57. Lukacher, "Nature Historicized," 132; Butlin and Joll, *Paintings*, 69.

58. This watercolor is reproduced in Shanes, "London Series," 40.

59. For a discussion of these two paintings, see Katherine Solender, *Dreadful Fire! Burning of the Houses of Parliament* (Bloomington, Ind., 1984).

60. Craig Hartley, *Turner Watercolours in the Whitworth Art Gallery* (Manchester, 1984), 55. *Fire at Fenning's Wharf* shares with *Thames* the concern with steamers as an important pictorial element. Likewise, in the Cleveland version of *The Burning of the Houses of Lords and Commons*, a steamboat can be seen at the lower right. Richard Dorment suggests that it is towing a floating fire-engine. See his *British Painting in the Philadelphia Museum of Art* (Philadelphia, 1986), 398.

61. Peter Gaskell, *Artisans and Machinery: The Moral and Physical Condition of the Manufacturing Population* (1836; reprint, New York, 1968), 94; A. Meiklejohn, *The Life, Work, and Times of Charles Turner Thackrah* (1957), in Thackrah, *Effects*, 12 and 59. Thackrah practiced in Leeds, but his conclusions applied to most large industrial cities. See also Gildea, *Barricades*, 7–8, for disease and the modern urban environment.

62. Sheppard, *London*, 247–49.

63. Ibid., 123, 131–33.

1. *Art-Union*, June 1844, quoted in Olmsted, *Victorian Painting*, 1:501.

2. Butlin and Joll, *Paintings*, 256.

3. Wyld, *Great Western*, 38–39.

4. Finley, "Turner and the Steam Revolution," 20; Burke, *Sublime*, 144–47.

5. *Morning Post*, 9 May 1844, 5; Alison, *Principles of Taste*, 181.

6. *Morning Post*, 9 May 1844, 5; Lister, *British Romantic Art*, 136. Lister referred to both *Rain, Steam, and Speed* and *Snow Storm—Steam-Boat off a Harbour's Mouth*.

7. Olmsted, *Victorian Painting*, 1:502. The painting was by F. Creswick.

8. McCoubrey, "Time's Railway," 38.

9. For a discussion of other depictions of railroads, see Gage, *Rain, Steam, and Speed*, 13–14. Finley, "Turner and the Steam Revolution," 25, points out that "though steam locomotives may have become a familiar subject for popular prints they had never been considered the subject of high art"; and Murray, "Art, Technology, and the Holy," 79, calls the painting "the first lyric work of art to feature a major example of the new techniques" in transportation.

10. Lockwood, *Passionate Pilgrims*, 49; Emerson is quoted in Marx, *Machine in the Garden*, 17; [David Brewster], "Life and Works of Thomas Telford," *Edinburgh Review* 70 (October 1839): 47; Whishaw, *Railways*, v.

11. *Athenaeum*, 26 June 1841, 483; *Art-Union*, May 1833, 19; Elizabeth Longford, *Wellington: Pillar of State* (New York, 1972), 219–21.

12. Daunton, *Progress and Poverty*, 310–11.

13. Sussman, *Victorians and the Machine*, 42, notes that prior to railroads the new mechanization appeared to most in the form of the occasional Thames steamer.

14. *Athenaeum*, 26 June 1841, 483.

15. See G. R. Hawke, *Railways and Economic Growth in England and Wales, 1840–1870* (Oxford, 1970), 213 and 364.

16. Elie Halévy, *A History of the English People in the Nineteenth Century: Victorian Years* (1951; reprint, London, 1970), 188. By 1845 many worried that too much of the nation's ready capital had been committed to railways.

17. J. H. Clapham, *An Economic History of Modern Britain*, 3 vols. (2d ed., Cambridge, 1964), 1:389; *Herpath's Journal and Railway Magazine*, 20 January 1844, 61; John Stuart Mill, *Collected Works of John Stuart Mill, 1812–1848*, ed. Francis E. Mineka, 29 vols. (Toronto, 1963), 13:685. For the most thorough examination of the boom in railways during this period, see Henry Grote Lewin, *The Railway Mania and Its Aftermath, 1845–1852* (1936; reprint, New York, 1968).

18. Marx, *Machine in the Garden*, 27.

19. Ibid., 35. Turner's only other title that contains the specific name of a technological object is *Snow Storm—Steam-Boat off a Harbour's Mouth* (1842),

which alludes to the *Ariel* steamer (*The Author was in this Storm on the Night the "Ariel" left Harwich*).

20. Whishaw, *Railways*, 141. See also John Francis, *A History of the English Railways: Its Social Relations and Revelations* (1851; reprint, Newton Abbot, 1967), 213.

21. Rolt, *Victorian Engineering*, 41, and *Brunel*, 181.

22. Johann Georg Kohl, *England and Wales* (1844; reprint, New York, 1968), 157; *Herpath's Journal and Railway Magazine*, 24 August 1844, 993.

23. Russell, *Guide*, 111–14.

24. Gage, *Rain, Steam, and Speed*, 22; MacDermot, *Great Western*, 1:467–69. For the locomotive's specifications, see F. George Kay, *Steam Locomotives* (New York, 1974), 56.

25. MacDermot, *Great Western*, 68.

26. *Morning Chronicle*, 8 May 1844, 4; see the illustrations *Premium, Par, Discount* and *The Railway Dragon*, from *George Cruikshank's Table Book Edited by Gilbert Abbott a Beckett* (London, 1845), in Richard A. Vogler, *Graphic Works of George Cruikshank* (New York, 1979), 89–90.

27. Lady Simon is quoted in Stirling, *Richmond Papers*, 55; the quote from James H. Lanman's 1840 article is in Marx, *Machine in the Garden*, 207.

28. Marx, *Pilot*, 122.

29. Serres, "Turner Translates Carnot," 56–57.

30. The phrase is from Paulson, *Literary Landscape*, 96.

31. Susan Sidlauskas, "Creating Immortality: Turner, Soane, and the Great Chain of Being," *Art Journal* 52, no. 2 (summer 1993): 62.

32. MacDermot, *Great Western*, 402; Jack Simmons, *The Victorian Railway* (New York, 1991), 77.

33. MacDermot, *Great Western*, 384.

34. Arthur Elton, "The Piranesi of the Age of Steam," *Country Life Annual* (1965), 40. Elton describes the locomotive depicted with vivid realism by J. C. Bourne in the frontispiece of his *History and Description of the Great Western Railway* (1846), "her copper haystack boiler gleaming." See also Whishaw, *Railways*, xxiv, for a complete description of the working of a locomotive engine.

35. The Actaeon, a locomotive of the Firefly class, would explode in such a fashion in 1856. MacDermot, *Great Western*, 469.

36. [Head], "Railroads in Ireland," 13.

37. *Times*, 8 May 1844, 7; *Morning Chronicle*, 8 May 1844, 4; *Illustrated London News*, 11 May 1844, 1306; *Critic*, 15 May 1844, 196; *John Bull*, 18 May 1844, 311; *Fraser's Magazine*, June 1844, 712–13; *Morning Post*, 9 May 1844, 15.

38. Stephen Wildman et al., *David Cox, 1783–1859* (Birmingham, 1983), 88–89, 92. Wildman links *Night Train* to other versions of this subject from 1849.

39. George Augustus Sala, *Life and Adventures of George Augustus Sala, Written by Himself*, 2 vols. (New York, 1895), 1:212.

40. Wilton, *Turner and the Sublime,* 186; Ruskin, *Works,* 35:601.

41. Ibid., 3:231.

42. Gage, *Rain, Steam, and Speed,* 35; McCoubrey, "Time's Railway," 38.

43. Mona Wilson, "Travel and Holidays," in *Early Victorian England,* ed. G. M. Young, 2 vols. (London, 1934), 2:292; Pevsner, *Pioneers of Modern Design* (1936; rev. ed., Harmondsworth, 1974), 135; Klingender, *Art and the Industrial Revolution,* 154; Mumford, *Techniques and Civilization* (1934; modern ed., New York, 1963), 330, 200; Wosk, *Breaking Frame,* 34.

44. *Critic,* 15 May 1844, 196; *John Bull,* 18 May 1844, 311.

45. *Morning Chronicle,* 8 May 1844, 4; *Fraser's Magazine,* June 1844, 712–13; *Critic,* 15 May 1844, 196.

46. Alison, *Principles of Taste,* 119; Finley, "Turner and the Steam Revolution," 23.

47. Hamerton, *Life of Turner,* 295.

48. Klingender, *Art and the Industrial Revolution,* 151.

49. *Art-Union,* May 1839, 141.

50. See Susan Danly Walther, *The Railroad in the American Landscape: 1850–1950* (Wellesley, Mass., 1981), 19.

51. Mazlish, "Historical Analogy," 20–24.

52. Marx, *Pilot,* 194; Gage, *Rain, Steam, and Speed,* 29.

53. Egerton, *Temeraire,* 103.

54. Quoted in Jennings, *Pandemonium,* 233–35.

55. Finley, "Turner and the Steam Revolution," 19–20; Burke, *Sublime,* 144 and 147; Ruskin, *Works,* 36:97.

56. Alison, *Principles of Taste,* 19, 29, 103. Alison's work was an important reevaluation of Burke's concept of the sublime. See Samuel H. Monk, *The Sublime: A Study of Critical Theories in Eighteenth-Century England* (Ann Arbor, Mich., 1960), 154–55.

57. Sidney Smith, "To the Editor of the *Morning Chronicle,*" 7 June 1842, in *The Selected Writings of Sydney Smith,* ed. W. H. Auden (New York, 1956), 314.

58. "Chronicle," in *Annual Register for the Year 1838* (London, 1839), 159, 110.

59. *John Bull,* 17 May 1840, 234.

60. Rolt, *Red for Danger,* 36–37.

61. "Chronicle," in *Annual Register for the Year 1839* (London, 1840), 136; Lardner, *Railway Economy,* 295.

62. Frances Ann Kemble, *Records of a Girlhood* (New York, 1879), 281, 283; [Head], "Railroads in Ireland," 13.

63. Carlyle and Carlyle, *Collected Letters,* 11:182–83; 13:113, 116. The comparison with projectiles was popular during the period. See Schivelbusch, *Railway Journey,* 58.

64. Hill, *Thames,* 156; Schama, *Landscape,* 362.

65. Marx, *Pilot,* 118; Paulson, *Literary Landscape,* 93.

66. [Buchanan], "Rail-Roads," 377; *Athenaeum*, 26 June 1841, 483.

67. Wyld, *Great Western*, xiii; MacDermot, *Great Western*, 372; Rolt, *Brunel*, 175.

68. O. S. Nock, *The Great Western Railway in the Nineteenth Century* (London, 1962), 34. Brunel had once predicted that trains between London and Bristol could reach 100 mph. See Rolt, *Red for Danger*, 28.

69. Smiles, *Lives*, 232.

70. Lardner, *Railway Economy*, 71.

71. Finley, "Turner and the Steam Revolution," 22.

72. Quoted in Thomas Burke, *Travel in England* (London, 1949), 119.

73. Robert Hughes, *The Shock of the New* (New York, 1981), 12; Schivelbusch, *Railway Journey*, 63.

74. Wyld, *Great Western*, 3.

75. Ibid., 49.

76. Gage, *Rain, Steam, and Speed*, 16.

77. The first version is in Stirling, *Richmond Papers*, 55–56; the second, in Ruskin, *Works*, 35:600. There Simon mentions that she had not eaten since breakfast that day, so her perception could have been influenced by acute hunger.

78. C. Lewis Hind, *Turner: Five Letters and a Postscript* (London, [1907]), 56.

79. *Morning Chronicle*, 8 May 1844, 7; *Fraser's Magazine*, June 1844, 712–13.

80. Alison, *Principles of Taste*, 331.

81. Sussman, *Victorians and the Machine*, 31.

82. Murray sees nature's superiority presented more subtly here than in other Turner paintings: "The train is not overpowered by a violent Nature, but a Nature in its calm vastness. . . . When Nature does not express or show its violence, but holds it in reserve, it can appear even more awesome and terrible." See "Art, Technology, and the Holy," 83.

83. Schivelbusch, *Railway Journey*, 24.

84. Mazlish, "Historical Analogy," 34; Whishaw, *Railways*, 143.

85. Mackay, *Thames*, 1:318, for the quote; Gage, *Rain, Steam, and Speed*, 19; Harold P. Clunn, *The Face of the Home Counties* (London, n.d.), 19. It has been suggested that Turner saw the two Thames bridges as symbolic of the changes in his own life, since he was born around the time the old bridge was completed and was an old man by the 1840s. See Hill, *Thames*, 156. Some objection to Brunel's viaduct came from business interests concerned about the possible loss of toll revenue from the old road bridge. See Isambard Brunel, *The Life of Isambard Kingdom Brunel, Civil Engineer* (1870; reprint, Newton Abbot, 1971), 67.

86. Wyld, *Great Western*, 39. See also Rolt, *Brunel*, 171–72.

87. W. L. Wyllie, *J. M. W. Turner* (London, 1905), 133.

88. Christopher Johnstone, *John Martin* (New York, 1974), 111 and 129.

89. Gage, *Rain, Steam, and Speed*, 27. See Fever, *Martin*, 79, for the obser-

vation that the tunnel above the "Bridge over Chaos" could be linked to the Thames tunnel of Marc Brunel, Isambard's father.

90. Gina Crandell, *Nature Pictorialized: "The View" in Landscape History* (Baltimore, 1993), 151; Ruskin, *Works,* 4:31; William Wordsworth, *The Prose Works of William Wordsworth,* ed. W. J. B. Owen and Jane Worthington Smyser, 3 vols. (Oxford, 1974), 3:345.

91. McCoubrey, "Time's Railway," 38.

92. J. W. Croker, *The Correspondence and Diaries of the Late Right Honourable John Wilson Croker, LL.D., F.R.S.,* ed. Louis J. Jennings, 2 vols. (New York, 1884), 2:233–34.

93. Turner to George Cobb, 10 October 1840, in Gage, *Correspondence,* 180.

94. [David Brewster], "Life and Discoveries of James Watt," *Edinburgh Review,* 70 (January 1840), 467. Beyond his intellectual engagement with steam travel, Turner also, late in life, reaped a pecuniary advantage from the railway. In 1848 he sold some land in Twickenham to the South-Western Railway Company for 550 pounds. This tidy sum, which was more than he had hoped to get, reflects the ability of the expanding railways to spare no expense in developing their lines. See Thornbury, *Life and Correspondence,* 339–40.

95. Sussman, *Victorians and the Machine,* 34.

96. Smiles, *Lives,* 25.

CONCLUSION

1. "Industrial Exhibition," *Westminster Review,* July 1851, 186–88.

2. Gage, *Correspondence,* 224–25.

3. Ibid., 227.

4. Asa Briggs, *Iron Bridge to Crystal Palace: Impact and Images of the Industrial Revolution* (London, 1979), 179, 182, 167.

5. Helsinger, "Turner and the Representation of England," 104.

6. Shelley, *Defence,* 137.

7. See Andrew Hemingway, "Genius, Gender and Progress: Benthamism and the Arts in the 1820s," *Art History* 16, no. 4 (December 1992): 619, for an excellent discussion of this point of view.

8. Robert Blake, *The Conservative Party from Peel to Churchill* (New York, 1970), 25, describes this transformation as "acceptance of the industrial revolution, compromise with the forces of change and adaptation of traditional institutions to the new social demands."

9. Daniels, "Implications of Industry," 14–16, and idem, "Loutherbourg's Chemical Theatre: *Coalbrookdale by Night,*" in *Painting and Politics of Culture: New Essays on British Art, 1700–1850,* ed. John Barrell (New York, 1992), 196 and 212.

10. McCord, *British History,* 217.

11. Barrell, *Darkside,* 153–54. For a recent view of Turner as strongly critical of some of the new agricultural realities, see Michele L. Miller, "J. M. W. Turner's *Ploughing Up Turnips, near Slough:* The Cultivation of Cultural Dissent," *Art Bulletin* 77, no. 4 (December 1995): 570–83.

References

Only works cited more than once are included in the bibliography. Single citations of works are given in full in the notes.

Aikin, John. *A Description of the Country from Thirty to Forty Miles Round Manchester.* 1795. Reprint. New York, 1968.

Alfrey, Nicholas. "The French Rivers." In *Turner en France: Aquarelles, peintures, dessins, gravures, carnets de croquis,* edited by Jacqueline and Maurice Guillaud, 188–89, 192–93. Paris, 1981.

Alison, Archibald. *Essays on the Nature and Principles of Taste.* 1790. 2d ed. Hartford, Conn., 1821.

Altick, Richard. *The Shows of London.* Cambridge, Mass., 1978.

Arscott, Caroline, Griselda Pollock, and Janet Wolff. "The Partial View: The Visual Representation of the Early Nineteenth-Century Industrial City." In *The Culture of Capital: Art, Power and the Nineteenth-Century Middle Class,* edited by Janet Wolff and John Seed, 191–233. Manchester, 1988.

Atkinson, Frank. *The Great Northern Coalfield, 1700–1900.* London, 1968.

Baines, Edward. *Directory, General and Commercial, of the Town and Borough of Leeds.* Leeds, 1817.

Ballard, Joseph. *England in 1815.* Boston, 1913.

Barrell, John. *The Darkside of Landscape: The Rural Poor in English Painting, 1730–1840.* New York, 1980.

Bears, P. C. D. *Armley Mills: The Leeds Industrial Museum.* Leeds, n.d.

Berger, John. *About Looking.* New York, 1980.

Bermingham, Ann. *Landscape and Ideology: The English Rustic Tradition, 1740–1860.* Berkeley, Calif., 1986.

Birt, David, and David McDougall. *Black Country Bygones.* York, 1984.

———. *Black Country Canals.* York, 1984.

Booker, Luke. *A Descriptive and Historical Account of Dudley Castle and Its Surrounding Scenery.* Dudley, 1825.

Breckinridge, Robert J. *Memoranda of Foreign Travel: Containing Notices of a Pilgrimage Through Some of the Principal States of Western Europe.* 2 vols. Baltimore, 1845.

[Brewster, David]. "Statistics and Philosophy of Storms." *Edinburgh Review* 68 (January 1839): 406–32.

British Almanac of the Society for the Diffusion of Useful Knowledge. London, 1840.

Broodbank, Joseph G. *History of the Port of London.* 2 vols. London, 1921.

Bryson, Norman. "Enhancement and Displacement in Turner." *Huntington Library Quarterly* 49 (1986): 47–65.

[Buchanan, George]. "Rail-Roads and Locomotive Steam-Carriages." *Quarterly Review* 42 (March 1830): 377–404.

Burke, Edmund. *A Philosophical Enquiry into the Origin of Our Ideas of the Sublime and Beautiful.* 1757. Reprint, edited by James T. Boulton. Notre Dame, Ind., 1968.

Burritt, Elihu. *Walks in the Black Country.* London, 1868.

Butlin, Martin, and Evelyn Joll. *The Paintings of J. M. W. Turner.* 2 vols. Rev. ed. New Haven, Conn., 1984.

Butlin, Martin, and Andrew Wilton. *Turner, 1775–1851.* London, 1974.

Carlyle, Thomas. *The Works of Thomas Carlyle.* Edited by H. D. Traill. 30 vols. 1899. Reprint. New York, 1969.

Carlyle, Thomas, and Jane Welsh Carlyle. *The Collected Letters of Thomas and Jane Welsh Carlyle.* Edited by Charles Richard Sanders. 21 vols. Durham, N.C., 1970.

Chandler, G., and I. C. Hannah. *Dudley.* London, 1949.

Cherry, Bridget, and Nikolaus Pevsner. *London 2: South.* The Buildings of England. Harmondsworth, 1983.

Chumbley, Ann, and Ian Warrell. *Turner and the Human Figure: Studies of Contemporary Life.* London, 1989.

Clammer, Richard. *Paddle Steamers, 1837 to 1914.* London, 1983.

Clark, Kenneth. *The Romantic Rebellion.* London, 1973.

Clunn, Harold P. *The Face of London.* London, n.d.

Cole, Thomas. "Essay on American Scenery." *American Monthly Magazine* 7 (January 1836): 1–12.

Connell, E. J., and M. Ward. "Industrial Development, 1780–1914." In *A History of Modern Leeds,* edited by Derek Fraser, 142–76. Manchester, 1980.

Crump, W. B. "The History of Gott's Mills." In *The Leeds Woollen Industry, 1780–1820,* edited by W. B. Crump, 254–71. Publications of the Thoresby Society, vol. 32. 1929. Reprint. New York, 1967.

Cunningham, Alan. *Life of Sir David Wilkie.* 3 vols. London, 1843.

Daniell, William. *A Voyage Round Great Britain.* 8 vols. London, 1814–25.

Daniels, Stephen. *Fields of Vision: Landscape Imagery and National Identity in England and the United States.* Princeton, 1993.

———. "The Implications of Industry: Turner and Leeds." *Turner Studies* 6, no. 1 (summer 1986): 10–17.

———. "Loutherbourg's Chemical Theatre: *Coalbrookdale by Night.*" In *Painting and Politics of Culture: New Essays on British Art, 1700–1850,* edited by John Barrell, 195–230. New York, 1992.

Daunton, M. J. *Progress and Poverty: An Economic and Social History of Britain, 1700–1850.* New York, 1995.

Disraeli, Benjamin. *The Works of Benjamin Disraeli, Earl of Beaconsfield.* Edited by Edmund Goose. 20 vols. London, 1905.

Dudley, Dud. *Metallum Martis; or Iron Made with Pit-Coale, Sea-Coale, etc.* 1665. Reprint. London, 1851.

Dunham, Arthur Louis. *The Industrial Revolution in France, 1815–1848.* New York, 1958.

Egerton, Judy. *Turner, "The Fighting 'Temeraire.'"* Making and Meaning. London, 1995.

Eitner, Lorentz, ed. *Neoclassicism and Romanticism, 1750–1850.* Vol. 1. *Restoration/ Twilight of Humanism.* Englewood Cliffs, N.J., 1970.

Elmes, James, and Thomas H. Shepherd. *Metropolitan Improvements; or London in the Nineteenth Century.* London, 1827.

Emerson, Ralph Waldo. *English Traits.* 1856. Reprint. London, 1951.

Everett, Nigel. *The Tory View of Landscape.* New Haven, Conn., 1994.

Fever, William. *The Art of John Martin.* Oxford, 1975.

Finberg, A. J. *A Complete Inventory of the Drawings of the Turner Bequest.* 2 vols. London, 1909.

———. *The Life of J. M. W. Turner, R.A.* 2d ed. Oxford, 1961.

Finley, Gerald. "The Genesis of Turner's Landscape Sublime." *Zeitschrift für Kunstgeschichte* 42 (1979): 141–65.

———. *Landscapes of Memory: Turner as Illustrator to Scott.* Berkeley, Calif., 1980.

———. *Turner and George the Fourth in Edinburgh, 1822.* London, 1981.

———. "Turner and the Steam Revolution." *Gazette des Beaux-Arts* 6, no. 112 (July–August 1988): 19–30.

Forbes, James D. "On the Colour of Steam under Certain Circumstances." *London and Edinburgh Philosophical Magazine* 14 (January 1839): 121–26.

[Forsyth, Robert]. "Mourn, Ancient Caledonia!" *Blackwood's Magazine* 27 (April 1830): 634–39.

Gage, John. *Colour in Turner.* New York, 1969.

———. *J. M. W. Turner: "A Wonderful Range of Mind."* New Haven, Conn., 1987.

———. *Turner: Rain, Steam, and Speed.* New York, 1972.

———, ed. *The Collected Correspondence of J. M. W. Turner.* Oxford, 1980.

Gale, W. K. V. *The Black Country Iron Industry: A Technical History.* London, 1979.

Galignani, A. and W. *Galignani's New Paris Guide.* Paris, 1829.

Gater, George, ed. *The Strand*. Part 2 of *The Parish of St. Martin-in-the-Fields*. Survey of London, vol. 18. London, 1937.

Gildea, Robert. *Barricades and Borders: Europe, 1800–1914*. New York, 1987.

Goede, Christian Augustus Gottlieb. *A Foreigner's Opinion of England*. 3 vols. London, 1821.

Grasemann, C., and G. W. P. McLachlan. *English Channel Packet Boats*. London, 1939.

Greg, Andrew. *John Wilson Carmichael, 1799–1868*. Newcastle-upon-Tyne, 1982.

Griscom, John. *A Year in Europe in 1818–1819*. 2d ed. New York, 1824.

Guillaud, Jacqueline and Maurice, eds. *Turner en France: Aquarelles, peintures, dessins, gravures, carnets de croquis*. Exhibition catalogue. Paris, 1981.

Hall, John W. "Joshua Field's Diary of a Tour in 1821 through the Midlands." *Transactions of the Newcomen Society* 6 (1925–26): 1–41.

Hamerton, Philip Gilbert. *The Life of J. M. W. Turner, R.A.* London, 1879.

Hardy, J. *A Picturesque and Descriptive Tour in the Mountains of the Pyrenees*. London, 1825.

Hawes, Lewis. "Turner's *Fighting 'Temeraire.'*" *Art Quarterly* 35 (1972): 23–48.

Haydon, Benjamin Robert. *The Diary of Benjamin Robert Haydon*. Edited by Willard Bissell Pope. 5 vols. Cambridge, Mass., 1963.

[Head, Francis B.]. "Railroads in Ireland." *Quarterly Review* 63 (January 1839): 1–60.

Head, George. *A Home Tour in the Manufacturing Districts of England in the Summer of 1835*. London, 1836.

Helsinger, Elizabeth. "Turner and the Representation of England." In *Landscape and Power*, edited by W. J. T. Mitchell, 103–25. Chicago, 1994.

Hemingway, Andrew. *Landscape Imagery and Urban Culture in Early Nineteenth-Century Britain*. New York, 1992.

Henderson, W. O. *J. C. Fischer and His Diary of Industrial England, 1814–51*. London, 1966.

Herrmann, Luke. *Turner Prints: The Engraved Work of J. M. W. Turner*. New York, 1990.

Hill, David. *In Turner's Footsteps: Through the Hills and Dales of Northern England*. London, 1984.

———. *Turner on the Thames*. New Haven, Conn., 1993.

Hobsbawm, E. J. *Industry and Empire*. New York, 1968.

Hoole, Barbara Wreaks [Mrs. Hofland]. *River Scenery by Turner and Girtin*. London, 1827.

Houghton, Walter, ed. *The Wellesley Index to Victorian Periodicals, 1824–1900*. 5 vols. Toronto, 1979.

Humphrey, Heman. *Great Britain, France and Belgium: A Short Tour in 1835*. 2 vols. New York, 1838.

Inkster, Ian, and Jack Morrell, eds. *Metropolis and Province: Science in British Culture, 1780–1850*. Philadelphia, 1983.

Jennings, Humphrey. *Pandemonium, 1660–1886: The Coming of the Machine as Seen by Contemporary Observers*. Edited by Mary-Lou Jennings and Charles Madge. London, 1985.

Johnson, E. D. H. "Victorian Artists and the Urban Milieu." In *The Victorian City: Images and Realities,* edited by H. J. Dyos and Michael Wolff, 2:449–74. London, 1979.

Klingender, Francis D. *Art and the Industrial Revolution.* 1947. Edited and revised by Arthur Elton. New York, 1970.

Landes, David S. *The Unbound Prometheus.* New York, 1969.

Lardner, Dionysius. *Railway Economy: A Treatise on the New Art of Transport.* 1850. Reprint. New York, 1968.

Lees, Andrew. *Cities Perceived: Urban Society in European and American Thought, 1820–1940.* Manchester, 1985.

Lindsay, Jack. *J. M. W. Turner: His Life and Work.* New York, 1966.

———, ed. *The Sunset Ship: The Poems of J. M. W. Turner.* Lowestoft, England, 1966.

Lister, Raymond. *British Romantic Art.* London, 1973.

Lockwood, Allison. *Passionate Pilgrims: The American Traveller in Great Britain, 1800–1914.* Rutherford, N.J., 1980.

Lubbock, Basil. "Mercantile Marine." In *Early Victorian England,* edited by G. M. Young, 1:379–414. London, 1934.

Lukacher, Brian. "Nature Historicized: Constable, Turner, and Romantic Landscape Painting." In *Nineteenth-Century Art: A Critical History,* edited by Stephen F. Eisenman et al., 115–43. New York, 1994.

Lumsden, James. *Lumsden & Son's Steam-Boat Companion; or Stranger's Guide to the Western Isles and Highlands of Scotland.* 3d ed. Glasgow, 1831.

Lyles, Anne, and Diane Perkins. *Colour into Line: Turner and the Art of Engraving.* London, 1989.

Macaulay, Thomas Babington. *Critical and Historical Essays.* Introduction by Douglas Jerrold. Arranged by A. J. Grieve. 2 vols. New York, 1963.

MacDermot, E. T. *History of the Great Western Railway.* 3 vols. Revised by C. R. Clinker. London, 1972.

Mackay, Charles. *The Thames and Its Tributaries.* 2 vols. London, 1840.

Mackenzie, E. *Descriptive and Historical Account of the Town and County of Newcastle-upon-Tyne.* Newcastle-upon-Tyne, 1827.

Marestier, Jean-Baptiste. *Mémoire sur les bateaux à vapeur des Etats-Unis d'Amérique.* Paris, 1824.

Marx, Leo. *The Machine in the Garden.* New York, 1967.

———. *The Pilot and the Passenger.* New York, 1988.

Mazlish, Bruce. "Historical Analogy: The Railroad and the Space Program and Their Impact on Society." In *The Railroad and the Space Program: An Exploration in Historical Analogy,* edited by Bruce Mazlish, 1–52. Cambridge, Mass., 1965.

McCord, Norman. *British History, 1815–1906*. New York, 1991.

———. *North-East England*. London, 1986.

McCoubrey, John. "Time's Railway: Turner and the Great Western." *Turner Studies* 6, no. 1 (summer 1986): 33–39.

Mitchell, B. R. *Abstract of British Historical Statistics*. Cambridge, 1962.

Morlent, Joseph. *Voyage historique et pittoresque du Havre à Rouen, en bateau à vapeur; avec une carte*. 2d ed. Rouen, 1827.

Murray, John. *Handbook for Travellers in Switzerland 1838*. Edited by Jack Simmons. New York, 1970.

Murray, Michael. "Art, Technology, and the Holy: Turner." *Journal of Aesthetic Education* 8 (1974): 79–90.

Musson, A. E. *The Growth of British Industry*. New York, 1978.

"Newcastle upon Tyne." *Naval Chronicle* 18 (July–December 1807): 312–13.

Olmsted, John Charles. *Victorian Painting: Essays and Reviews*. 2 vols. New York, 1980.

Oulton, W. C. *The Traveller's Guide*. 2 vols. London, 1805.

Page, William, ed. *The Victoria History of the County of York*. Vol. 2. The Victoria History of the Counties of England. 1912. Reprint. Folkestone, 1974.

The Parliamentary Gazetteer of England and Wales. 12 vols. London, 1843.

Passavant, Johann David. *Tour of a German Artist in England*. 1836. Reprint. Wakefield, England, 1978.

Paulson, Ronald. *Literary Landscape: Turner and Constable*. New Haven, Conn., 1982.

Piggott, Jan. *Turner's Vignettes*. London, 1993.

Price, Roger. *The Economic Modernization of France*. New York, 1975.

Raumer, Frederick von. *England in 1835*. 3 vols. London, 1836.

Rawlinson, W. G. *The Engraved Work of J. M. W. Turner*. 2 vols. London, 1913.

Read, Richard. "'A name that makes it looked after': Turner, Ruskin and the Visual-Verbal Sublime." *Word and Image* 5, no. 4 (October–December 1989): 315–25.

Rees, Abraham. *Rees's Manufacturing Industry (1819–20)*. Edited by Neil Cossons. 5 vols. Trowbridge, England, 1972.

Rennie, Sir John. "Retrospect of the Progress of Steam Navigation." *Mechanics' Magazine* 45 (2 January 1847): 18–22; 46 (9 January 1847): 42–47, 67.

"Report of the Committee of the House of Commons on Steam-Boats." *Philosophical Magazine* 60 (August 1822): 113–32, 294; 60 (October 1822): 258–62.

Ritchie, Leitch. "Havre." In *The Keepsake for 1834*, 114–17. London, 1834.

———. *Liber fluviorum; or River Scenery in France Depicted in Sixty-one Line Engravings by J. M. W. Turner*. London, 1853.

———. *Turner's Annual Tour, 1834: Wanderings by the Seine, from Its Embouchure to Rouen*. London, 1834.

Roberts, Howard, and Walter H. Godfrey, eds. *South Bank and Vauxhall*. Survey of London, vol. 23. London, 1951.

Rodner, William S. "Humanity and Nature in the Steamboat Paintings of J. M. W. Turner." *Albion* 18, no. 3 (fall 1986): 455–74.

———. "Turner and Steamboats on the Seine." *Turner Studies* 7, no. 2 (winter 1987): 36–41.

Rolt, L. T. C. *Isambard Kingdom Brunel*. Harmondsworth, 1985.

———. *Red for Danger*. 1955. Reprint. London, 1971.

———. *Victorian Engineering*. Harmondsworth, 1980.

Ruskin, John. *Works*. Edited by E. T. Cooke and Alexander Wederburn. 39 vols. London, 1903–12.

Russell, Ronald. *Guide to British Topographical Prints*. North Pomfret, Vt., 1979.

Ryley, John. *The Leeds Guide*. Leeds, 1808.

Sauvan, Jean-Baptiste-Balthazar. *Picturesque Tour of the Seine from Paris to the Sea*. London, 1821.

Schama, Simon. *Landscape and Memory*. New York, 1995.

Schivelbusch, Wolfgang. *The Railway Journey: Trains and Travel in the Nineteenth Century*. Translated by Anselm Hollo. New York, 1979.

Serres, Michel. "Turner Translates Carnot." Trans. Marilyn Sides. In *Hermes: Literature, Science, Philosophy*, edited by Josué V. Harari and David F. Bell, 54–62. Baltimore, 1982.

Shanes, Eric. *Turner's Human Landscape*. London, 1990.

———. *Turner's Picturesque Views in England and Wales*. New York, 1979.

———. *Turner's Rivers, Harbours and Coasts*. London, 1981.

———. "Turner's 'Unknown' London Series." *Turner Studies* 1, no. 2 (1981): 36–42.

Shelley, Percy Bysshe. *A Defence of Poetry*. In *The Complete Works of Percy Bysshe Shelley*, edited by Roger Ingpen and Walter E. Peck. Vol. 7. New York, 1965.

Sheppard, Francis. *London, 1808–1870: The Infernal Wen*. Berkeley, Calif., 1971.

Singleton, Fred. *Industrial Revolution in Yorkshire*. Clapham, England, 1970.

Smiles, Samuel. *The Lives of George and Robert Stephenson*. 1874. Reprint. London, 1975.

Smith, Stuart. *A View from the Iron Bridge*. London, 1979.

Smith, William Hawkes. *Birmingham and Its Vicinity*. London, 1836.

———. *Historical and Topographical Notices of Dudley Castle*. London, 1835.

Spratt, H. P. *Science Museum: Handbook of the Collections Illustrating Merchant Steamers and Motor-ships*. Part II, *Descriptive Catalogue*. London, 1968.

Starke, Mariana. *Information and Directions for Travellers on the Continent*. 5th ed. London, 1824.

"Steam Navigation in the Port of London." *Journal of the Franklin Institute* 14, no. 2 (August 1834): 83–90; 14, no. 6 (December 1834): 361–65.

Stewart, Dugald. *Philosophical Essays*. 1810. American ed. Philadelphia, 1811.

Stirling, A. M. W. *The Richmond Papers: From the Correspondence and Manuscripts of George Richmond, R.A., and His Son Sir William Richmond, R.A., K.C.B.* London, 1926.

Sussman, Herbert L. *Victorians and the Machine: The Literary Response to Technology.* Cambridge, Mass., 1968.

Tann, Jennifer. *The Evolution of the Factory.* London, 1970.

Tarnas, Richard. *The Passion of the Western Mind.* New York, 1991.

Thackrah, Charles Turner. *The Effects of the Arts, Trades, and Professions on Health and Longevity.* 2d ed., 1832. Reprint, with preface by Saul Benison. Published with *The Life, Work, and Times of Charles Turner Thackrah* (1957), by A. Meiklejohn. Canton, Mass., 1985.

Thornbury, Walter. *The Life and Correspondence of J. M. W. Turner.* 1877. Reprint. London, 1970.

Timbs, John. *Curiosities of London.* London, 1855.

Tristan, Flora. *The London Journal of Flora Tristan.* 1842. Reprint. London, 1984.

Ure, Andrew. *The Philosophy of Manufactures.* London, 1835.

Vaughan, William. "London Topographers and Urban Change." In *Victorian Artists and the City: A Collection of Critical Essays,* edited by Ira Nadel and F. S. Schwarzbach, 59–77. New York, 1980.

Walker, John. *Joseph Mallord William Turner.* New York, 1976.

Wallace, Marcia Briggs. "J. M. W. Turner's Circular, Octagonal, and Square Paintings, 1840–46." *Arts Magazine* 53, no. 8 (April 1979): 107–17.

Whishaw, Francis. *The Railways of Great Britain and Ireland.* 1842. Reprint. New York, 1969.

Wilton, Andrew. *J. M. W. Turner: His Art and Life.* New York, 1979.

———. "Turner and the Sense of Place." *Turner Studies* 8, no. 2 (winter 1988): 26–32.

———. *Turner and the Sublime.* London, 1980.

———. *Turner in His Time.* New York, 1979.

Woodring, Carl. *Nature into Art: Cultural Transformations in Nineteenth-Century Britain.* Cambridge, Mass., 1989.

Wosk, Julie. *Breaking Frame: Technology and the Visual Arts in the Nineteenth Century.* New Brunswick, N.J., 1992.

Wyld, James. *The Great Western, Cheltenham and Great Western, and Bristol and Exeter Railway Guides.* London, 1839.

Index

Individual works by Turner are listed as subentries under Turner, J. M. W.; Turner's print series are listed as main entries by title. Italic page references indicate illustrations.

mill design, 1, 90–91. *See also* urban industrialism

Miller, William, after J. M. W. Turner: *Melun*, 45; *The Tower of London, 128*

Milton, John, *Paradise Lost, 158*

modernity: art of, 2, 5–19, 162–66; Dudley, 111–12; Leeds, 95–96; tradition integrated with, 53, 94, 121, 164, 165; Tyneside, 96; urban, 86–139. *See also* Industrial Revolution; technology

Monet, Claude, 124–25, 191

Moon, Boys and Graves Gallery, 104, 120

moonlight, 103–4, 118–19

Morlent, Joseph, *Voyage historique et pittoresque du Havre à Rouen, en bateau à vapeur*, 31

Morning Chronicle: on *Keelmen*, 103; on *Rain, Steam, and Speed*, 144, 147, 149, 156; on *Rockets and Blue Lights*, 75; on steamer deaths, 126

Morning Herald, 70

Morning Post, 75, 84, 103, 141, 148

Morse, Samuel Finley Breese, 26, 173

Mumford, Lewis, 149

Murray, John, *Handbook for Travellers in France*, 37–38; *Handbook for Travellers in Switzerland*, 49; *Handbook for Travellers on the Continent*, 47

Murray, Michael, 199

Murray, Taylor and Wordsworth, 91

music: romantic, 14–15; "Steam-Boat Divertimento," 21

Naiad (steamer), 128, 130

Napoleon, 178, 179

Nash, Treadway, *Collections for the History of Worcestershire*, 119

Nasmyth, James, 110

National Gallery of Practical Science Blending Instruction with Amusement, 79

nationalism/patriotism, 159–60, 165

nature: as dangerous, 12–13, 35–38, 62–85, 136–37, 156–57; human vulnerability to, 12–13, 62–85, 164, 166, 199; landscapes, 2, 3, 8–9, 11–13, 62–85, 94, 111; railroads and, 156–57, 159; romanticism and, 4, 11–12, 14, 28; speed conquering, 154; steamboats and, 35–36, 47–49, 62–85, 157, 166; sublimity beyond, 18; technology and, 2, 3, 8–9, 11, 13, 70–71, 75–77, 84–85, 156–57, 166; travel books and, 28; in Turner's paintings, 2, 3, 4, 12–13, 14, 48, 62–85, 103, 156–57

Nautical Magazine, 20–21, 127, 178

nautical subjects. *See* marine painting; transport

Nelson, Horatio, 52, 53, 54–55, 179

Newcastle, 86, 97–99, 187

Newcomen, Thomas, 108

New Monthly Magazine, 103

New Steam-boat Companion, 21, 126

Niagara Falls, 13

noise, in *Rain, Steam, and Speed*, 149–50

Normandy, 28, 31, 39

Northumberland, 64

Nymph (steamer), 128, 130

Oastler, Richard, 93

Oban, 66–67, 69

objectivity, 19

optimism. *See* progress

Oriental (steamer), 55, 57–61, 179

Oulton, W. C., *Traveller's Guide*, 96–97

Paddington Station, 161

"palm of ugliness" awards, 8–9

Paris, 30, 31

Parliament: Houses burned, 5, 53, 136, 137; and industrial smoke, 192; and steamers, 53–54, 172; West Riding representation in, 94

Passavant, Johann, 124, 135

patriotism/nationalism, 159–60, 165

Paxton, Joseph, 1

Peacock, Thomas Love, *Nightmare Abbey*, 15

Peel, Sir Robert, 165

Peninsular and Orient Steam Navigation Company, 57

Pevsner, Nikolaus, 148

"Philosophic Radicals," 165

"Phoenix," 155

Physick, W., after N. J. Kempe, *The Steamship "Oriental,"* 58

"Pictorial and Mechanical Exhibition," 82

picturesque, the, 2, 8–9, 53, 94

Picturesque Views in England and Wales, 3, 27, 29, 94; H. E. Lloyd, text by, 187; and traditional landscape painting, 94, 163. *See also under* Turner, J. M. W.: *Coventry, Warwickshire; Dudley, Worcestershire;* and *Dunstanborough Castle; Richmond Hill and Bridge*

Picturesque Views on the Southern Coast of England, 25, 56–57

poetry: Campbell, 44–45; German, 16; Hood, 133; and imagination, 17–18; Milton, 158; and painting, 18; Shelley, 17–18; Turner, 12–13, 17–18, 86, 134, 135; Wordsworth, 16, 68, 159

Designer: Barbara Jellow

Compositor: Integrated Composition Systems

Text: 10/14 Sabon

Display: Weiss

Printer: Data Reproductions Corp.

Binder: John H. Dekker & Sons